Catching Light in Your Paintings

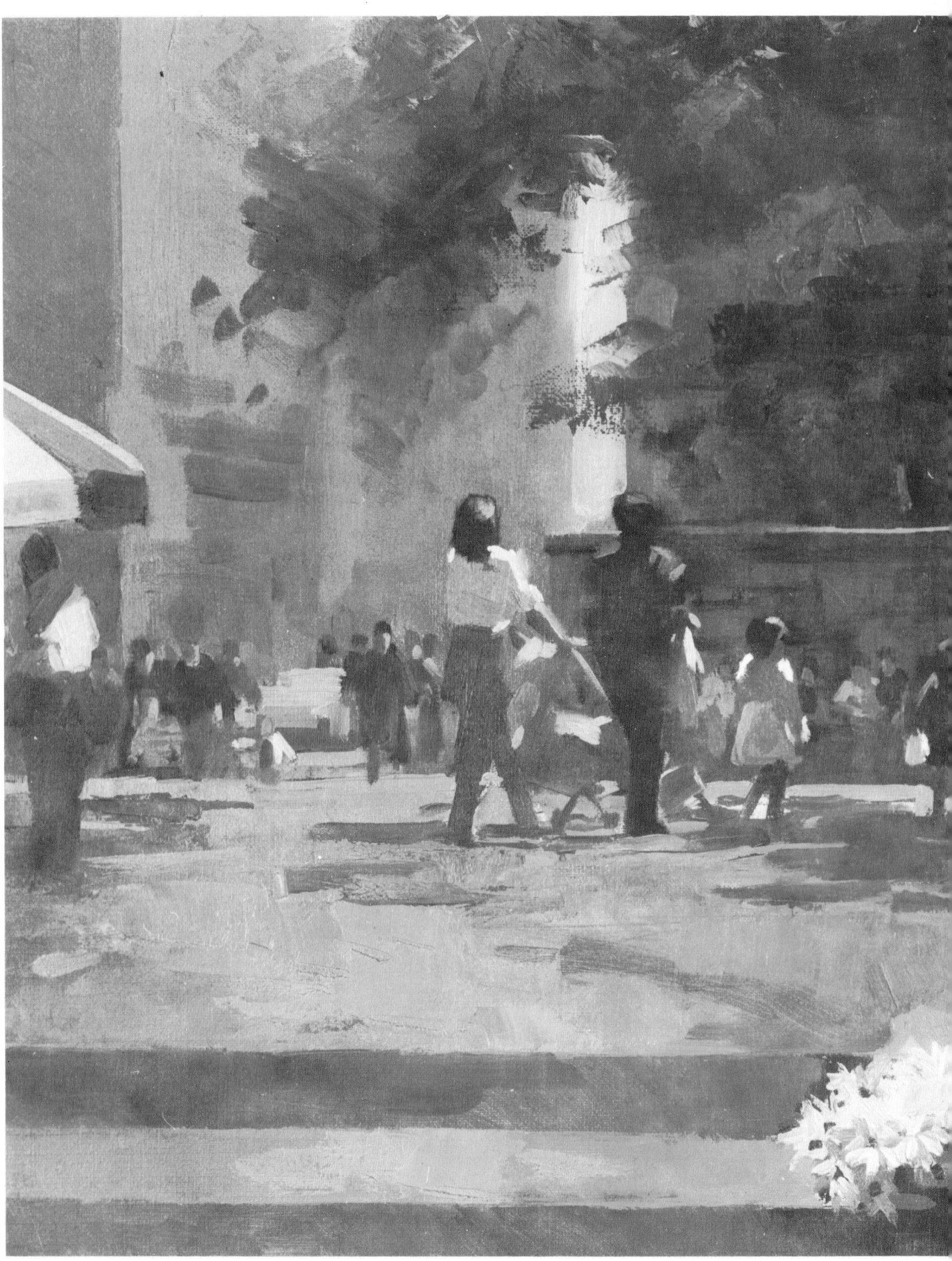

Catching Light in Your Paintings

by Charles Sovek

North Light Publishers

Published by North Light, an imprint of Writer's Digest Books, 9933 Alliance Road, Cincinnati, Ohio 45242

Copyright 1984 by Charles Sovek, all rights reserved.

No part of this publication may be reproduced or used in any form or by any means—graphic, electronic, or mechanical, including photocopying, recording, taping, or information storage and retrieval systems—without written permission of the publisher.

Manufactured in U.S.A.
First Printing 1984

Library of Congress Cataloging in Publication Data

Sovek, Charles.
 Catching light in your paintings.

 Includes index.
 1. Light in art. 2. Painting—Technique. I. Title.
 ND1484.S68 1984 751.4 84-19054
 ISBN 0-89134-106-4
 ISBN 0-89134-107-2 (pbk.)

To the fond memory of my father, Charles H. Sovek
teacher, craftsman, thinker and friend

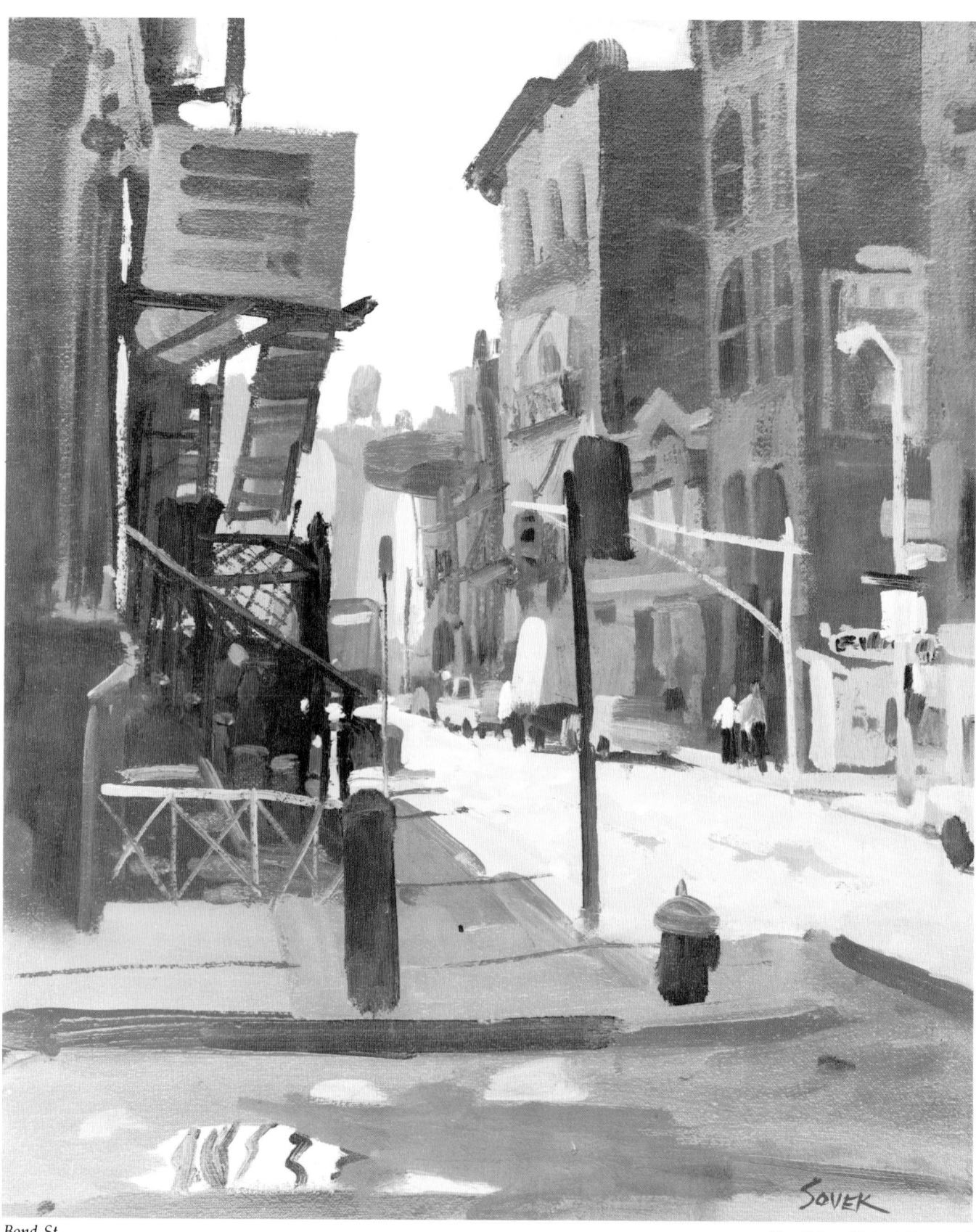

Bond St.
15"x18" oil on canvas.

River Gallery, Westport, Connecticut

Contents

Introduction	9
Chapter 1	
Past masters	10
Important movements in painting light	14
Color portfolio of past masters	16
Painting light today	25
Chapter 2	
Shadow, the foundation of light	26
Changing the direction of light	30
Less obvious effects of shadows	34
Chapter 3	
Values, the language of light	36
The value palette	38
Home values	39
Halftones	40
Simplifying complex objects	42
Enlarging value scale	44
Reflective surfaces	52
Changing light and mood	56
Foreground, middle ground and background	58
Aerial perspective	60
Controlling textures	62
Truth of tone	65
Chapter 4	
Controlling edges, atmosphere and edges	66
The four kinds of edges	70
Keying your pictures	72
Atmosphere	74
Subtlety of mood	78
Chapter 5	
The many kinds of light	80
Various kinds of light sources	82
The poetry of light	105
Chapter 6	
Color and light	106
Choosing the right colors	110
Palettes of Old Masters	110
Values, color, intensity and temperature	112
Compliments	114
Reflecting light	117
Painting different times of day	120
Portraits and figures	125
Color expressiveness	129
Chapter 7	
Interpreting what you see	130
Choosing the view	132
Gathering reference material	136
Photography and the artist	137
Fact or fancy?	141
Chapter 8	
A variety of techniques	142
Oils	146
Acrylics	150
Acrylics and pastel	151
Gouache	152
Watercolor	153
Pencil, charcoal and pen	154
Mixing mediums	156
Chapter 9	
Picture making	158
Demonstration, "Flower Child"	164
Demonstration, "A Breezy Day on the Saugatuck"	166
Be a maverick	169
Some final thoughts	170
Suggested reading	173
Index	174, 175

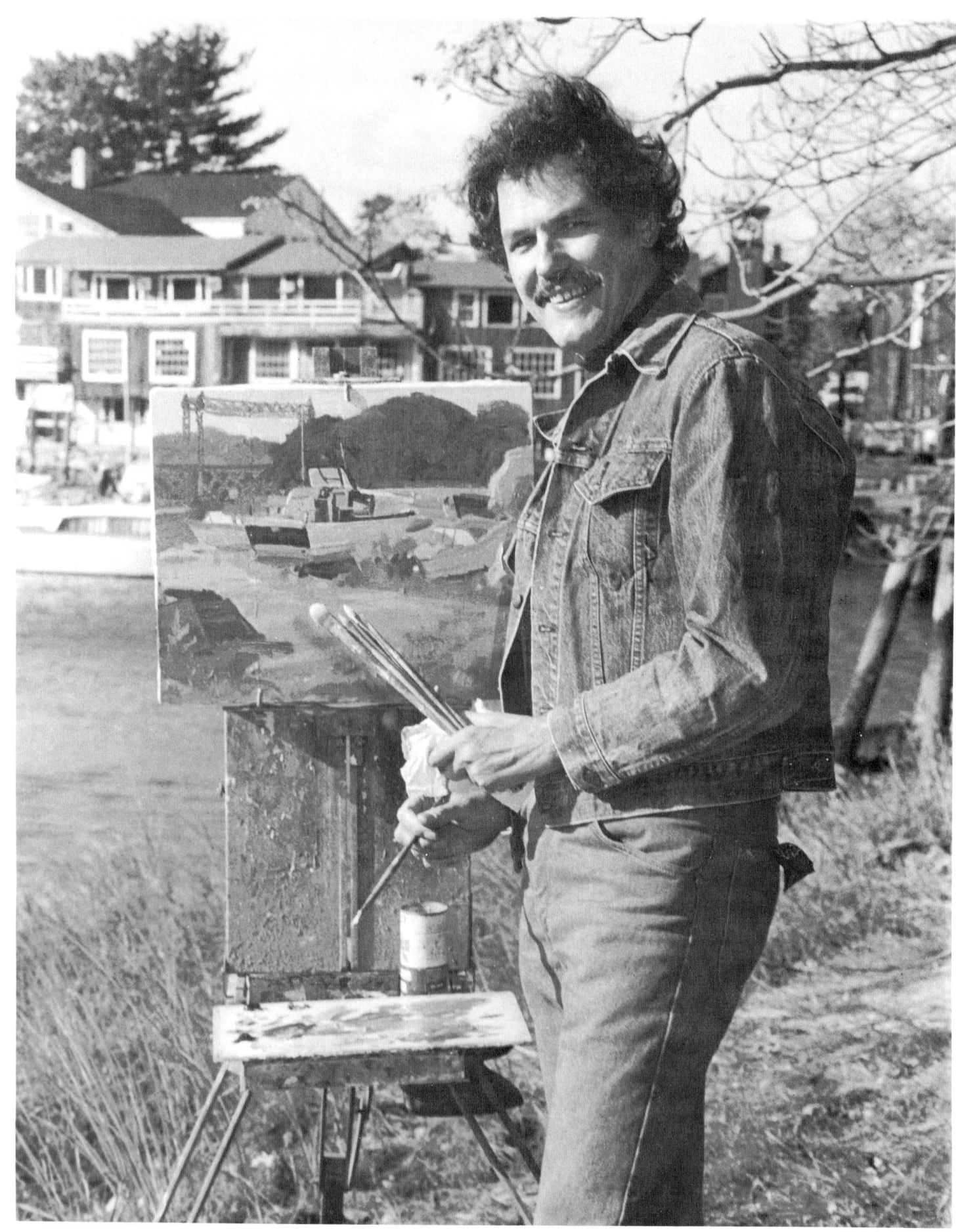

Photo by Bill Noyes

Introduction

The writing of this book is the result of a life-long love affair with light. Hardly a day has passed in my twenty-five years of painting that some lighting effect has failed to stir me. The pursuit has been long and hard, though never boring, and I still find myself bristling with anticipation when seeing some singular effect.

The flame was lit in art school by the chance exposure to a portfolio of work by an advanced painting student. After one look at his light-filled canvases, I knew that was my kind of painting, and to this day I can still recall the flutter of excitement and thinking—that's for me. Little did I then realize the difficulties that lay ahead in pursuing that goal. Yet as I paint today, that same motivation propels me.

Serving my apprenticeship in New York as an illustrator began a period of living a double life. By day I painted figures in shiny automobiles, hunting and fishing scenes and couples in passionate embraces, trying to bathe the scenes in sparkling light but usually ending up rendering rather than painting.

Fortunately, evenings and weekends were devoted to subjects of my own choosing. The benefits of that vigorous period proved to be twofold. Painting illustrations polished my craft to a professional level while working outdoors on weekends kept alive my desire to *catch light*. Looking back I know those years in New York were both necessary and worthwhile for me. Painting in the kaleidoscope of a great city, though frustrating, is a real learning experience.

I now live in the country, beside a river and not far from Long Island Sound. The subjects I paint are different from those of the city, though equally captivating. In the summers, between painting assignments, I'll frequently take out my small boat and patrol up and down the Saugatuck River studying the light as it plays over the water and riverbanks. When I find an area of interest I'll make fast to the shore or drop anchor and pull out my portable easel and painting gear and set to work.

It's my feeling that most painters, both beginners and old hands, share my fascination with light and it's to them that this book is directed. Though my methods may not be right for everyone, I feel that what I have to offer is basic and universal enough to help those who are seeking to improve the quality of light in their painting.

The knowledge I offer isn't limited to art school theories; rather it is a lifetime learning experience based on countless treks to museums, endless discussions with fellow artists, the reading and scrutinizing of great books, teaching, and most important of all, the thousands of hours spent in front of an easel studying the effects of light with enthusiasm and respect. In the final analysis, it's the desire that counts. This book is for those who have that desire.

Chapter **1**

Past Masters of Painting Light

Studying the work of many artists throughout history who used light effectively in their paintings is fascinating and wonderfully rewarding. It's clear to see that, in painting, as with most other of mankind's discoveries, understanding the effects of light was a slow, cumulative development. Seldom does progress hinge on an isolated incident of a particular artist sitting at his easel one day and deciding to paint light.

Because painting reflects the times an artist lives in, a brief look into the past will give us a better perspective in understanding how light evolved as a tool for artistic expression.

Before the beginning of the Renaissance in the fourteenth century, paintings of ancient civilizations including the Egyptian, Chinese, Greek, and Roman, generally have one quality in common—the use of painting as a symbol rather than a realistic representation of nature. Emphasis was often on flat silhouettes, with shapes surrounded by lines rather than fully modeled forms. Paintings of this period, or more precisely colored drawings, either accompanied or were closely related to the writing of the day. Nature and naturalism were seldom referred to directly. Instead, symbols were developed to convey scenes of hunts, migrations or important deities.

The inquiring mind of the Renaissance painter sought new and more scientific ways of seeing nature. Subjects formerly ignored were now appropriate painting material. Researches into Greek and Roman art led to a new awareness of sculptural solidity, and the modeling of forms replaced the linear outlines and flat shapes previously used.

As paintings came to be thought of as a window into space, perspective evolved, giving pictures an optical trueness rather than a symbolic one. Painters such as Sandro Botticelli, Giotto and Piero della Francesca are good examples of the artists of this period. The effect of light shining in a painting, though not sought after for its own sake, was still an important consideration for these artists because in modeling the forms in their paintings, a choice had to be made as to which part of a form was to be relegated to light and which to shadow.

If all the forms in the composition were to be shown consistently, some sort of directional light source must be established. So concerned, however, were these artists to

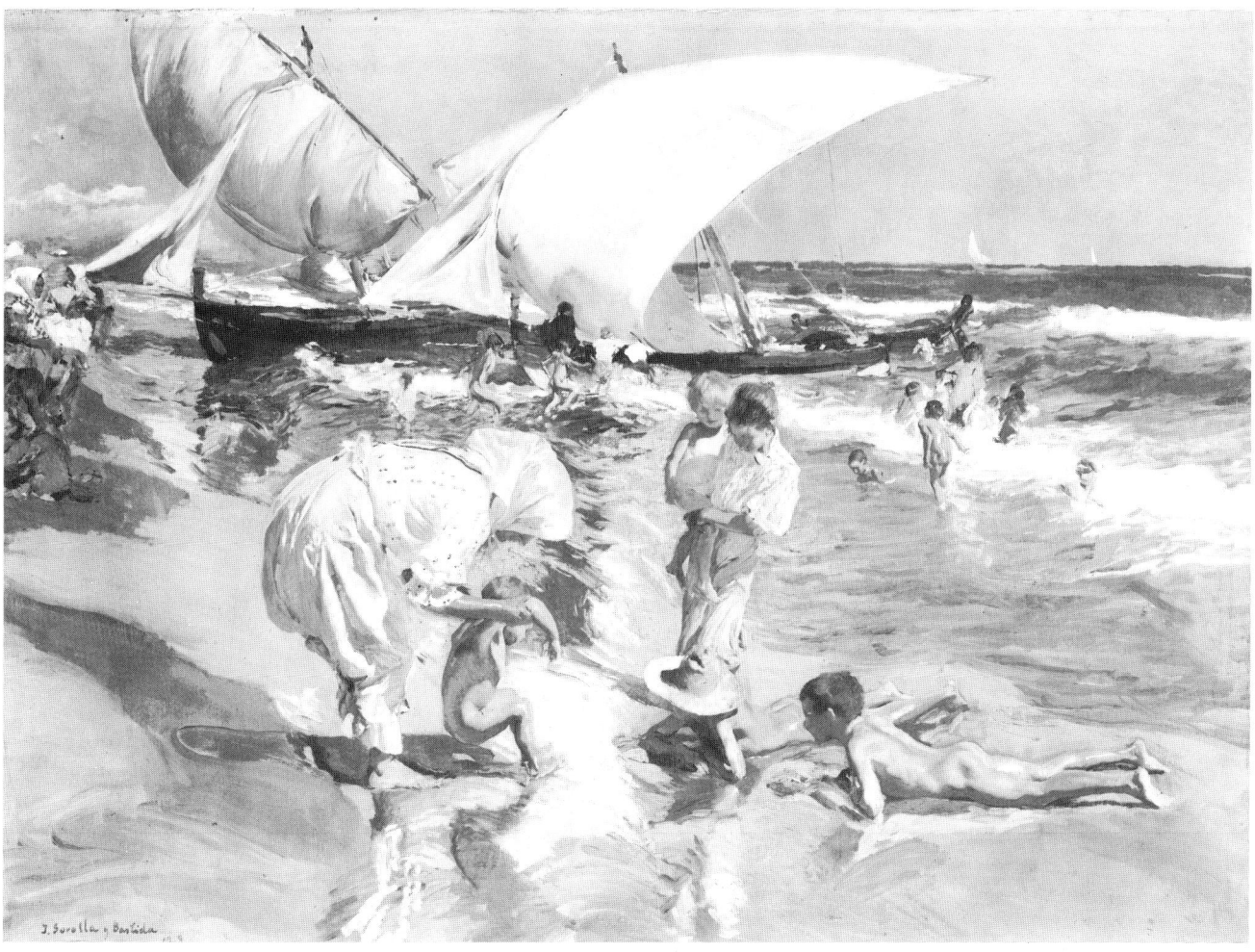

Hispanic Society of America

JOAQUÍN SOROLLA (1863-1923)
Beach of Valencia by Morning Light, 1903
28"x36" oil on canvas.

Sorolla was one of the first painters to combine the new discoveries in color, pioneered by the French Impressionists, with the rich values of earlier, more traditional artists. This sun-filled beach scene shows the painter at the height of his powers, wonderfully capturing the effects of sunlight as it played over the sand and shore. Notice how the figures are not only solid and light-struck but also depicted in natural, relaxed gestures, adding greatly to the picture's believability.

render solid forms that little thought was given to the particular effects of light. This resulted in giving the paintings of this period, whether they were depicting indoor or outdoor scenes, the appearance of being lit by the same soft, diffused light.

The high point of the Renaissance saw such artists as Michelangelo, Raphael and Leonardo da Vinci pushing further the ideas initiated by their predecessors. Modeling became more sophisiticated, compositions more daring. How exciting it must have been for these artists to paint their masterpieces and see them come alive on the walls and ceilings of churches. And how many people, when viewing them, probably gazed in awesome wonder. The superstars of the Renaissance set the pace for many years to come, and it wasn't until Michelangelo da Caravaggio (in the early 1600s) that a new language of vision was to come on the scene.

Until Caravaggio, painters usually ignored the less detailed effects of mysterious shadow passages and rendered both light and shadow with equal importance. Caravaggio painted mostly local peasants, rendering his forms as if lit by a spotlight, which left large parts of his picture in darkness (a ploy, incidentally, picked up by the early avant-garde filmmakers). Despite the initial shock and disapproval of this approach, within a half century artists all over Europe were following the example set by this Italian innovator.

Interesting and dramatic lighting effects were also pioneered by El Greco, whose exaggerated figure compositions were further dramatized by a cool light shining on them; Vermeer, who chose the clear light of day spilling through a window to depict genre scenes in Holland; and Rembrandt, who bathed his pictures in warm, luminous light.

Two English painters of the early nineteenth century, J. M. W. Turner and John Constable, added still another contribution to painting light. Consistent with that century's renewed interest in naturalism, they began working on location, studying various effects of light and atmosphere and using these small, quickly painted studies as reference for larger studio paintings. Constable, in particular, experimented with accents of pure color in certain passages of his studies which gave them added life and vitality. A generation later Claude Monet and Camille Pissarro would be influenced by Constable's methods and combine these with their own discoveries, to produce some of the best work of the French Impressionist movement.

Painting light reached its zenith with the Impressionists in the latter part of the nineteenth century. Interesting lighting, color and atmospheric effects dictated the subject matter and paintings were usually completed on location rather than in the studio. Other important Impressionist painters were Pierre Renoir, Alfred Sisley, Berthe Morisot and Mary Cassatt. Though we now view the Impressionists' work as fresh and inspired when compared to the colorless, overly detailed Academy paintings of the day, great resistance was brought to bear on these painters by the conservative faction of the French art establishment. By the late 1800s, though, Impressionism became accepted and its influence showed itself in the paintings of many artists throughout Europe and America.

Though probably unaware of French Impressionism, other artists living in different parts of the world were also experimenting with brighter, higher-keyed palettes and also going after the effects of light as a means of artistic expression. In Spain, Joaquín Sorolla used a colorful, high-keyed palette similar to the Impressionists to capture remarkable light-filled scenes of Spanish beaches and countrysides. Anders Zorn in Sweden, though working with a darker palette, also started to see light as an important compositional device in his genre paintings. There were many others, such as Antonio Mancini in Italy and Valentin Serov in Russia. American Impressionists—namely Childe Hassam, Theodore Robinson, Edmund Tarbell, John Twachtman, Frank W. Benson and Edward Potthast—specialized in light-filled canvases of figures and landscapes. Potthast was an important American Impressionist perhaps not as well known but as good as any of them.

As more personal art forms, many of them abstract, followed the liberating movement of Impressionism, the interest in impressionistic effects decreased. However, the Ashcan School of American painters of the early 1900s, which included Robert Henri, John Sloan, George Bellows, Maurice Prendergast and Edward Lawson, continued to show concern for realistic light in their work.

Impressionism's chief drawback was the loss of a full range of values, particularly useful in modeling. This was due to the lim-

ited range of high-keyed values the Impressionists preferred in suggesting the effects of sun-filled landscapes. The Ashcan School, while using the loose painterly technique of the Impressionists, also incorporated the darker, richer value range reminiscent of Rembrandt and Frans Hals.

In the 1930s Edward Hopper, a student of Robert Henri's, added further to the repertoire of painting light with evocative cityscapes, carefully simplifying and designing patterns of light and shadow, not only to capture a strong mood but to impart a satisfying abstract quality to his paintings.

Since the 1920s painting has changed in ever-quickening cycles. On page 25 I'll discuss more fully what is being done today by painters interested in capturing the challenging effects of light.

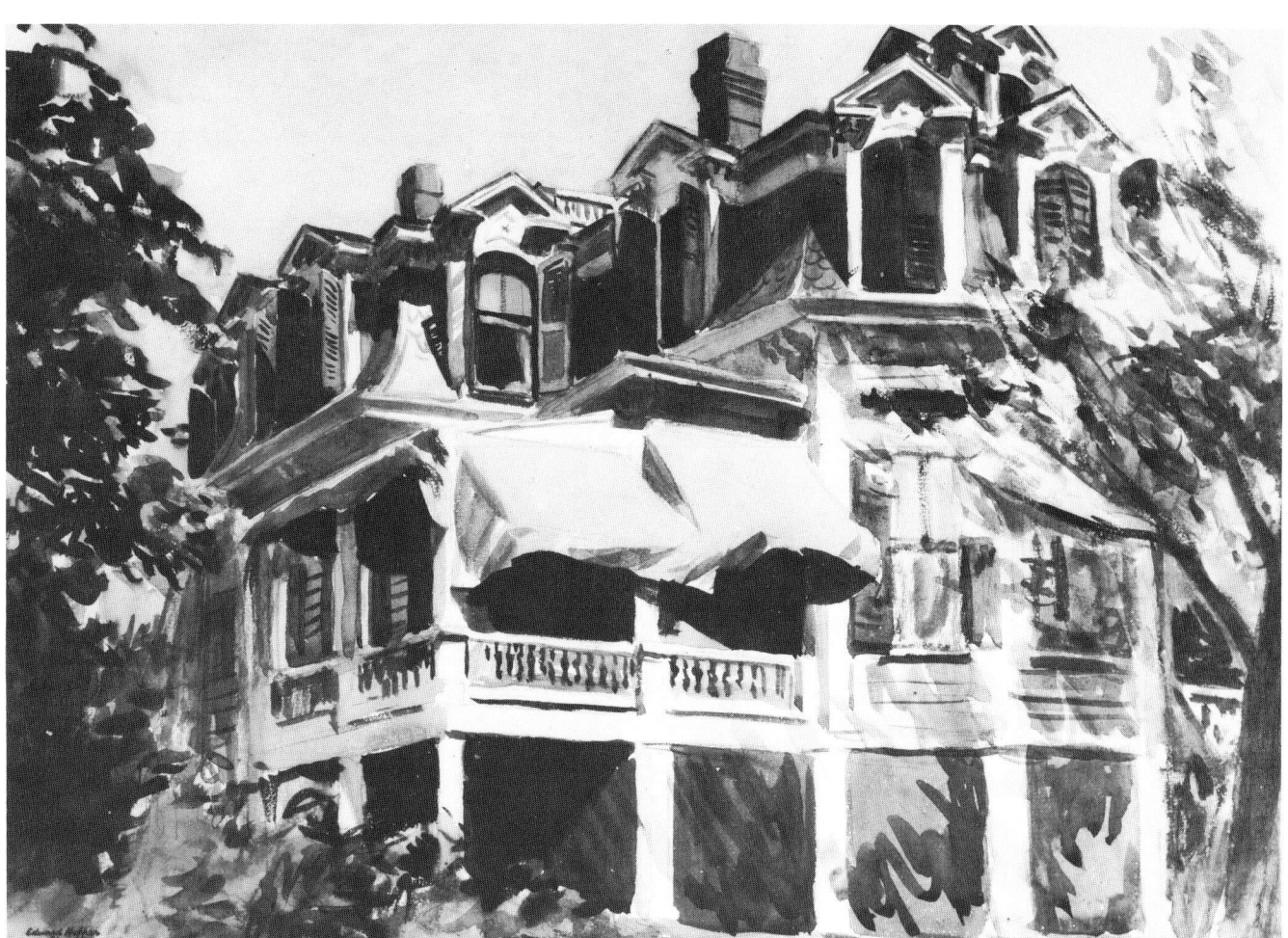

The Brooklyn Museum, Museum Collection Fund

EDWARD HOPPER (1882-1967)
The Mansard Roof, 1923
13¾"x19" watercolor on paper.

The Mansard Roof is one of six watercolors Hopper exhibited at the Brooklyn Museum. The artist was forty-one at the time and had never before shown his watercolors publicly. Painted entirely on location, as were all his watercolors, this picture is an excellent example of not only catching the effect of sunlight on architecture but magically infusing the subject with a feeling of wind and temperature as well. Notice the boldness of the painter's brushstrokes as they sculpt the geometric planes of the building. *The Mansard Roof* is consistent with Hopper's mature work. Besides being an accurate recording of a time of day, it is a satisfying arrangement of abstract shapes.

Important Movements in Painting Light

Although the look and style of a painting vary with each individual artist, when viewed collectively, the endless number of pictures painted from the late 1500s (about the time light started to take on artistic importance) to the present day can be broken down into three broad movements. They are: tonalism, impressionism and realism. They form the basis on which today's artists approach the problems of lighting in their paintings.

Tonalism

Tonalism means using tones or values rather than lines or colors as the dominant structure in painting a picture. Because a full range of prepared tube colors was unavailable to artists prior to the 1850s, painters relied heavily on tone to establish the effects they wanted. Study Figures 1-1 and 1-2, and notice the feeling of completeness each artist achieved through his manipulation of values. Even without any color, the paintings look resolved, solid and believable.

Impressionism

Now have a look at Figures 1-3 and 1-4, and observe the loose, brushy treatment of the paint strokes with less regard for a strong tonal organization. If these paintings were reproduced in full color they would appear more complete. Because they're executed in a more impressionistic manner they rely heavily on the juxtaposition of warm and cool color.

One aim of impressionism was to minimize tonal form and rely heavily on color to create depth and model forms. While some impressionist works are successful in this respect, many others, sans color, appear washed-out approximations of the scene.

Realism

Realism can be said to be an amalgam of the best of both tonalism and impressionism. By realism I mean that every detail in a painting is recognizable in not only tone but color. Edouard Vuillard (1868–1940), classified as a Nabis painter, could well be one of the first artists to bridge the gap between tone and color, not only incorporating the rich value schemes of the tonalists but also injecting his work with the fresh, bright colors of the Impressionists. The paintings of Jan Hoowij and Edward Hopper, Figures 1-5 and 1-6, are two other examples of painters who have also found a compromise between tonalism and impressionism.

Artists have always been influenced by one another, first emulating, then eventually updating whatever style inspired them. Today we can learn from the past, and, hopefully, make our own innovative offering. This, in turn, will probably be elaborated upon still again, in years to come.

All pictures on the opposite page are courtesy of The Brooklyn Museum

Tonalism

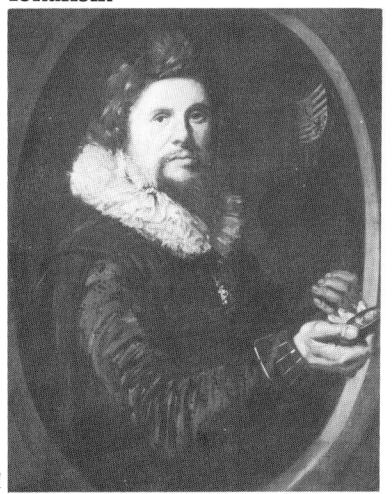

Figure 1-1
FRANS HALS (circa 1580-1666)
Portrait of a Man Holding a Medallion,
c. 1614-16 29¼"x22½" oil on canvas.

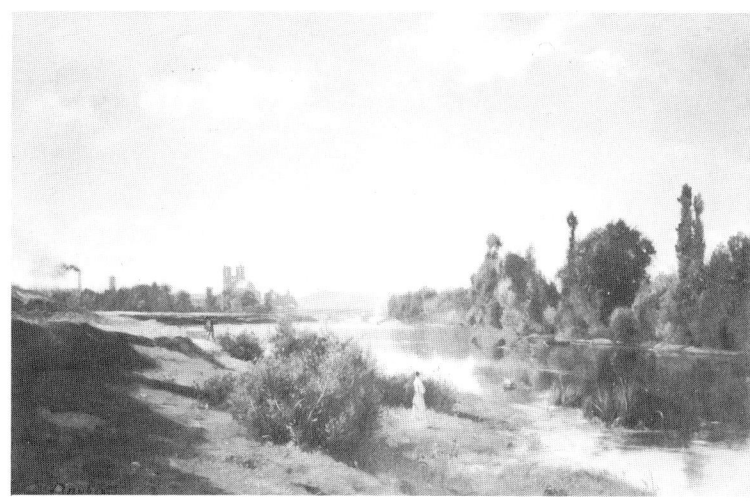

Figure 1-2
CHARLES FRANÇOIS DAUBIGNY (1817-1879)
The River Seine at Mantes, c. 1865
19¹/₁₆"x29¹¹/₁₆" oil on canvas.

Impressionism

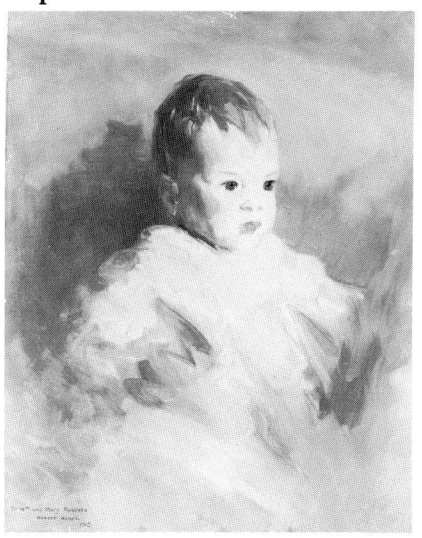

Figure 1-3
ROBERT HENRI (1865-1929)
Portrait of Patricia Roberts, 1915
24"x20" oil on canvas.

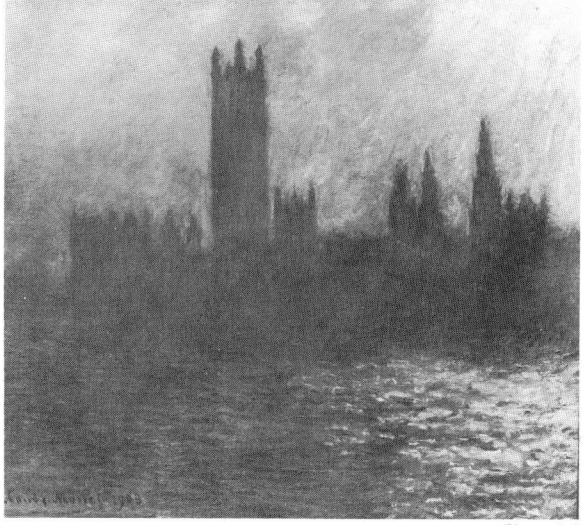

Figure 1-4
CLAUDE MONET (1840-1926)
House of Parliament, Effect of Sunlight, 1903
32"x36¼" oil on canvas.

Realism

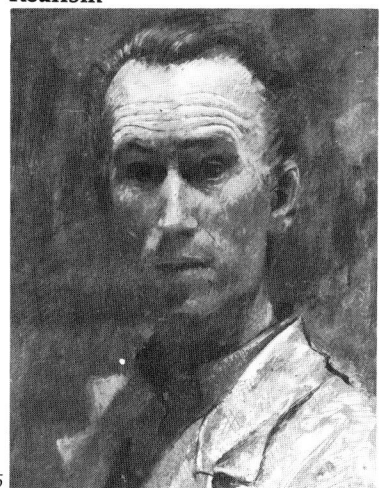

Figure 1-5
JAN HOOWIJ (1907-)
Self-Portrait, 1946
16"x12" oil on Masonite.

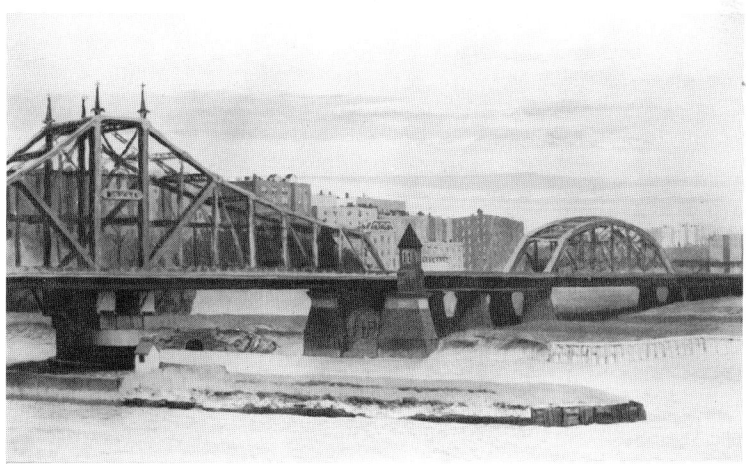

Figure 1-6
EDWARD HOPPER (1882-1967)
Macom's Dam Bridge, 1935
35"x60³/₁₆" oil on canvas.

A Color Portfolio of Past Masters of Painting Light

The following color portfolio displays the work of eight painters who I feel are masters of catching light. A special effort was made to show works not frequently seen by the public. Because of this you'll not find Claude Monet or John Constable or Winslow Homer and many others that deservedly belong in this group. With the wealth of art books and reproductions available today, I've opted instead to show painters who, though less exposed, are equally masterful artists and, because of their superb facility in handling light, deserve to be seen. Rather than accompany the paintings with lengthy text and explanations, I've chosen to use as much of the page as possible to display the paintings, keeping the commentary short and pertinent. The paintings will also be discussed at various times throughout the book as examples of certain effects, color qualities and techniques.

The National Gallery of Art, Washington, D.C., Widener Collection 1942

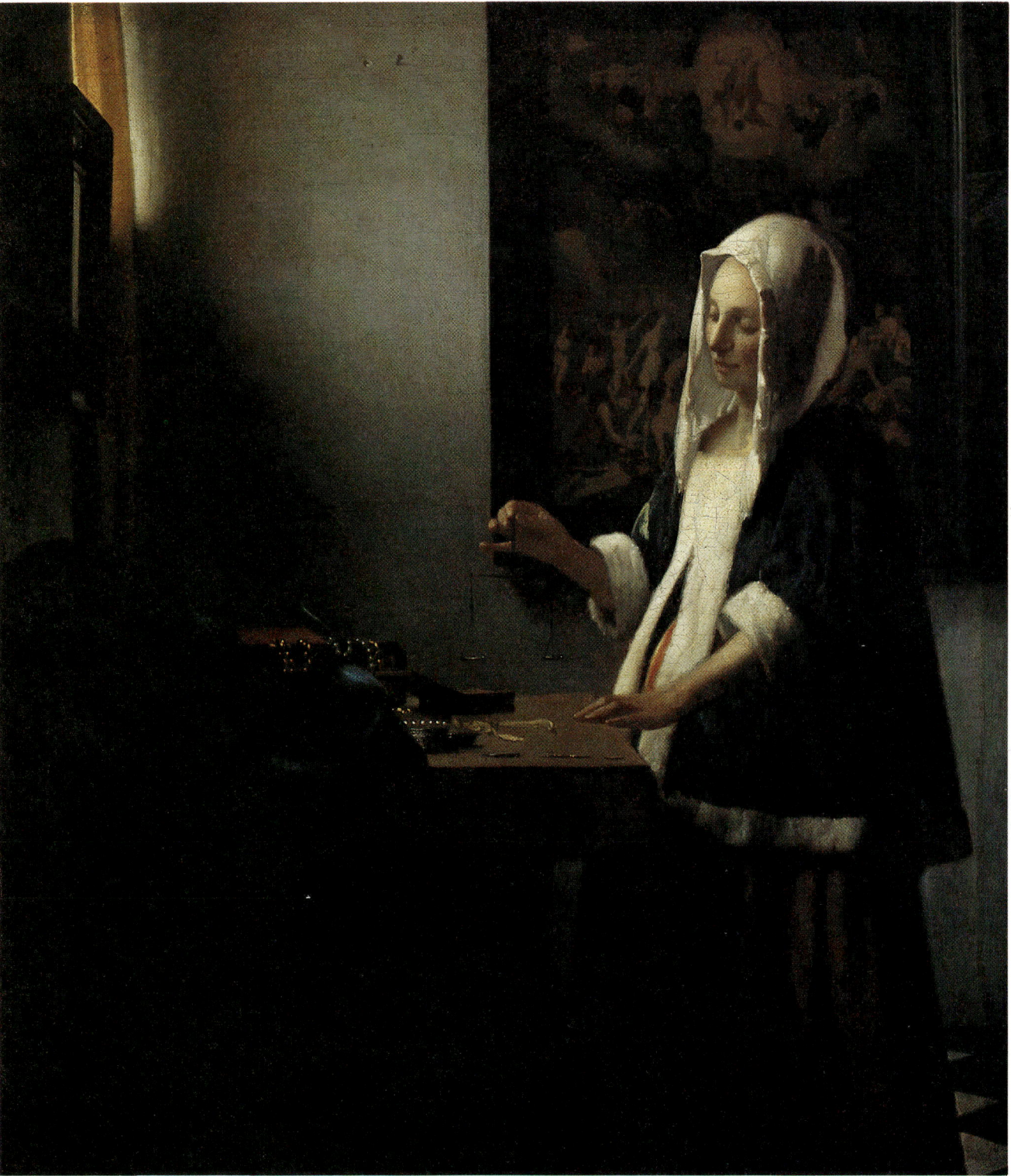

JAN VERMEER (1632-1675)
A Woman Weighing Gold
16¾"x15" oil on canvas.

Vermeer's obvious fascination with light is clearly evident in this quiet genre scene. The artist's smooth, sensitive paint application makes no discrimination between figure or objects, painting both with equal care. Notice how the clarity of the light-struck objects beautifully complements the more subdued, oftentimes lost shadow passages, with the cool, natural light of day acting as Vermeer's guide in painting this remarkably believable interior.

The Metropolitan Museum of Art, Gift of Katrin S. Vietor in loving memory of Ernest G. Vietor, 1960

CAMILLE PISSARRO (1830-1903)
The Boulevard Montmarte on a Winter Morning, 1897
25½"x32" oil on canvas.

Pissarro's output of paintings, beginning in his early twenties, steadily grew in wave upon wave of experiments and sometimes failures to full artistic maturity. All his work, however, was aesthetically tied together by his preoccupation with light and color. This early morning street scene was painted in the artist's sixty-third year. Working from a hotel window, Pissarro reveals to us his lifetime of experience in this straightforward rendition of early morning light on a busy French boulevard. Although Pissarro's colors are grey and muted and are applied in almost childlike daubs, the scene pulses with life and vitality, appearing as fresh as the day it was painted.

The Metropolitan Museum of Art, Gift of Mr. and Mrs. Henry Ittleson, Jr., 1964

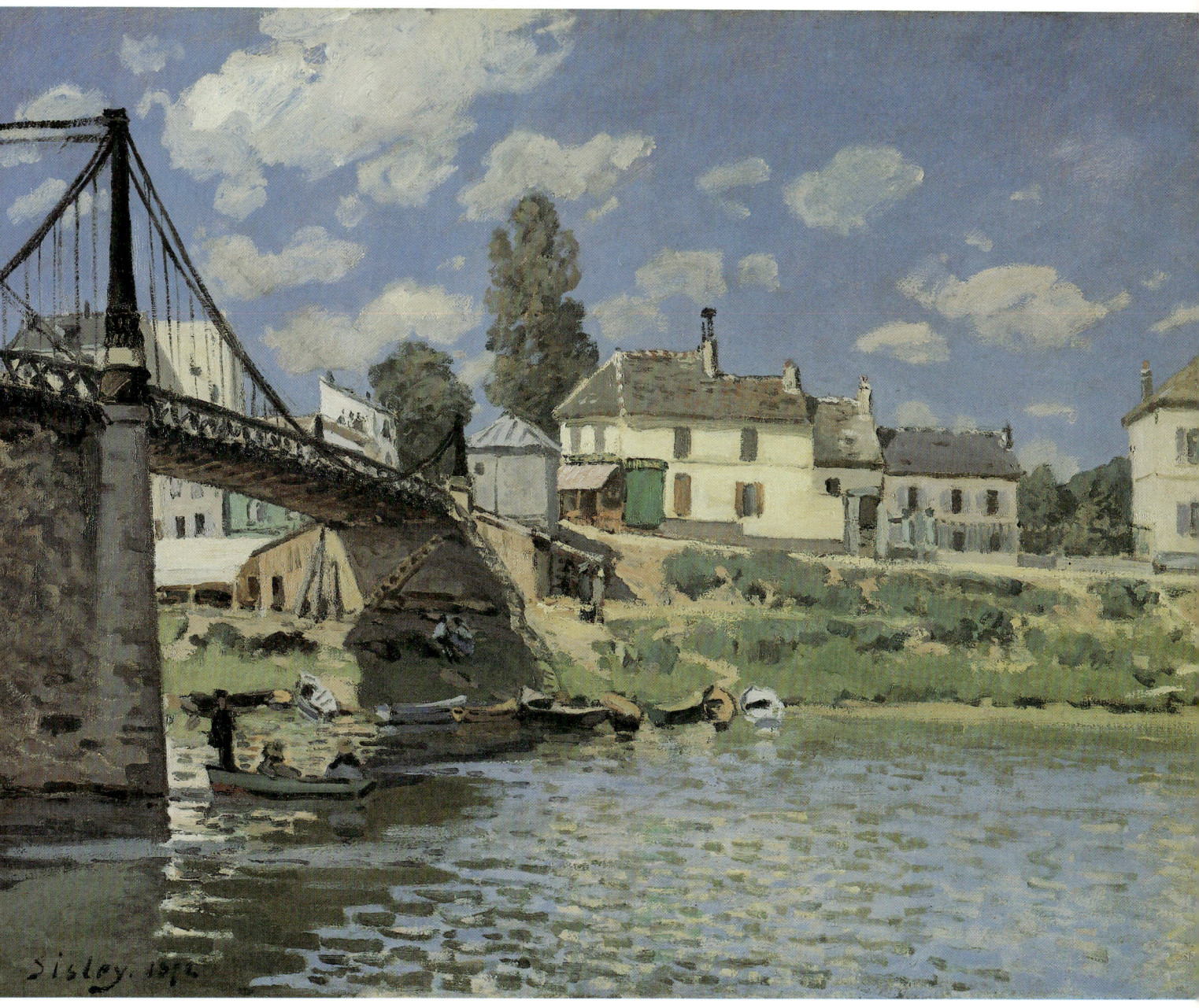

ALFRED SISLEY (1839-1899)
The Bridge at Villeneuve-la-Garenne, 1872
19½"x23¾" oil on canvas.

 To me this light-filled painting by Alfred Sisley sums up the whole movement of Impressionism. The colors are bright, without being gaudy; the values are light and high-keyed with sunlight (the real subject of the picture) casting a unifying glow over the entire scene.

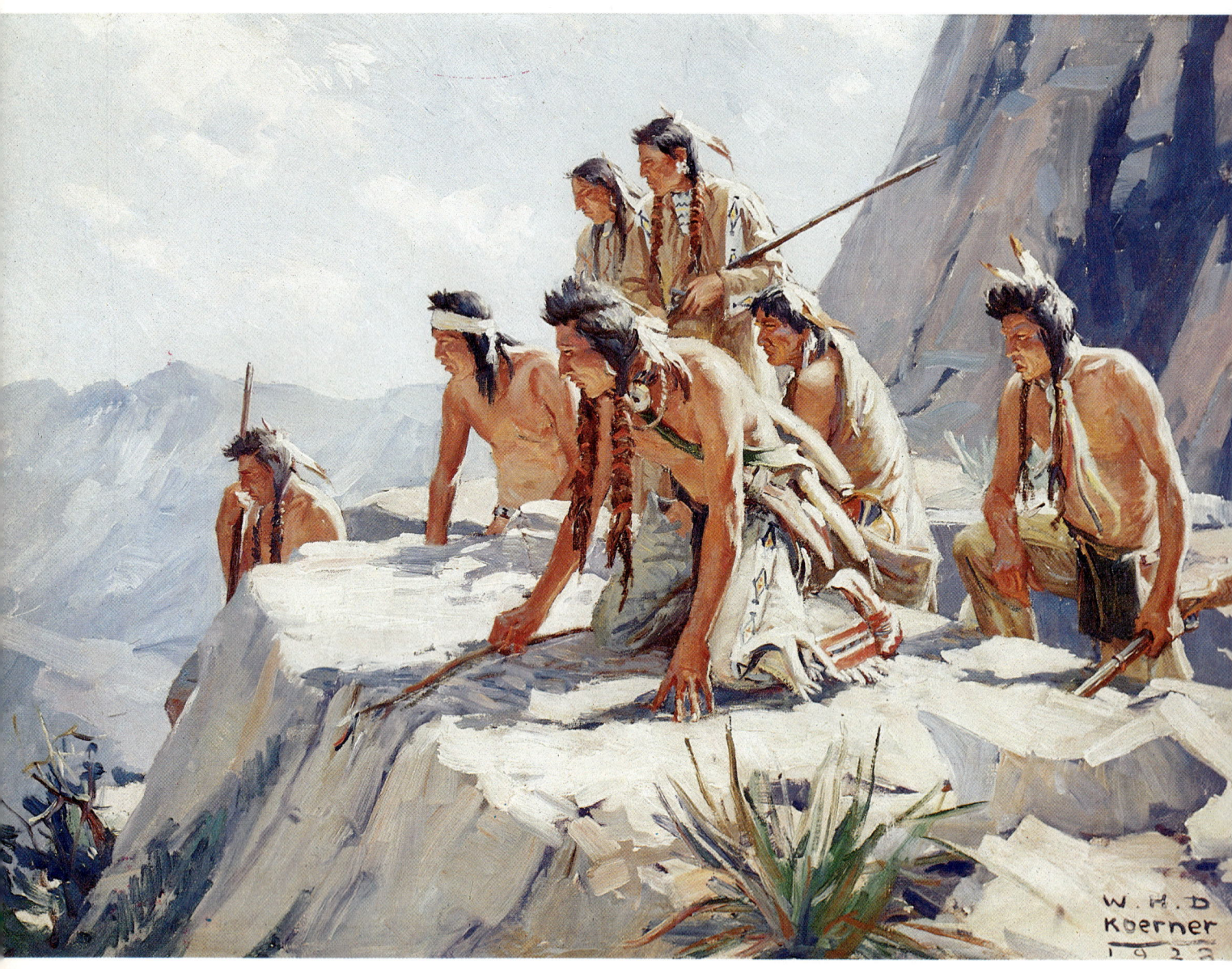

W. H. D. KOERNER (1878-1938)
Shoshone Scouting Party, oil on canvas

Mrs. Ruth Koerner Oliver

Koerner was one of a number of artists of his day who felt illustration and painting were not necessarily different vehicles of expression. Although this painting was used as an illustration for a *Saturday Evening Post* story, the treatment of the light-struck figures poised on the cliff are worthy of Monet or Sorolla. Notice the fresh, high-keyed color and the juxtaposed warm and cool color passages to reinforce the feeling of sunlight. Also adding to the picture's success is the artist's broad, painterly technique.

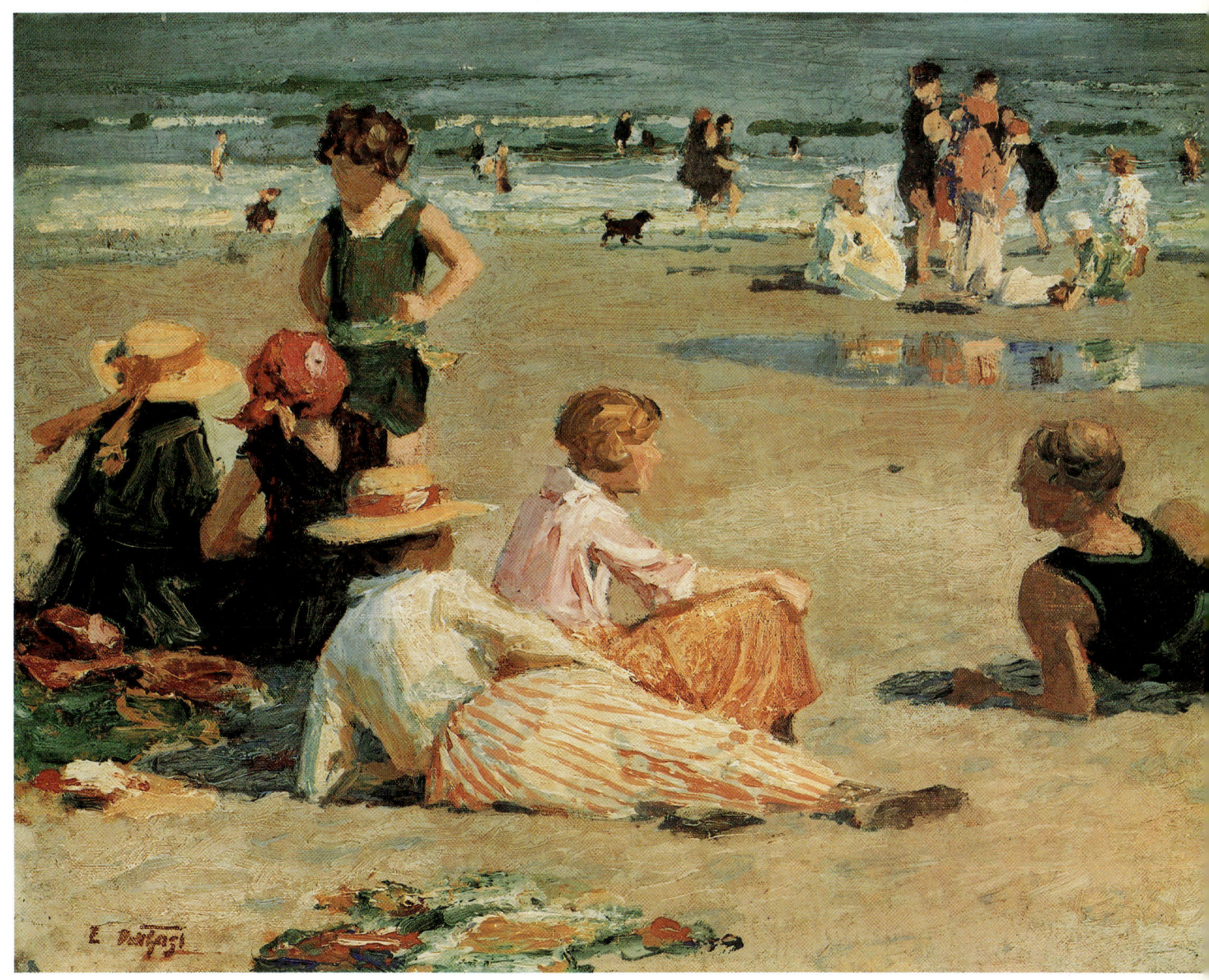

Mr. and Mrs. Merrill J. Gross

EDWARD POTTHAST (1857-1927)
Manhattan Beach
12"x16" oil on canvas.

American Impressionism had a wide following in the early 1900s, and one of its most sensitive practitioners was Edward Potthast. Beach scenes, such as the one reproduced here, were a favorite theme of Potthast, and it's easy to see why these crisp, brightly lit subjects were so popular. Notice how the entire scene emanates a bracing, seaside atmosphere. Although the artist has liberally sprinkled his painting with bold dashes of color, he's still managed to keep his forms solid and well grounded.

The Freer Gallery of Art, Smithsonian Institution, Washington, D.C.

JOHN SINGER SARGENT (1856-1925)
Breakfast in the Loggia
20″x28″ oil on canvas.

While Sargent gained international renown from his portraits, I feel his genre scenes, such as the one shown here, are the painter's highest artistic achievements. Although *Breakfast in the Loggia* is full of dazzling bravura, the technique never overpowers the artist's genuine interest in catching light. Seldom has any painter ever surpassed Sargent's magicianlike powers of indicating forms and textures with such ease and complete visual believability.

The Addison Gallery of American Art, Phillips Academy, Andover, Massachusetts

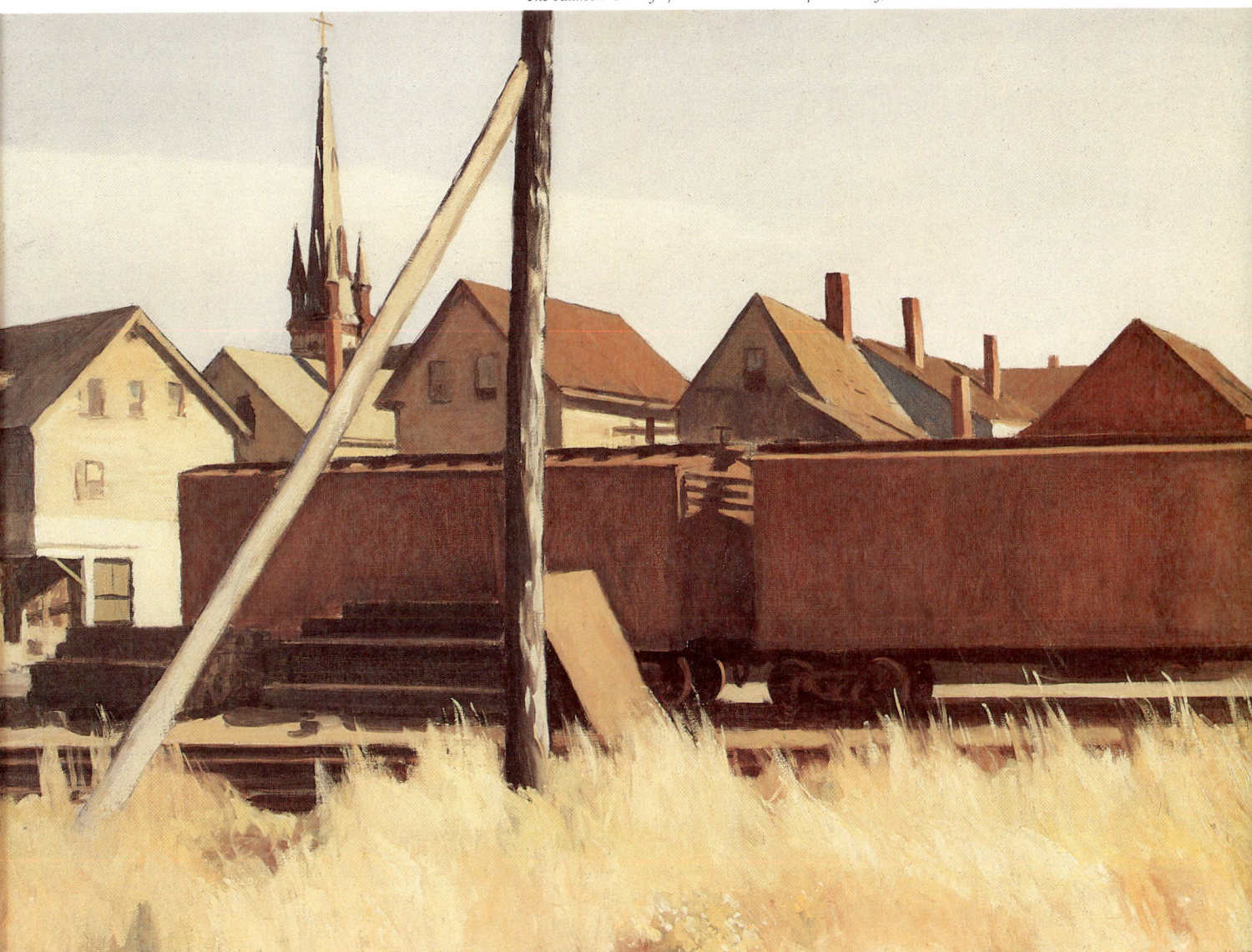

EDWARD HOPPER (1882-1967)
Freight Cars, Gloucester, 1928
29"x40" oil on canvas.

Like many of his subjects, Edward Hopper was a lonely realist in the years when most American painters were seeking abstract solutions to picture making. Typical of his mature paintings, *Freight Cars, Gloucester* captures a moment in time. Sunlight shining on a deserted railroad siding reveals the sculptural qualities of the most ordinary of subjects. Yet somehow, Hopper has managed to instill the scene with a quiet dignity and turn it into a most extraordinary painting.

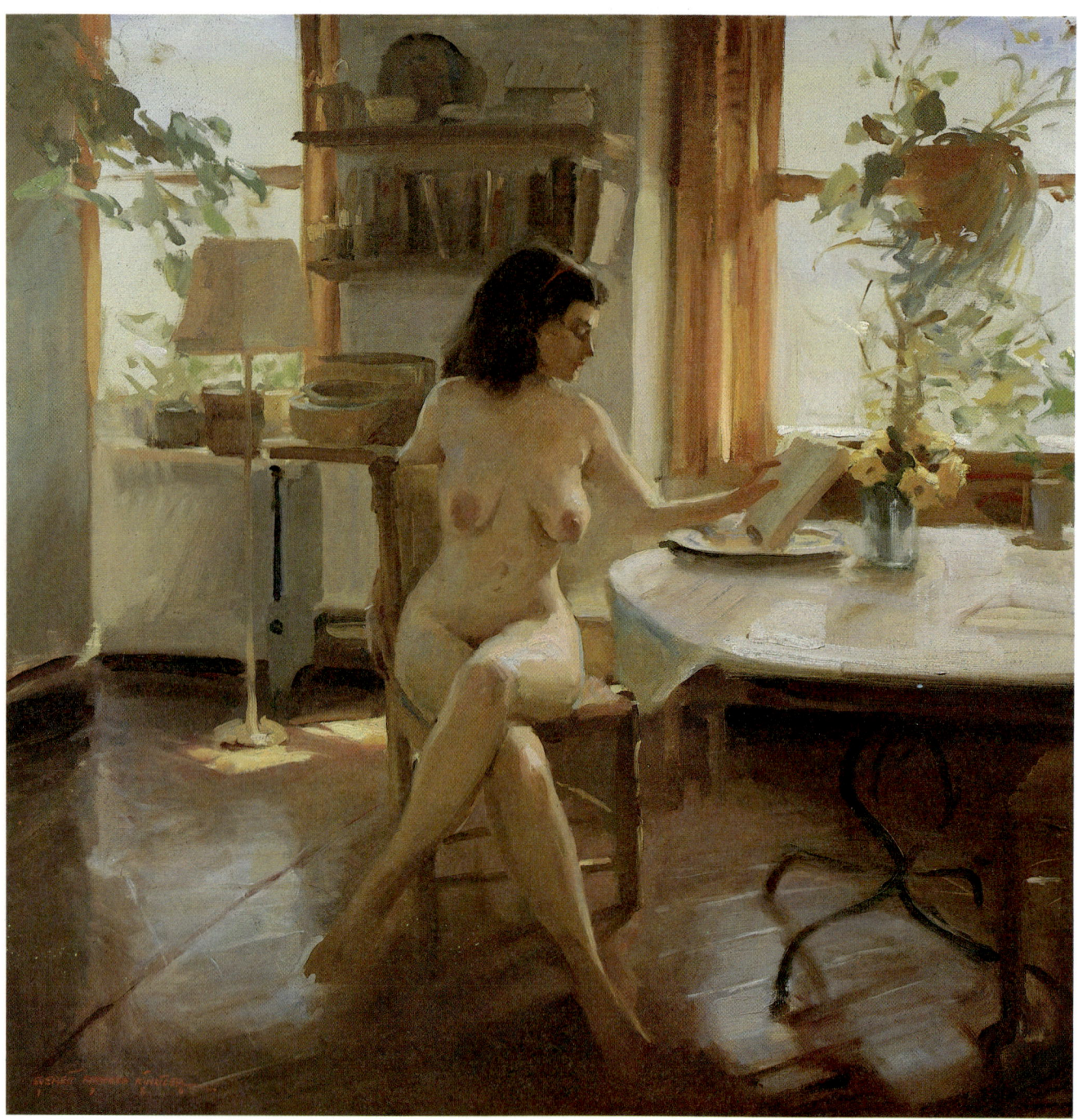

EVERETT RAYMOND KINSTLER (1926-), N.A., A.W.S.
Interior
34"x34" oil on canvas.

Collection of the artist

When a sensitive portrait painter turns his hand to painting the figure, the results can't help but be impressive. Notice the complete naturalness with which the figure belongs to the scene, both encompassed in dreamy, yet tangible space. With great economy, Kinstler has not only subordinated detail but imparted a quiet vitality to what could have been a very busy picture.

Collection of Charles and Deborah Sovek

CHRISTY GALLAGHER (1939-)
Loon Lake
9"x12" oil on Masonite.

This small, jewellike landscape could easily be enlarged to heroic proportions without losing any of its quiet power. Notice how the artist has taken a commonly depicted subject and artfully recycled it to become not only a convincing recording of a particular place and time of day but also a contemporary orchestration of shapes and colors satisfying to even the most discriminating of viewers.

Painting Light Today

After briefly reviewing the remarkable works of some of the past masters of painting light, one wonders, is there anything left to express for the artist today? My answer is an unqualified yes! Years ago in track a four-minute mile seemed unobtainable. Today, it's not uncommon for an athlete to run the mile in three minutes fifty seconds, or even less. So too with painting. Influenced by the rich heritage of styles, techniques and theories passed down to us, contemporary artists are pioneering all sorts of new avenues of expression. Thanks largely to the Impressionists and the abstract movement that followed, the painter is free from the restricting bondage of subject matter. A picture need no longer be judged by its content or subject; rather, it's the expression and mood which give a painting quality and worth.

A quick survey of recent painting reveals a diversified group of artists, seeking their own particular form of expression, using light as a source of inspiration for their pictures. These include Fairfield Porter, Richard Dash, Jane Freilicher, Charles Pfahl, Jane Wilson, Charles Reid, Richard Schmid and Everett Raymond Kinstler to name a few.

It's interesting to study the work of these artists and try to trace back their sources of inspiration. Charles Reid, the popular contemporary painter, for example, has been admittedly influenced by Fairfield Porter, who, in turn, was inspired by the Post Impressionists and Vuillard. Ray Kinstler's lively style owes a debt to John Singer Sargent. The next generation of painters influenced by the past—including our present—will no doubt make their own singular contribution. And so it goes. As the great teacher Robert Henri observed: we're all part of a brotherhood, each of us related by our mutual interests.

Certainly you, as an artist, can benefit from the past. However, don't fall into the trap of emulating a favorite past master to the point of losing your own identity. Be of your own time, sing your own song and your paintings can't help but reflect the world you live in, warts and all!

Chapter **2**

Shadow, the Foundation of Light

The dictionary definition of shadow is "comparative darkness caused by cutting off the rays of light." Or, simply stated, shadow is the absence of light. For the painter, however, shadow means much more; shadows are the artist's building blocks for creating a convincing illusion of the things in his picture.

Imagine a room with light pouring in from all directions; there are lights on the ceiling, wall and even the floor. The furniture and objects in such a room would appear flat, devoid of a third dimension, and they would be recognizable only by color and value changes. Of course if we sat in one of the chairs or touched a table top we would verify their existence, but visually, our eyes would only recognize the objects because of their color and value changes.

Imagine again the same room, this time with only one table lamp lighting the whole scene. Our eyes now see the dimension of the furniture and objects much more easily. The room takes on depth; everything looks more solid and understandable. Why? Because the shadows cast from the single table lamp guide our eye, much like a map, showing us the planes of objects that don't receive light. By contrast, the areas catching light inform us of other planes directly in the path of the light. Still other areas catch only small amounts of light and show us still more about the appearance of a given object.

One of the best ways to learn to see and draw shadows is to use just *one* tone or value. It's surprising how much a single dark value can reveal about the appearance of our subject. Notice the silhouette drawing on this page, Figure 2-1. Although no lights were used, we easily recognize the face. This kind of decorative silhouette was popular at the turn of the century, many times done with black paper cut with scissors. The charm of these drawings lies in their ability to suggest. Though we see no eyes or ears we know they exist; our imagination fills them in. This is another quality of shadow the dictionary doesn't mention, and that is, the "magic" of shadows. As moviemakers discovered years ago, the power of suggestion can make something appear much more real than something completely defined. We've all

Figure 2-1
Silhouette drawing

clutched our seats while watching something lurking in the shadows of a scary movie, and how much more frightening it is when it's lurking than when we finally see it in full light and great detail.

The same power of suggestion can be effectively used by the painter. Rembrandt achieved powerful dramatic moods in his paintings by putting secondary passages into mysterious shadows, only suggesting detail and saving strong lights and clear definitions for important areas. Andrew Wyeth's watercolors often appear as studies of shadow areas of strongly lit subjects, the lights being the untouched white paper.

Looking at shadows can be confusing at first because of the many changes of value our eye sees. One reason for this is that our eyes almost instantaneously adapt to different changes in lighting. Consequently, not only do there appear to be many value changes within a shadow, but all the values seem to grow lighter the longer we look at them. One remedy to this is the "quick glance" method of looking at your subject for only a few seconds, turning away, and remembering the values you saw. Another way is to squint your eyes, which eliminates small unimportant value changes.

Massing Shadows

Using one dark value for all the values in shadow is called massing. Observe the drawing of the bicycle on this page, Figure 2-2. I've drawn all my shadows with a single dark tone of the pencil. None are lighter or darker in value. The result is not only a clear illusion of a bicycle on a porch but an interesting arrangement of lights and darks. Stating the shadows and design of my composition would have been much more difficult if I had tried to juggle subtle changes of value as well. Painting my subject now becomes much easier because a firm foundation of shadow has been established.

Pencil drawings like this are valuable exercises in training your eye to see simple shadow patterns. Try some, both indoors, working under one light source, and outdoors on a sunny day when the shadows are clearly defined.

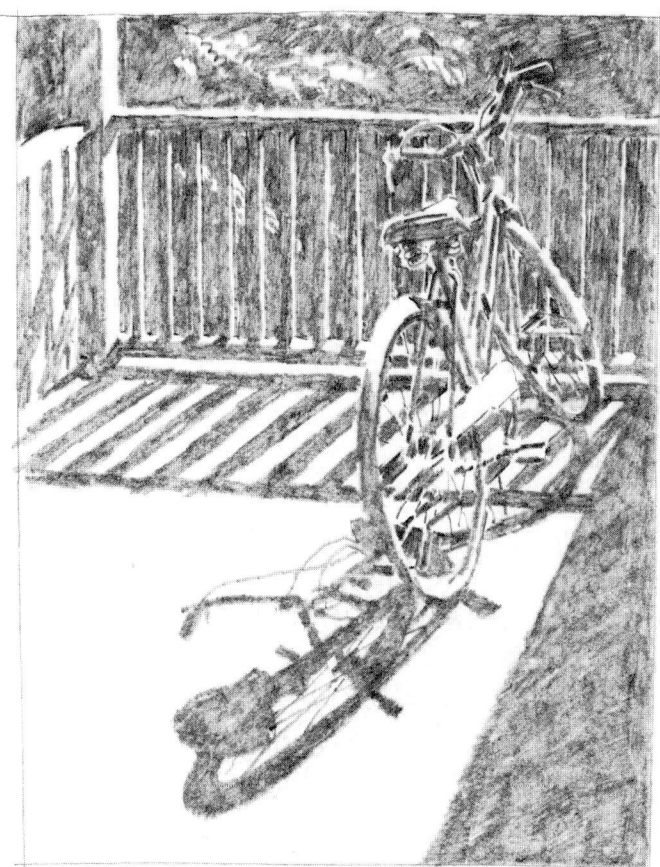

Figure 2-2
Drawing only the shadow masses

Light Shining on Simple Forms

A good way to understand light and shadow is to imagine switching on a light to illuminate a darkened object. Observe the darkened cone, ball and box in Figure 2-3. Now study the same three forms in Figure 2-4. Notice the effect of the single light shining on them. On all three forms the light, because its source originates from above and to the left, illuminates only the sides of the objects which most directly face the light. Remember, light can't go around corners. The box, with its square edges, shows this most clearly. When observing light-struck objects, it's important to keep this principle in mind.

The cast shadows of the three objects are shaped by the object itself and will vary in size depending upon the angle and distance of the light source. Cast shadows should be correctly stated, for they anchor an object to the surface it's resting on.

Working under a single light source has many advantages. Multiple light sources will add conflicting tones and distract from the firmness of the shadows.

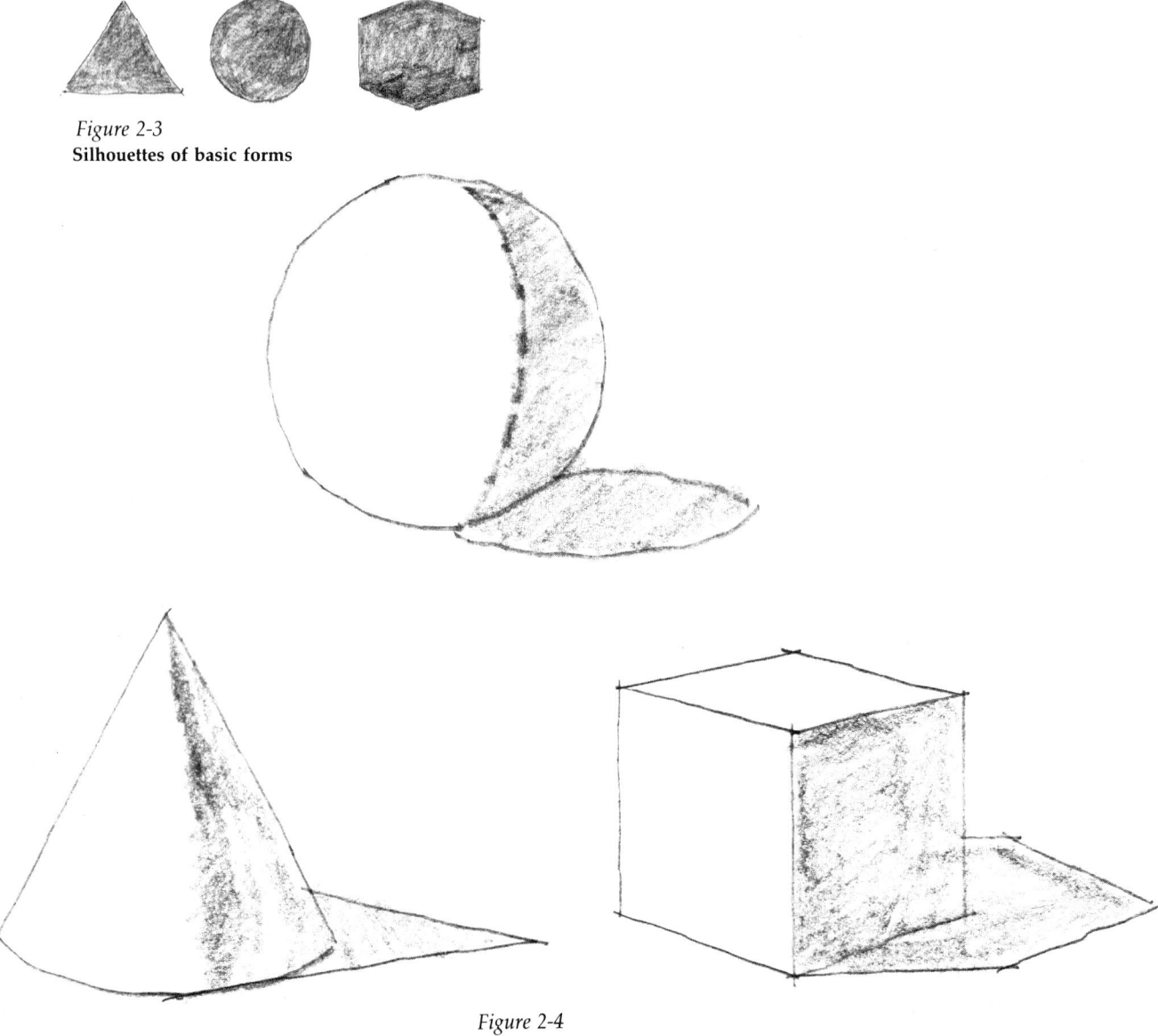

Figure 2-3
Silhouettes of basic forms

Figure 2-4
Light shining on basic forms

Designing Shadows

For me, one of the most enjoyable aspects of catching light is exploring the many designs that can be manipulated from the shadows of a subject. Before we begin designing, however, a few basics need to be understood. First, shadows describe the forms they're cast upon. Notice the shadow cast from the box in Figure 2-5. Observe how the shadow rolls over the fold of cloth the box is resting on. You might think of shadows as water spilling over a surface, with its course directed by the contours of the surface. Second, when a shadow meets an upright form it will change direction and follow that form. Study the effect of shadow cast from the ball, in Figure 2-6, and how it moves up the side of the cone.

Experiment yourself. Set up a couple of simple objects and place them under a single light source. Move the objects around, observing and making sketches until these basic facts are understood.

By adding a background to the three objects and enclosing them within a border we arrive at the basis for picture making. Learning to place simple objects within a defined area and lighting them with an eye for design is the first step in learning to express your individual taste. In Figure 2-6 I've overlapped the cone with the box and left the ball isolated. I've also placed a dark in back of the objects to emphasize the light sides of the ball and cone and carefully positioned the shadow of the cone in back of the box to accentuate its light side. This kind of planning is well worth the effort, for it gives the compositon a unity, clarity and design which satisfy the eye.

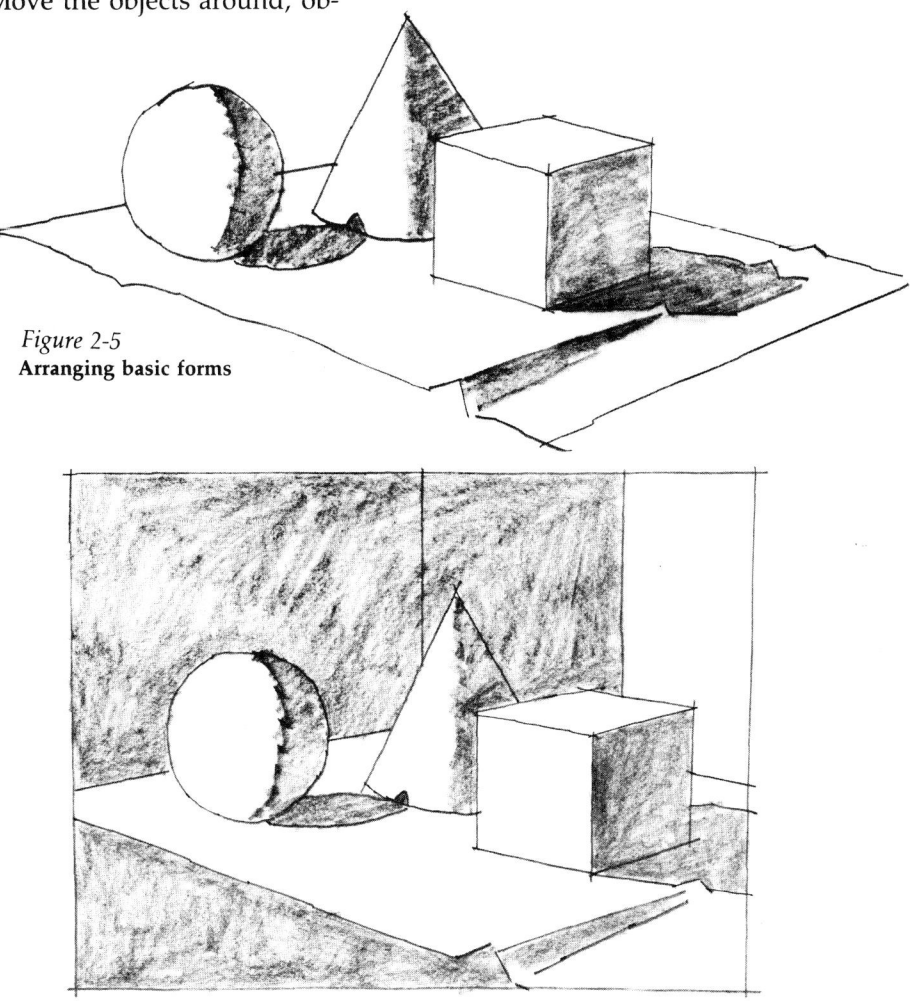

Figure 2-5
Arranging basic forms

Figure 2-6
Composing basic forms into a picture

29

Changing the Direction of Light

As artists, we have a wide variety of choices in lighting our subjects. Outdoors, the sun provides us with the best single light source of all. The only drawback is its slow but constant movement. This is compensated for, however, by a wealth of interesting and varied shadow patterns. To explore some of the possibilities of lighting a subject under sunlight I've chosen a simple composition of a figure sitting in a field. In each of the four variations of this composition, the sun is at a different position.

Figure 2-7 shows how the subject would look at dawn or dusk. The sun is over the horizon, and the whole scene, with the exception of the sky, is in shadow. The picture resembles the cutout silhouette of the head shown earlier. No values are defined and, with the exception of the boy's head and hat and the background foliage, there are no recognizable shapes.

In Figure 2-8, the sun is at the right of the figure. Forms are now more clearly defined by their shadows. The figure and berry basket are clearly recognizable. The simple lights striking the background bushes give further definition to the scene.

Figure 2-9 shows the sun directly above the figure. The hat throws the face, shoulders and chest into shadow; the few lights which define the figure, however, remain consistent with the light source, giving the drawing solidity and believability.

Figure 2-10 shows the sun shining from the left, just the opposite of Figure 2-8. Notice how the mood is altered. The face and figure are more clearly explained with larger passages of light shining on them.

I prefer the moods in Figures 2-8 and 2-9 because, in these, the figure seems to "belong" to the field and background, whereas the boy in Figure 2-10 looks somewhat isolated.

George Bridgman, a famous artist and teacher, once said, "When drawing a figure avoid an equal distribution of light and shadow, make one or the other predominate." It is sound advice.

I have to thank Winslow Homer for inspiring this set of illustrations. His paintings of figures in fields are excellent examples of simplifying lights and shadows into interesting shapes and patterns. Those interested in lighting in their paintings can benefit greatly by studying Homer's paintings.

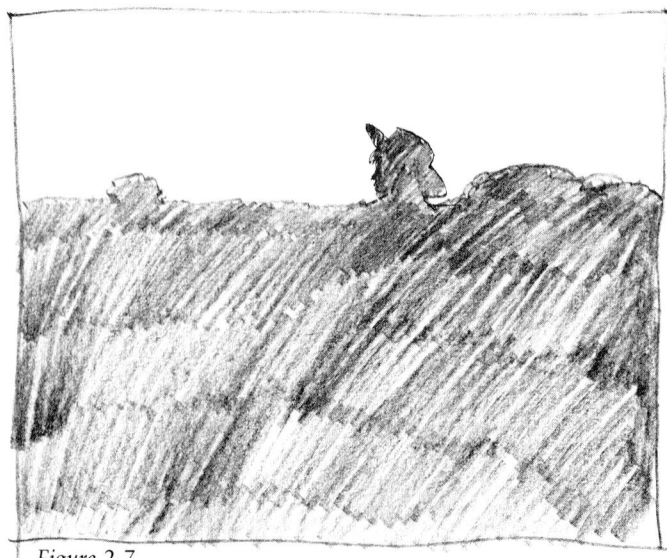

Figure 2-7
Subject entirely in shadow

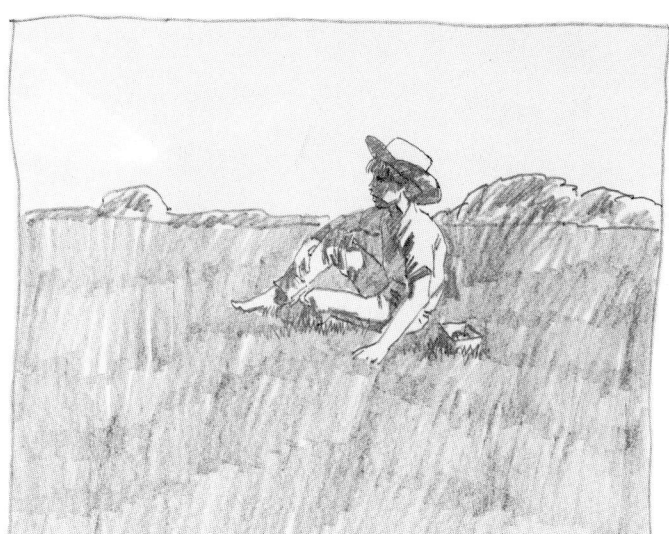

Figure 2-8
Light shining from top, right of subject

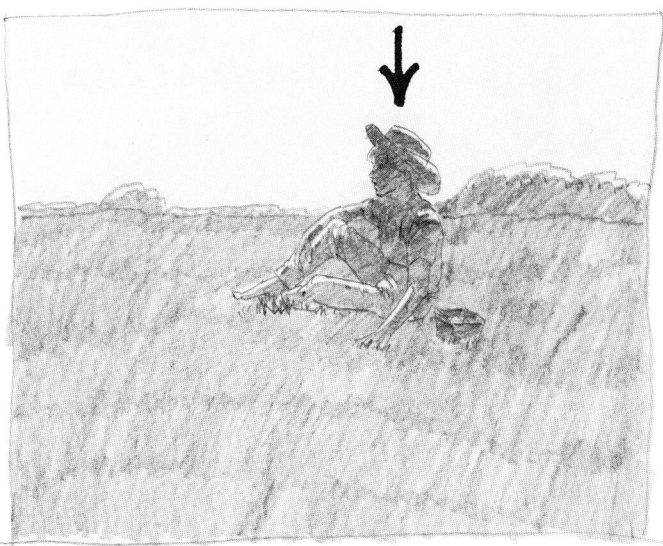

Figure 2-9
Light shining directly above the subject

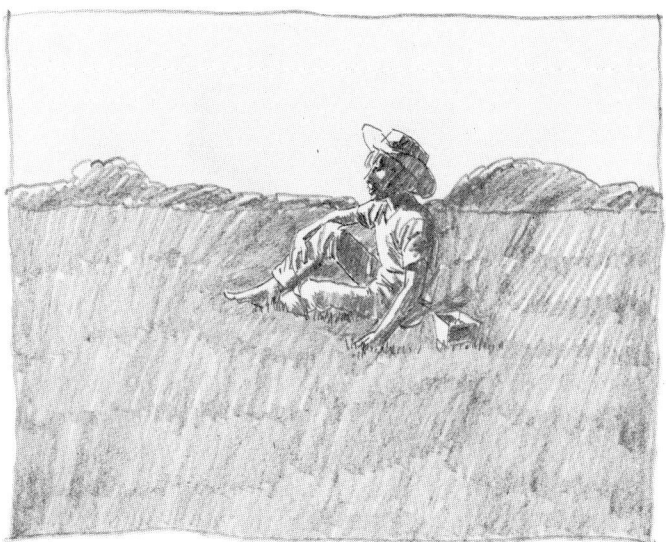

Figure 2-10
Light shining from top, left of subject

PHOTOGRAPH OF SUBJECT

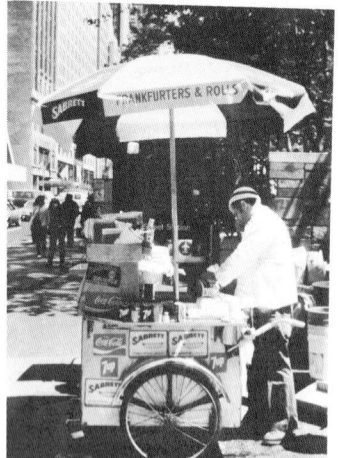

PRELIMINARY SKETCHES

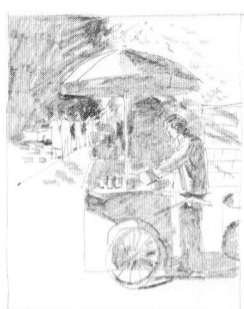

Figure 2-12

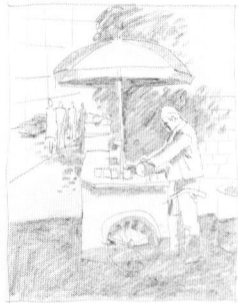

Figure 2-13

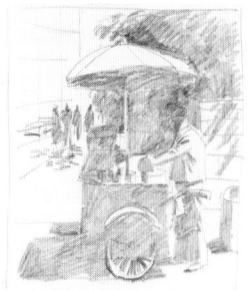

Figure 2-14

Complex Subjects

Light shining on a complex subject can be a source of problems for the painter. What details should be left out? Which ones included? How do you tie everything together in a simple way without losing the vitality of the subject? The sketches and photo on this page show such a problem. When I chose to paint the New York hot dog vendor I realized painting on location would be difficult. The view I felt most effective placed me on a crowded sidewalk. This, combined with the quickly changing light and altered shadow patterns, persuaded me to take some photographs instead and do the painting at home.

When I studied the photos later in my studio, I saw details recorded accurately but everything was shown with equal importance. Selective editing was needed. I made some sketches to get back the feel of the city and simplified a lot of the unnecessary details. You'll notice that my sketches are simple statements of shadow patterns, all tonal variations on a theme.

By moving the sun around to different positions I was able to see which patterns best fit my subject. Figure 2-12 proved least successful. The light-struck background figures took interest away from the vendor, and the bottom portion of the composition looks dull and empty.

Figure 2-13 works better. The foreground shadows covering part of the vendor's legs and stand imply the presence of buildings outside the borders of the picture, adding a feeling of space, and giving the composition a nice breakup of light and dark shapes.

Figure 2-14, however, won out. The shadows cast from the stand are not only interesting shapes but firmly anchor the stand to the street. The background stays back where it should, and the trees silhouette the light side of the umbrella in a simple yet pleasing shape.

Drawing variations on a subject forces the artist to be selective, and in so doing, brings a more personal vision to his pictures.

These sketches, like others in this chapter, were drawn on inexpensive typing paper with a soft number one office pencil.

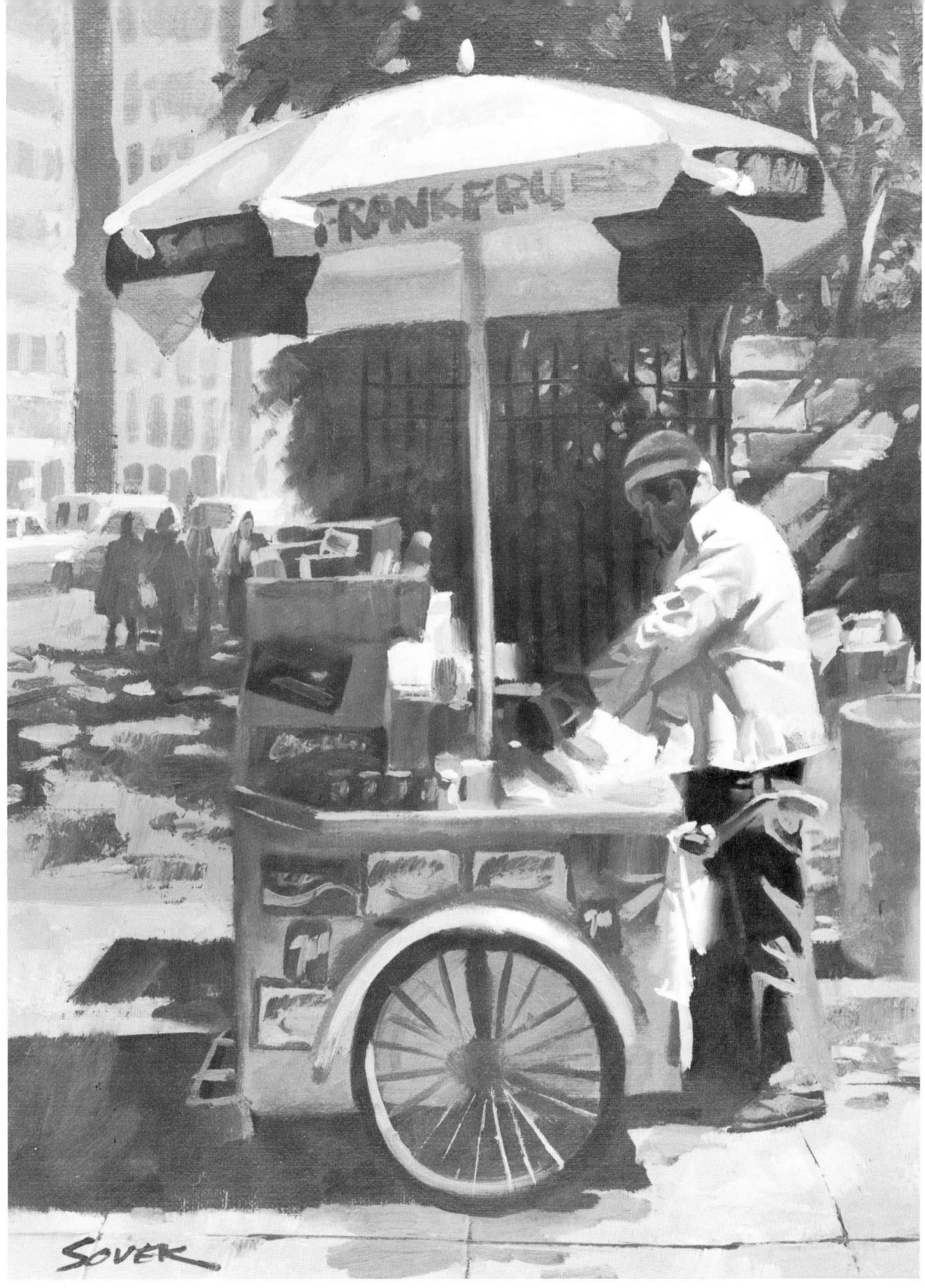

Hot Dog Man
12"x16" oil on canvas.
This painting was done alla prima and completed in one day. I find this approach to be the most effective in capturing the hustle and bustle of the city—one of my favorite subjects.

Collection of Mr. and Mrs. A. Weitzer, Stamford, Connecticut

Figure 2-15
Simple shadow pattern of subject.

Less Obvious Effects of Shadow

Up to now I've put a lot of stress on seeing only strong contrasts between light and shadow. However, nature isn't always so obvious, and many of the subjects that stir our imagination may be more subtly lighted. My painting of watermelons is an example of this type of softer illumination.

One problem is the lack of clear boundaries between light and shadow. In the watermelons, for example, the many halftones woven through the subject make clear explanation more difficult. The best way to handle such a problem is to make a simple sketch using only one dark value, carefully scrutinizing your subject, eliminating lights and halftones, and drawing the patterns of shadow remaining. Figure 2-15 is an example of this kind of diagram. When I set up my still life I tried many different arrangements, until I was satisfied with the way the light played across the knife and melons. After a while diagrams become unnecessary and your subconscious takes over, enabling you to push your subject around until it "feels right."

I chose to call this chapter "Shadow, the Foundation of Light," because without a thorough understanding of shadow, catching the effects of light are futile. It took a long time for me to understand this. I recall a painting class in art school where we had to finish a figure painting in one three-hour session. As I saw the instructor work his way closer to my easel, I speeded up an already furious pace to get some fat, juicy highlights stated. When he looked over my shoulder to comment, his only words were, "Slow down, Sovek. Get those shadows under control. The rest is child's play." Painting might not be quite that simple but I learned a lesson, and still apply his wise advice.

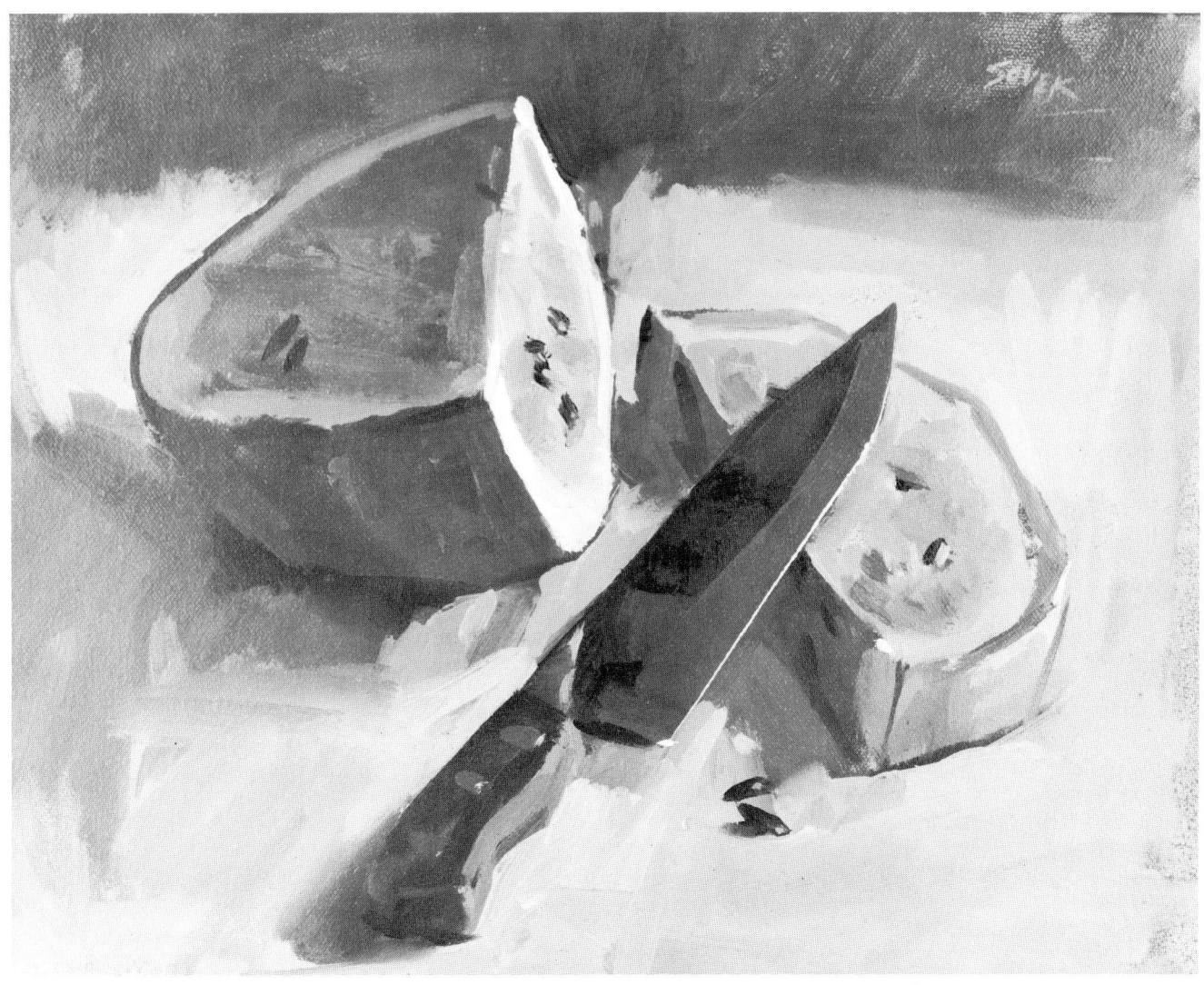

Watermelon
12"x16" oil on canvas.
Watermelon is also shown on page 113 in full color.

Collection of Tatiana Ledovsky, New York City

Chapter **3**

Values, the Language of Light

Understanding values is the essence of painting. A good analogy would be to compare values to the keys on a piano—each one has the potential to produce infinite variety in compositions. Similarly, it's awesome to reflect that all the great masterpieces ever painted came from the same range of tones available on your palette right now!

Just what are values? The dictionary tells us that in art a value is the relative lightness or darkness of a tone or color. Perhaps it is simpler to understand if we first think of value in terms of grey. If you mix a small amount of black with a lot of white you would get a light grey tone or value. More black added to the white would give a darker value and so on until the mixture is made up entirely of black, which is the darkest value obtainable in paint. It's possible to mix twenty or even more values between black and white. The differences would be so slight, however, as to be almost imperceptible. Most painters work with a range of ten or twelve values; some work with as few as five or six. The reason for reducing the number of values used is to help make this mixing of light and dark tones more manageable. Imagine a piano keyboard with three hundred keys or a guitar with sixty strings. Though such instruments could probably be built, and even played, performing on them would be such a chore that it's doubtful worthwhile music would result. Likewise, a simplified value scale permits the artist to better control his painting.

Before moving on to the study of values, a differentiation should be made between linear techniques and value painting. Some artists use lines to describe the content of their paintings. Henri de Toulouse-Lautrec and Henri Matisse are two such artists. If you feel you're at your best by putting a line around what you paint and filling it with color, breathe easy, for this is a perfectly legitimate approach. On the other hand, if you're naturally inclined to mix different values and colors in painting a subject, your approach would be considered tonal.

Observe the two paintings in Figures 3-1 and 3-2. The beach scene with the figures and umbrella is drawn with fine, sensitive lines. The flat, washed-in colors are light and high-keyed, the only darks being the handle of the umbrella and field in the background.

Figure 3-1 *Courtesy of the artist*

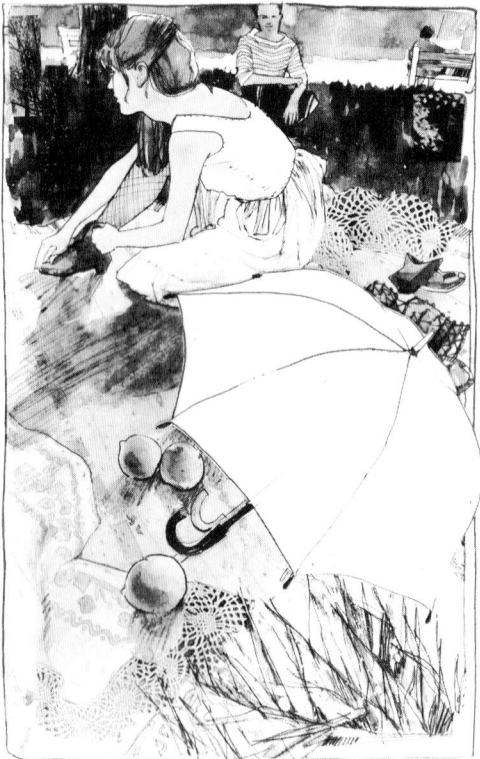

JANIS MELONE
Untitled
7"x10" mixed media on board.

I'm very pleased to show this picture because it's by one of my former students. While maturity and sophistication are easily evident in this lovely work, I can attest to the many years of hard work Janis put in to reach this plateau. Observe how the subject, instead of being modeled with strong contrasts of tone, is painted with deceiving simplicity. Note that the spare use of line, texture and wash heightens rather than weakens the light and airy quality of the scene.

Figure 3-2

The Scavenger
20"x24" oil on canvas.

The Douglas Gallery, Stamford, Connecticut

This picture was painted from material gathered on one of my frequent trips to Rockport, Massachusetts. I used a lot of palette knife work on this painting, particularly on the boat and stone embankment, to help show the subject's rugged texture. Notice how the ladder, rising up from the stone wall, helps give the scene a sense of space. It provides the viewer's eye with a path out of what would have been an otherwise confined and compositionally monotonous enclosure.

Study the subtle, yet effective pattern which gives the composition weight and unity. Compare this painting to Figure 3-2. Here the approach is definitely tonal with strong patterns of light and shadow defining the subject. In this case values show the content of the painting rather than lines.

Both of these approaches are acceptable, and between them lie untold combinations of line and tone. Some artists feel limited when confined to either lines or tones and prefer to combine them.

What's your method? By experimenting with both, singly or in combination, you'll probably find out. Most of the material in this book is directed toward the tonal approach. The following chapter will make you aware of the world of values, and help you decide which method or combination of methods is right for you.

Five Simple Values

Painting light demands a clear separation of values between light and shadow. To help make this differentiation I suggest starting with five values on your palette: white, light grey, middle grey, dark grey and black. To mix these five values you'll need a tube of black and a tube of white oil paint. Acrylics or opaque watercolor can also be used, but I prefer oils because the paint stays wet longer.

A painting or palette knife will be needed for the actual mixing of the paint. A 12x16-inch piece of clear glass or Plexiglas is an ideal palette. I avoid wooden palettes because the paint tends to sink into the wood; they're also hard to clean. Tear-off paper palettes will do in a pinch, but the paper is likely to become worn and ragged after continual use. You'll also want some paper towels or rags to wipe off your palette knife between mixings and a razor blade to wipe excess paint from the palette.

Since the tubes of black and white paint give us two of the five values, we need only mix three. Start by squeezing out two piles of paint, one white and one black, each equivalent to a heaping teaspoon. Next, cut off a third of each pile with the palette knife and put it on the end of your palette. Place the remaining paint piles in the center of your palette and thoroughly mix them together until they form an even, streak-free grey. This is your middle grey. Now cut the pile into thirds, placing one third between the black and white paint on the edge of your palette. Take another third and mix it with an equal amount of black; this will give you a dark grey. Mix the remaining third with an equal amount of white for the light grey. You should now have five piles of paint on the edge of your palette. Study these piles and see if they form an even gradation from light to dark. Squinting your eyes helps you to see the gradation more accurately. If they're uneven, some too dark or too light, adjust them by adding a small amount of either white or black.

The Value Palette

To make value mixing easier I use this same band of five values painted on the reverse side of my transparent palette, which enables me to squeeze paint directly on top of these values. This is a great help in accurately judging my value mixtures. When I'm finished painting I can easily wipe away the leftover paint without disturbing my value guide underneath.

The band of values is particularly useful in training your eye to judge values correctly. The value band consists of four one-inch strips of paint, running across the palette. Black is on the end, then dark grey, middle grey, and light grey. White is then painted over the remaining surface of the palette. Some painters choose a middle grey under their mixing area but I prefer white because it shows off the values more sharply.

The accompanying illustration, Figure 3-3, shows the finished palette with the five values in their proper places. A quick drying paint is acrylics, probably best for bands on the back of your palette, although oils are also suitable.

Home Values

We now have a value range simple enough to easily control yet with a wide enough range to show the effects of light and shadow on many different subjects. Study the three blocks shown in Figure 3-4 and notice that though each block is struck by the same

Figure 3-3
The value palette

light, the corresponding planes of each cube are different in value. This value change tells us the true or home value of each block. Knowing an object's home value—that is, the whiteness of a cup, the greyness of a barn siding or the blackness of a piece of cloth—is important in painting an object accurately.

Another way to visualize a home value is to imagine a black-and-white photograph of a red apple, a dark green bottle and a white plaster statue. In the photograph the red apple would appear middle grey in value, the bottle near black and the statue white.

If we disregard the home value, the contrast between the white statue, the gray apple and the nearly black bottle will be lost. Without home value, all three objects would look as if they were made of white plaster. Notice that the home value of each block in Figure 3-4 affects *both* its light and shadow planes.

The value range in light and shadow has limits, however, and going too dark in the lights or too light in the darks will destroy the illusion of light. To remedy this, keep your light values in the upper range of the value scale, going no darker than middle grey, and the shadow values in the lower range of the scale, not going above middle grey.

If all this seems confusing or even pointless remember that the actual range of tone between the white and black paint on your palette is only a tiny fraction of the enormous range between light and dark in nature. The sunlight reflected off a body of water is bright enough to hurt your eyes and make you reach for your sunglasses. You never had to do this while looking at a painting, regardless of how convincing the sunlight effect appears.

Figure 3-4
Determining the home value of a form

Halftones

Halftones give forms life and solidity. Together with light and shadow, they create the illusion of a third dimension on our flat paper surface. To understand how halftones function take a sheet of blank paper and hold it to the right of a lamp (Figure 3-5). Notice how the light falls evenly over the entire surface. Bend the paper into a slight arc (Figure 3-6) and observe how the right side of the paper becomes a value or two darker, forming a halftone. Now bend the paper into a half circle (Figure 3-7). Because light can't go around corners, the right side now falls into shadow, the halftone is about in the middle and the left side remains fully lit. Finally fold the paper down the middle (Figure 3-8), hold it in the same position, and notice the clean break between light and shadow. Because the paper is no longer rounded, the halftone disappears and the sharp light and shadow contrast resembles the corner of a cube.

The block in Figure 3-9 is made up of the three values, as compared with the blocks in Figure 3-4, which are painted in two values. This third, halftone value makes the block look more solid. The halftone falls on the lower left side of the block because the light is positioned above and to the left. If the light were lower so that it was almost level with the block, the halftone would be on the top plane of the block. Remember, halftones are not in the direct path of light but in the planes that fall away from the light. While the block clearly shows three definite planes of light, halftone and shadow, the tones on the sphere are less obvious (Figure 3-11). This is because the sphere is rounded, and light, traveling in straight lines, rolls around its smooth surface more subtly. The same three values are used but the edges are softened.

To decide which values to use for halftones

Figure 3-5
Flat surface

Figure 3-6
Halftone formed by slightly curved surface

Figure 3-7
Shadow appears as surface curves more—halftone now at center of surface

Figure 3-8
Halftone disappears when curved surface becomes a sharp corner

40

Figure 3-9
Painting a block in light, halftone and shadow

Figure 3-11
Painting a sphere in light, halftone and shadow

Figure 3-10

consult your value scale (Figure 3-10). First determine the home value of the object, in this case a light grey. Then choose the light and shadow values which will show this home value. The light values for the block and sphere are white, the shadow values middle grey. The halftone is made from the value lying between them, light grey. Later we'll be painting halftones lighter and closer in value to the light so as not to break up our light and shadow pattern. For now, however, paint your halftones the convenient middle value between light and shadow.

Be sure to paint your halftones *after* laying in the lights and shadows. My procedure is to start with shadow, which makes judging my lights easier, and painting my halftones last.

In painting rounded objects don't worry about softening the edges too carefully. We'll be dealing with edge handling in Chapter 4. For now the two-step procedure shown on this page in Figure 3-12 will do.

It's a good idea to paint a lot of studies limiting yourself to light, halftone and shadow. Start with simple objects such as blocks, eggs, cups or boxes, getting progressively more complex with things like shoes, hats or drapery.

Changing home values on complex forms comes next. However, before going on, make sure you thoroughly understand the idea of halftones, for in them lies the simple, yet subtle qualities of good painting. When painters like Chardin, Vermeer and Sargent chose subjects to paint, you can be sure they were careful in stating their light, halftones and shadows, usually eliminating or subordinating other values, to play up the power of these three. Today, a painter can learn a great deal by studying the work of these artists and by making simple black-and-white copies of their pictures using only the five values on the scale.

Figure 3-12
Softening an edge

41

Putting It All Together

Learning to paint is a lot like learning to juggle. You start simply by throwing one or two balls in the air, then you go to three, four and so on. You're bound to drop some while learning but if you keep at it you can't help but get better. It's now time to start juggling some of the pinciples we've discussed so far. In the previous pages I've talked about lights and shadows, a simplified value scale, home values and halftones. Combining these principles is simply a matter of thinking and application.

All the objects you see around you, whether indoors or out, in the country or city, can be reduced to three simple forms: the cone, sphere and box. The table you may be sitting at is basically a box; the trees outside your window are spheres; then there are ice cream cones or the water tower on the roof of a city building—basically a cone that doesn't taper. The front of a jet liner is a ball cut in half and so on.

We know these three shapes can be easily recognized by simply showing their silhouettes, as in Figure 3-13. We're now going to add to this. The first step in our juggling act will be to vary the home values of these three basic forms and strike them with a light (Figure 3-14). This is easily done by using the value scale to determine the proper range of tones for each object's light, halftone and shadow values. Although each object's set of values will be bracketed at a different place on the scale (Figure 3-15) the number of values in each bracket will be identical, much the way the changing chords on a piano or guitar still contain the same number of notes.

To paint a box with a home value of white, we position our value range as high as it will go. White becomes the light side, middle grey the shadow, with light grey the halftone. The cone's home value is middle grey. The value scale is now lowered: The light side of the cone is light grey, the shadow

Figure 3-13
Silhouettes of basic forms

Figure 3-14
Light-struck basic forms with different home values

Figure 3-15
Bracketing values to show light shining on forms with different home values

dark grey and the halftone middle grey. Because the home value of the ball is black, we lower the scale to its darkest extreme, making the shadow of the ball black, the light side middle grey and the halftone dark grey. Remember, our scale limits us to five values (we'll be mixing more later, but for now keep it at five). Notice how the three forms are now easily recognizable as being white, grey and black.

Simplifying Complex Objects

One of the great challenges in painting is in observing a complex object, a tree or a figure, and trying to see beneath the myriad details to the object's basic form. Many students mistakenly feel that if they copy every leaf on a tree accurately they will capture the essence of that tree. Unfortunately, painting is not that simple. To slavishly copy the surface detail of a subject will only result in flat, semiphotographic rendering of a bunch of leaves and branches, void of the qualities a tree inherently possesses—namely, solidity, unity, gesture and spirit.

I recently saw a large exhibit of paintings and sketches by John Constable. Viewed from a few feet, Constable's trees seemed to blow in the gentle English breeze, and the countryside was full of life and movement. Birds could fly and animals moved through these delightful landscapes. Upon close inspection I saw how simply Constable actually painted his trees. Rather than rendering every leaf and blade of grass, the artist focused his detail on only those passages he felt were necessary. The feel of the whole picture was first and foremost in Constable's mind, much more so than any one part.

The still-life paintings of Chardin show this same quality. Pieces of fruit, silverware and bottles, which appear meticulous in detail at first glance, are actually simply painted, with great care taken in their artful arrangment, the entire composition unified by carefully designed patterns of light and shadow.

Study the three objects in Figure 3-16. The box has now become a container for Chinese food, the cone an Indian tepee, and the sphere a tree. Despite surface detail, the home value of each object is still easily recognizable, and the forms appear solid.

Your interpretation of complex objects reveals much of the artist within you, for no two people will use quite the same procedure in painting. Learn to edit, to see the beauty in the large forms first, then add as much detail as you wish. As long as you're in control, your own uniqueness is bound to come through.

Figure 3-16
More complex objects based on simple forms with different home values

Enlarging the Value Scale

We're now going to fill out the value scale with an additional four values. To keep our approach simple, think of these four new additions as half-steps between the original five values instead of separate additions. We now have enough values at our disposal to handle even the most complex painting problems without needing to mix any additional tones. Up to now only three modeling values have been used: light, halftone and shadow. By adding three more—a highlight, dark shadow and accent—our range is complete and we're set to tackle almost any painting problem encountered.

The demonstration in Figure 3-17 shows all six modeling values on a light valued sphere. To paint a darker grey or black ball I need simply to bracket my values to a lower scale. The light striking the sphere is coming from the above left side. Study the gradual darkening of the halftone value as it rolls away from the light, the smooth gradation into shadow, then to dark shadow, where the least light appears. Notice the lighter value on the outer shadow edge of the sphere. Because the object is round, reflected light has bounced up from the surrounding light-struck areas and lightened this rounded edge.

Be careful not to go too light in painting reflected light, as it will distract from the values in the light. Reflected light at its lightest will be about the same value as halftone. The cast shadow is painted the same value as dark shadow because there, too, little light is received. Finally the accent is placed to anchor the sphere to the base and the highlight painted where light is striking most directly. Notice how I've kept reflected light the same value as the halftone and the cast shadow the same as dark shadow. This simplification helps to limit the number of values used to six rather than eight, making painting more manageable. Because the form is round the edges have been softened.

These newly acquired tones—highlights, reflected lights, dark shadows, cast shadows and accents—will certainly help improve and refine your painting. However, the real beauty and success of good painting lie in your ability to control three basic tones—lights, halftones and shadows.

Figure 3-17
Using a complete range of modeling values

Keep It Simple

The paint sketch shown on this page is an example of using all six modeling tones on different home-valued objects. By painting a dozen or so similar studies in black and white rather than color, you'll soon get the hang of how to model a form solidly and convincingly. You'll also learn to treat things more simply. Remember, painting is like any other skill—the more you practice, the better you get.

Massing Lights and Shadows

When light shines on complex subjects, interpreting and simplifying values can be a real chore. Most beginners start such a painting by trying to copy the lights and shadows of each individual item before them. Invariably they become bogged down with detail, and if the painting progresses to a finish, it usually has the busyness of a patchwork quilt. I know, because I've painted such pictures.

When painting complex subjects, most artists use a procedure called massing. It works like this. Take a good look at your subject, squint your eyes and try to simplify the jumble of tones you see into two big groups, light and shadow. Next, look at the shadows, letting your eyes skip quickly over entire passages. Don't linger too long on any one particular shadow, as it will lighten in value as your eye gets used to looking at it. After assessing all the shadows, mix up one value that appears to be the average value of all the tones in shadow. Now take an inventory of the lights and repeat the process, averaging all the values to one light tone. Working with the largest brush you can comfortably handle, cover the entire surface of the canvas, placing the averaged-out light and shadow values in their appropriate places (Figure 3-18). Keep your paint on the thin side at this stage.

Because the home value of the various objects in a picture usually differ, the massed-in light and shadow values just stated need to be adjusted to show that difference. To do this look again at the shadows of your subject and find the *lightest* value, usually not lighter than a middle grey, and the *darkest*, probably black or near black. You've now established your range of shadow values. So long as shadows are kept within this range they won't compete or clutter up the lights. Now look at the lights and find their limits of value. Be especially careful in judging the lights of objects with dark home values, as they tend to be a lot lighter than you think, usually about middle grey. Working directly into the wet lay-in, restate the shadows to show the various changes in home values (Figure 3-20). Notice the shadow side of the white building in the foreground. Because it's the lightest home value in the picture, its shadow is lighter than the shadow of the darker building beside it and the rocks below it. Correspondingly, the light side of the building is the lightest value in the painting.

Next comes the delicate procedure of placing the halftones. Delicate, because if the halftones are too dark they'll become a part of the shadow area. If painted too light, the halftones will mingle with the lights and hardly be seen. The right value for the halftone in this case is about one half-step darker than the lights (Figure 3-19).

On an overcast day when the light is diffused by clouds, halftones can be about a middle value between light and shadow. On a sunny day, however, like the light in this demonstration, the sun bleaches out the darker halftones, pushing them up the value scale. Working again into wet paint, brush in all the halftones. The painting now takes on a convincing quality. Busyness has been avoided and we need only add a few sprinkles of what I call the cleanup squad—that is, highlights, reflected light, dark shadows, cast shadows and accents. Now the painting is complete.

Avoid feeling obligated to use all six modeling values on every object in your picture. You can, of course, and some artists such as Ken Davies or James Bama do, but unless you're after sharp-focus realism, limit the less important parts of your painting to two or three values, leaving the viewer's imagination to fill in the detail.

Figure 3-18 **Massing-in a subject**

Figure 3-19

Value range of light **Value range of shadow**

Figure 3-20 **The completed painting**

47

Light Shining On the Figure

The idea of painting people always seems to strike terror into beginning students. While considerable skill may have been developed in painting "things," the very mention of doing a figure causes many to lose their confidence. Hard-won mastery over materials seems to fly out the window, hands become less steady. One reason for this apprehension is the inability of the novice to visualize a human being with the same bare objectiveness exercised when painting a tree or a barn. We know that every object we see is made up of a few basic forms, a pattern of light and shadow and a certain number of values. Why then, should a figure be the exception?

To paint people, a certain amount of basic drawing ability is required. Proportions should be reasonably accurate if the result is to be believable. A feeling for the figure's gesture should be present. There are many good books on drawing. Kimon Nicholidies' *The Natural Way to Draw* is an excellent choice for those who have never drawn or who wish to improve their skills.

Assuming a figure can be sketched with passable proportions, there's no reason not to jump directly into paint. Remember, drawings can also mean values, juxtaposed in the right places. Two values, shaped properly, can describe a leg merging into a shoe just as accurately as a line drawing.

Let's start by sketching a standing figure. I usually draw directly with a brush. You can also use charcoal or a pencil. Keep your drawing simple because it will quickly be covered with paint—don't forget to determine the placement and direction of the light source. The next step is to average and mass-in the light and shadow values, following the light and shadow pattern on the model or photo you're working from. This is the same procedure used in the demonstration on page 47. Use a large brush and work boldly, simplifying intricate details. See Figure 3-21.

Next, look at your subject and determine the various home values. Flesh is light grey, the blouse white, the jumper dark grey, the stockings and shoes black. Using the value scale, determine the range of tones available for each home value. I've chosen a two-value jump between light and shadow, so when painting the white blouse, white will be the lightest light with middle grey its shadow. All the other home values will have this same two-value jump, though bracketed at different places on the scale. See Figure 3-22.

After painting the various home-value changes into the light and shadow masses, brush in the halftones. I usually take a break following this stage to decide where I want to place emphasis, what parts of the painting should be sharp and defined, which ones left more suggestive. Molly, my little model, has an arresting smile, curly blond hair and young expressive hands. These are what I will accentuate (Figure 3-23). Deciding when the painting is complete is a personal decision. I prefer a looser treatment, rendering only areas which I feel important. You may choose a more careful approach, defining even the smallest forms. Whatever your method, paint with the whole figure in mind, keep your strokes varied, be sympathetic toward the flesh, the softness of the hair, the blocky quality in the folds. And always be receptive to the spirit of the person you're painting.

Figure 3-21
Massing-in a figure

Figure 3-22

Figure 3-23
The finished painting

49

Figure 3-24
Here we see the head lighted from the top and front. Notice the shadows cast by the nose and chin. When massing-in the head, these were the only darks stated. Squint your eyes and observe the halftones which merge between the shadows and light. After establishing these three key values, I subtly modeled the planes, being careful to keep lights and shadows distinct. Once the secondary planes were sculpted, the features were painted, a few wrinkles added, some edges softened and the painting was complete. Notice how the light and shadow on the teeth are lighter than the flesh. This is because of their lighter home value. The hair also varies in home value, being darker on top while lighter on the temples.

Light Shining On the Head

Most artists, sooner or later, take up the challenge of painting the head. The infinite variety of character revealed in people's faces can indeed be a lifetime study itself. One of my early heroes, Norman Rockwell, is a good example of an artist who tapped deeply into the wealth of human expression.

Beneath the surface peculiarities of fancy hairdos, beards and sagging jowls lies a surprisingly similar basic structure. The head is akin to an egg in shape and facial types and character differences are mere variations of similar forms or planes emerging from this basic structure.

The procedure most artists use in painting the head is to begin simply, massing-in large, mosaiclike planes. After carefully developing and refining these planes, the features are placed. Since planes are a prime factor in painting not just heads, but any object, it's important to understand just what planes are. Like a sculptor working from large to small masses, the painter uses planes as a preliminary carving, chiseling his forms progressively smaller until the desired squareness or roundness is achieved. Every human head is made up of a similar arrangement of planes. The sizes and proportions of these planes, however, vary with each individual, depending on age, weight and expression. The following demonstrations show the same head under the same light, which is placed in four different positions. Beside each painting I placed a cast of a head sectioned into planes. The left side of the cast shows the basic planes; the right side, the secondary planes.

Figure 3-25
The light is now moved to three-quarter side. The shadow pattern has changed, and now runs down the right side of the head. The shadow cast from the nose, "smile muscles" and chin also have changed accordingly. Study the light-struck planes in the middle left of the head. Their value and placement explain the direction of the light. The light hair on the left temple now appears white, and because light still reaches some of the teeth, they, too, are partially white. Observe the reflected light starting to illuminate the far shadow side of the head, giving the passage luminosity.

Figure 3-26
Because the light has been turned even more to the side, most of the head is now in shadow. Notice the change in character and the dramatic effect. The eyes and mouth, lost in shadow, are simply defined. Reflected light increases, illuminating more of the right side of the head.

Figure 3-27
With light coming from the top and rear, the head is almost completely in shadow. Only a few sliver shapes of light on top of the forehead and hair remain. Study the subtle modeling of the planes and features in shadow. I limited myself to four values here: shadow, cast shadow, reflected light and accents. The edges were softened to add to the illusion of shadow. Notice how the teeth still appear white in the shadows. This is because their lighter home value in shadow is lighter than the home value of the flesh in shadow.

Reflective Surfaces Indoors

Painting the reflective surface of an object can be confusing. The full range of values available to us in paint is usually inadequate in matching the bright glare of light reflected from such shiny, mirrorlike objects as glass dishes or metal pots. Compared to actual light, the range of paint values available is so limited that a compromise must be made. To compensate for this limitation I usually simplify reflective surfaces into four categories: mirrorlike, glossy, dull and flat. Mirrorlike surfaces like glass or shiny metal reflect light much like a mirror and in so doing, make it difficult to discern the object's home value. For example, a copper pot may be a light to middle grey in true home value. However, the light-struck areas can appear nearly white. The painter needs to tone down some of these lights and save his lightest values for, let's say, a white vase, placed beside the grey pot.

Glossy objects like some kinds of fruit, silk and polished leather present less of a problem because the range of values needed to catch their shine isn't as great. Dull surfaces like the leaves of trees, unpolished wood and most flesh have still less of a shine. Flat surfaces like velvet, stone or dry earth, because they reflect the least light, are probably the easiest subjects to paint, owing to their limited value range. Catching the effect of light on a shiny surface is a lot of fun. Thick, juicy highlights confidently applied can give a painting life and vitality. Study the demonstrations on these pages that illustrate the four kinds of reflective light.

Figure 3-28
Mirrorlike surface

Figure 3-29
Glossy surface

Figure 3-30
Dull surface

Figure 3-31
Flat surface

Mirrorlike

Glossy

Dull

Dull

Dull

Mirrorlike

Flat

Figure 3-32

Reflective Surfaces Outdoors

You have only to view a river's edge, bathing in the warm afternoon sun, with light reflecting dashes of orange, green, muted yellow and purple in the water, to understand the fascination the Impressionists must have felt gazing at similar scenes. Such views have intrigued artists for centuries and will probably continue to do so for centuries to come. Similar to reflective problems indoors, outdoor reflections are best realized by remembering the tonal limitations of paint and avoiding the photographic approach of copying values exactly as they appear. Knowing that white paint is the lightest light obtainable on our palette, darker passages such as light-struck trees or buildings must be lowered in value so as not to compete with the main lights. Reflections of light on water, sand or wet streets can have great believability if this value limitation is fully understood.

My approach to outdoor painting is similar to that of a stage designer. First, I develop the large areas of sky, land and water, brushing the paint around until the overall look feels right (Figure 3-34). Next come buildings, trees, rocks or whatever props the scene contains, carefully reflecting these onto the shiny surfaces (Figure 3-35). Finally the "main players" are painted. These could be a cluster of figures, boats, gulls or whatever subject I wish to emphasize. Final accents and embellishments are made and the painting is complete (Figure 3-36).

When studying the paintings of the Impressionists and also those of Joaquín Sorolla, Potthast and Sargent, look beneath the details and see the simple patterns of value and color. These are what hold these shimmering statements of light together. Earlier artists were confronted with the same problems we face today. By careful thinking and planning we, too, will be able to capture the timeless effects of light on reflective surfaces. All that's needed is a similar enthusiasm and a determination to *think* before you paint.

Figure 3-34 **Laying in a reflective subject**

Figure 3-35 **Refining the picture and painting the reflections of secondary forms**

Figure 3-36 **The finished painting**

Changing Light and Mood Outdoors

Outdoor scenes under various lighting conditions offer the painter a wide vista of picture-making possibilities. To capture a landscape's fleeting effects, most painters restrict themselves to a limited number of values. Camille Pissarro and Georges Seurat would mix three value gradations of all the colors on their palette. The French and English academicians of the nineteenth century, though less adventuresome in color, also premixed carefully gradated tones before going on location to paint. Like training wheels on a bicycle, premixed tones can be disregarded when seeing and mixing values become second nature.

The reason for all this preliminary thinking and planning is easily explained. Aside from the unobtainably wider range of values bright sunlight creates, the complex subject matter contained in most outdoor scenes can be discouraging to even the most experienced painter. Compound this with a constantly changing light source and it's little wonder that artists are continually seeking ways to simplify their approach. I find the five-toned value scale invaluable in reducing busy outdoor scenes to simple, uncluttered pictorial statements.

In each of the following four demonstrations the lights and shadows have been bracketed at different positions on the value scale. The number of home values has been reduced to five: the white siding of the church, the light grey sky, the middle grey ground, the dark grey trees and the black roof of the church. Notice the different mood each study takes on and how rich the ensemble of all four pictures appears though only five values were used for the entire exercise.

In Figure 3-37, the effect of hazy sunlight was accomplished by separating the light and shadow values with a one-tone difference. Contrast this with Figure 3-38, which has a two-value jump between light and shadow. Observe the stronger feeling of light, now approximating bright sunlight. To paint a dark, overcast day (Figure 3-39), white is eliminated from the scale and light grey becomes the lightest value, giving the overall scene a solemn, gloomy appearance. By lowering the value of the sky even more to a dark grey, the picture becomes a night scene (Figure 3-40). The light side of the church is lowered to a middle grey, which becomes the lightest light, with all the other values correspondingly darker in tone.

This kind of value control over a scene is invaluable either for capturing quick effects under changing light or as an aid in composing complex studio compositions. In either case, the artist is in control, using the subject to express his feelings and ideas rather than being at the mercy of a subject, feeling obliged to copy every nuance of tone.

Figure 3-37 **Hazy sunlight**

Figure 3-38 **Strong sunlight**

Sketches limited to combinations of the five basic values

Figure 3-39 **Overcast**

Figure 3-40 **Night**

57

Foreground, Middle Ground and Background

Overlapping objects, using perspective (the illusion that objects appear smaller and smaller as they get farther and farther away) and contrasting hard and soft edges are telling ways to create the effect of depth in our pictures. Another way to achieve depth is to divide your picture into distinct areas of distance. Artists call these areas foreground, middle ground and background. The feeling of depth can be easily achieved by reducing the range of values in each area as it recedes into the distance (Figure 3-41).

Here's how the principle works. Because the foreground is closest to the viewer, and least affected by atmosphere, the entire range of values from black to white may be used. The more distant middle ground, appearing less defined, will have a shorter value range, with black and white eliminated and forms modeled with only light, middle and dark grey. The background, being the most distant passage in the picture, needs but one or two middle greys to define forms. By keeping these three areas distinct, a painting will take on a convincing illusion of depth.

Figure 3-41

The foreground, middle ground and background planes of a picture

The sketches on the opposite page show two examples of this principle at work. Black, white and three greys are the only values used in these studies (half-step values will be included later, but for now let's keep it simple). The first study (Figure 3-42) is a tree-strewn landscape. Except for the sky, it contains about the same middle grey home value throughout. The picture is given depth and atmosphere by lessening the contrast between light and shadow on the trees as they recede into the picture. Compare the limited value range of the middle ground trees with those strongly contrasted in the foreground. The background hill is painted with one grey tone.

The second study, a ranch scene (Figure 3-43), also takes on dimension by playing the sharply contrasted foreground with the less strong middle ground and but a single value in the background. In this sketch, home values vary and are treated accordingly. Notice, for example, the light on the white-shirted cowboy in the foreground. Compare this to the light grey on the shirt of the figure in the middle ground. The atmospheric effect becomes quickly apparent, for in both cases, the home value of the shirt is light. Study the changing value range of both figures' dark pants and notice the same device in operation.

If photographs are used for reference, free license should be taken to change the values to fit the desired effect. Unfortunately, the camera sees values with less sensitivity than the human eye, sometimes registering values darker or lighter than they actually appear. By doing a few black, white and grey studies directly from nature, with emphasis on establishing the feeling of distance, you will soon develop a sense of how to control values in your paintings.

Figure 3-42

Figure 3-43

Aerial Perspective

Once the idea of a foreground, middle ground and background in a picture is understood, it's only a short hop to grasp the closely related principle of aerial perspective. The following chapter deals more thoroughly with atmospheric conditions. However, because values are such an integral part of this useful device, it is best we deal with it now.

The idea of aerial perspective is simply explained. If you stand on a dock and watch a far-off ship move its way to shore, an interesting visual effect occurs. The closer the vessel gets, the more detailed and full-valued it appears. Small pieces of rigging become recognizable, the texture of the hull becomes more evident and the whole image becomes increasingly sharper. When the ship was a hundred yards away, definition was less obvious and values more limited. When five hundred yards away, only an overall shape consisting of one or two values rendered the craft recognizable.

Why did this phenomenon occur? The answer is atmosphere. Weather-induced dust particles or moisture can sometimes place an atmospheric screen between the viewer and the more distant subjects in a scene. We know that by dividing a picture into foreground, middle ground and background a sense of depth can be achieved. If we add to this the effects of atmospheric perspective, a whole repertoire of pictorial devices is placed at our disposal.

The following demonstration shows how these two useful devices can work together. I've incorporated three different value scales into this demonstration to show the tonal range of each area. Study areas A, B and C in Figure 3-44.

The number and range of values used in each scale can vary, depending on the subject, light source, weather conditions and mood of the particular painting. I've chosen sunlight to illuminate this harbor scene and I'm painting with a full range of values. Note the handling of the foreground. See how the fishing shack is painted in strong lights and darks. The forms are richly modeled and appropriate textures have been indicated.

Move now to the middle ground. Observe the simplicity with which the boats and rocks are painted. Compare the limited three-value treatment given the boats with the five or six values used in the shack. Because atmospheric perspective is most obvious in the distance, the headland in the background is limited to one light grey. Step back a few feet from the demonstration and notice how the illusion of air and distance gives the picture a sense of space and believability.

Try some sketches on your own using subjects such as mountains, buildings or anything else that lends itself to the idea. Limit the values for each area and try to stick to those values. You'll be amazed at the results.

Figure 3-44

A
Value range of foreground

B
Value range of background

C
Value range of middle ground

61

Detail on sack simplified to keep attention focused on figure.

Texture of jacket minimized to place emphasis on head.

Texture simplified to unify shadow pattern.

Wrinkles eliminated and only large folds painted to keep jacket and pants from becoming too distracting.

Controlling Texture

Equipped with an understanding of form, values, reflective surfaces and depth, it's now time to put the icing on the cake. By this I mean texture—the tactile characteristic of any surface. For example, stone can be rough or pitted, cloth-smooth or coarse, flesh-soft or weathered, etc. Care must be taken in painting the texture of an object. Too much will overpower the forms, causing a loss of solidity. Detail can destroy carefully built-up light and shadow patterns. Too little texture will result in giving all the objects in a painting a monotonous surface appearance with everything appearing to be made of the same material. Striking the right balance needs careful consideration. Surprisingly, very little texture is needed to make an object appear convincing.

Study the demonstration on the opposite page. While the subject is full of rich and varied textures, the light and form are never lost. To achieve this unity a careful procedure was used in laying in and developing the painting. After a simple brush drawing the light and shadow tones were averaged and the two resulting values layed in broadly. Home values were established and halftones stated. The figure and background were modeled, with emphasis on the head, jacket and hands. Thus far, any indication of texture has been ignored.

After a break and some thoughtful pondering, the final stages of the painting were completed, by distributing textures, softening edges where needed and generally tying the whole painting together.

63

Bananas
5"x8" oil on Masonite.

 While this painting started out as a tentative study, it evolved naturally into a finished piece. I owed a debt to Edouard Manet. I had just seen an exhibition of his, including some charmingly small, uncluttered still lifes, and couldn't wait to get home and paint a few of my own. *Bananas* was completed in one, 45-minute session.

Douglas Gallery, Stamford, Connecticut

Truth of Tone

Before closing this chapter on the understanding of values, mention needs to be made of a quality of tone which underlies all good painting. Not easily defined, this quality could be called consistency of tone, or unity of tone. I choose to call it truth of tone. In Kenneth Clark's definitive survey *Landscape in Painting*, a revealing comparison is made between a picture by Pissarro and one by a popular academician of the day, B. W. Leader. Both paintings are similar in composition and both are lit from about the same angle. Wrote Clark, "Monet, Sisley and Pissarro, during the 1860's and even to 1874, achieved the most complete naturalism which has ever been made into art. I doubt if a picture could be much truer to a visual impression, with all its implications of light and tone, than Pissarro's 'Lower Norwood,' and it is worth comparing to such a picture as B. W. Leader's 'February Fill Dyke,' long accepted by the public as a paragon of perfect truth to nature. A nature, however, that has not been perceived as a whole but described piece-by-piece. Leader still thinks of the world as made up of a number of 'things,' which have to be treated separately."

In studying values and their relationships in paintings, a pitfall can easily occur when theories and principles replace direct observation. Though surely knowledgeable about the theories of the day, Pissarro approached nature directly. His trained eye saw and recorded with truth and accuracy. Pissarro's paintings reflect nothing false or preconceived; instead we see a live, convincing scene before us—one we might encounter if we walked along the same country road.

The analogy between painting and music is again appropriate, for the painter, like the musician, needs to learn and understand scales and exercises, then literally forget them and concentrate on how to express what is to be played. Interpreting nature in a personal way is no small task. However important the basics are, they can never replace sensitive observation.

Like perfect pitch, truth of tone is seldom a natural gift. Most artists have to put in long and hard hours to acquire this highly selective way of seeing. A study of other painters can be helpful to a point, but only by painting from life can real growth occur and expression bloom.

Chapter 4

Controlling Edges, Atmosphere and Mood

We're now going to add to the building blocks of shadow and values, and deal with three subtle qualities of painting. Without them, your picture will remain incomplete. They are: edge control, atmosphere and mood. The effects they have on a picture can be likened to the delicate sauces a fine chef uses to marinate his meats and vegetables.

Edge control, or the hardening and softening of edges in a painting, gives a subject dimension and believability. Whenever one stroke of paint is placed beside another the artist is immediately faced with a decision. Should the edge be left hard or softened, and if softened, to what degree? In painting a sharp-angled piece of wood or metal, for example, the edge could be left hard and untouched. On the other hand, if the subject is a soft fabric, the edge would require some softening. If these considerations of edges aren't taken into account, the true character of a subject can be easily lost.

In the previous chapter, portraying atmosphere was touched on briefly in the handling of a picture's foreground, middle ground and background. Atmosphere, or air, gives a painting that subtle quality of existence. Without it we sense a false or contrived effect in the painting.

The last of these three subtle qualities is mood, the very heart of a painting. Without mood, a subject can be easily reduced to a catalog of facts, accurate, perhaps, yet uninspiring to view.

Edge control, atmosphere and *mood* are best learned and understood when working from life. With a real three-dimensional subject before you, responses are more direct and your sensitivity as a painter will sharpen more quickly than when working from two-dimensional photographs. Later you may choose to use photos as reference material. For now, try to stick to the real thing. Let's now move on to the specifics of handling these three important, yet illusive qualities of painting.

This is one of my few "tight" paintings. The technique I used was to employ hundreds of small carefully placed strokes over the entire figure until a feeling of solidity was achieved. I then glazed the areas I felt needed softening. Finally, I put in a few carefully placed opaque lights, such as those on the hair and hands, to emphasize their importance. Although I usually work more directly, I felt this particular subject demanded a more subtle and sensitive approach.

The Clam Digger
15"x20" acrylic on board. *Figure 4-1*

Private collection

An Awareness of Edges

Like the limited number of tones used in the value scale, I find it useful to simplify the kinds of edges I paint to just four. These are: hard, firm, soft, and lost. Close scrutiny of any given subject would probably reveal many more. A piece of metal, for instance, might have a slightly harder edge than a freshly cut piece of wood or angled rock. However, when comparing these three surfaces to the soft edges of a cloud formation or snowbank, they appear equally hard. For this reason, I find it best to cluster similar surfaces into one of the four categories rather than complicate a painting with a myriad of confusing edges.

Edges are also a factor in considering the placement of the center of interest in a picture. Because our eyes focus almost instantaneously on whatever we're looking at, everything we view usually seems to be sharp and defined. In a painting, however, this overall sharpness can be a deterrent in guiding the viewer's eye to where we want it to go. Equally sharp, focused edges can also give a hard, brittle look to a painting. Study the paint sketch in Figure 4-2. Notice that all the edges are of equal hardness, and the effect appears static and unsympathetic to the subject's variety of surfaces.

Compare this sketch to Figure 4-3. Observe the rocks in the foreground. Although most of them are hard, some softness does occur on the far left and right. Because the eye can focus on only one area at a time, these peripheral areas are intentionally blurred to concentrate emphasis and create visual variety. The shack, pier and figure fishing from the boat in the middle ground are softer and less detailed than the foreground. Notice the softer treatment of shadows in this passage—how the water is painted in close-valued sta-cattolike strokes to contrast with the foreground rocks.

Compare the background buildings with the shack in the middle ground. The softness is quite apparent in the buildings. Without it there would be confusion between what's middle ground and background. The background trees, if viewed close-up, might appear as a detailed mass of leaves and branches. In the distance, however, only their overall shapes are apparent with a few branches defined here and there. The clouds are painted with nearly lost edges to contrast with the firmness of the rocks and buildings and to add depth and space to the composition.

Each picture you paint has its own set of edge challenges, and only by solving them will the painting take on life and believability.

Figure 4-2 **All edges left hard.**

Figure 4-3 **Edges softened to indicate various textures and distances.**

The Four Kinds of Edges

The following demonstration shows the four kinds of edges and how they're used to define the solidity and character of a subject. Although the potbellied stove is made of cast iron, a large number of soft edges were used to model its various forms. As light and shadow bathe the subject, the roundness and squareness of the stove's construction become apparent. Notice how the pipe, extending up from the stove, is made to appear round by the softened, brushed-together strokes, with only the outer edges remaining hard. The bellylike midsection is also treated softly. The base, however, because of its squareness, has harder edges. The rounded legs of the stove were handled accordingly. The hinges, handles, lettering and small filigrees of engraving are all sharply defined.

Set up a still life of your own, using some miscellaneous household items, and study the edge qualities of each object, deciding which are hard, firm, soft or lost. Be sure to work with a single light source positioned from either top left or right to ensure an interesting light and shadow pattern. Keep your value scale limited to the usual nine.

Figure 4-4

How to Soften Edges

There are various ways of softening edges, and as you paint and gain more proficiency, you'll probably be adopting one or two favorites that best suit your purposes and temperament. Here are four ways I find effective.

Figure 4-5
After brushing in the two areas to be softened, wipe your brush clean and, starting at the top of the passage, work your way down using a crisp zigzag motion. Wipe off your brush and again, starting at the top, firmly stroke down the zigzagged area. Presto, the edge is softened. Don't be discouraged if the first few attempts are crude and uneven; with practice you'll get it. The zigzag method is best suited for blending soft and lost edges. For a firmer edge you need only run the brush between the two areas and dispense with the zigzag.

Figure 4-6
Small hatchlike strokes are mostly used with tempera and acrylics. Start by mixing a value halfway between the two areas to be softened and paint down the edge using stitchlike strokes. Next, mix two values each halfway between the first hatched stroke and the tones to be blended. Paint these two values down the side of the softened tone. Finally, blend all three tones with fine, interwoven strokes until you have a smooth gradation.

Figure 4-7
I particularly like this next method because it's not only fast but just as effective as the others, and all you need is your thumb. Some painters wrap a paper towel or rag around their thumb, but I don't find it necessary. Thumb or finger softening works best with oils, though I occasionally employ it when using gouache or acrylics if the paint happens to be wet.

Figure 4-8
Beautiful accidental effects can be gotten with transparent and opaque watercolor by softening edges while the paint is still wet. Most painters proceed by wetting the entire surface to be painted with a light tone, quickly washing in the dark, and letting the softening automatically occur as the wet paint mixes. A surprising amount of control can be achieved when this technique has been thoroughly mastered.

Keying Your Pictures

For me, the big challenge in painting atmosphere is in catching the subtle value changes caused by the effects of the sun, filtering clouds, rain, fog, snow or any other condition that gives the air a unique tone and color. A good way to achieve these changing atmospheric effects is to "key" your values to suit a particular mood. A brilliantly lit field, for instance, would most likely lend itself to values in the higher range of the scale. The same field, late in the day and darkened by long cast shadows, would need a wider range of tones and probably qualify for a middle range of values. To portray the field in the darkness of an approaching storm, values would drop to low key.

Other low-key subjects could be a street scene at night, a dimly lit interior or a view of a dense forest.

Most daylight subjects fall into the middle range, which is the workhorse of the three. Interesting effects can also be obtained by switching keys. For example, by transposing a middle-key scene of a fisherman in a sunlit stream to high-key, the sparkling effect of light shining on the water might be shown to better advantage. It's also fun to experiment. Painting a study in all three keys can be not only fascinating but rewarding as well. Sometimes, and usually when you least expect it, an ordinary solution will magically turn into a jewel of pictorial interest. Until keying a picture becomes second nature keep strictly within the values allotted to that key. Later you can borrow a value or two from another part of the scale to accent or highlight a passage. For now, though, keep it simple.

The following demonstrations, Figures 4-9, 4-10, and 4-11, show the same subject painted in high, middle and low keys. Notice the changing mood from one sketch to the next. I prefer the high-key version, but I never would have known which was the best solution if I hadn't tried all three.

Figure 4-9
High key

Figure 4-10
Middle key

Figure 4-11
Low key

73

Atmosphere

Atmosphere in a painting can mean more than the effects of weather. While sun, rain or fog certainly play a major factor in the kind of mood a painting will acquire, there's more to it than just recording a particular weather condition. Camille Pissarro, in a letter to his son Lucian, gave the following advice: "First comes the sensation, from that all else is subordinated." What Pissarro was referring to is that intangible subjective "click" a painter sometimes feels when responding to a subject. Atmosphere and weather conditions can play a big part in helping that click to take place. Pissarro's paintings clearly show that he also used atmosphere as a foil for self-expression.

Like the weather, however, sensations can come and go. During my morning jog, there are subjects that I pass day after day without the slightest interest in painting them. There's a filling station on my route that most times appears to be nothing more than a dirty grey slab of concrete, some upright metal pumps, a block-shaped garage with windows that look too big and an array of gaudy pennants. I usually wave to the attendant and trot on, without an artistic thought in my head. Every so often, though, I'll approach that station and see that a spell has been cast upon it. The light is filtering through a tree at a perfect angle, some filmy atmosphere is hanging in the air just so and almost magically, the usually gritty scene has been transformed into something out of Edward Hopper. Poetry made a visit that day, and my impulse is to abruptly reverse my direction, grab my paints and easel and make a picture. In fact, on more than one occasion I've done just that. When Pissarro talked about a sensation, I'm sure this is what he meant. Fortunately, geographic locale has little to do with discovering picture possibilities, for if the artist has developed his responsiveness to such things, pictorial material can be found anywhere you happen to live.

The following three demonstrations, Figures 4-12, 4-13, and 4-14, show not only how atmosphere can affect a subject but how the exercise of some artistic license can hone down that subject to the exact shade of meaning the artist wishes to communicate. When edges were discussed a few pages ago, the emphasis was on factual ways of seeing them, followed by an explanation of how to paint them. However, once learned, these methods should only be considered as tools. Edges, pictures in different keys and atmospheric effects are all means to an end, and that end is to communicate, through your paintings, how you feel about what you see.

Figure 4-12
Here we have a crisp sunny morning. Clouds wisp across a clear sky, light and shadow patterns are firm and well defined and the whole range of nine values is employed. Edges are clean-cut to further emphasize the fresh, bracing air of a spring morning.

Figure 4-13
The sky has now turned overcast, softening the light and blunting many of the hard edges. The scene takes on a more melancholy quality, the air is heavier and some rain might be in the offing. Black and white have been eliminated from the palette, with only greys used to heighten the overcast mood.

Figure 4-14
The atmosphere has now become heavy. Fog nearly obliterates the background and clouds up many passages of the middle ground. Except for a few firm edges in the foreground, the entire picture has a soft, marshmallowlike appearance. The few areas of clear definition tease the viewer into imagining what might lie beneath the heavily shrouded atmosphere. Again, black and white have been removed from the palette, with most of the picture painted in values hovering around middle grey.

The Spotlight Effect

Here's a way of not only quickly achieving a mood but also controlling the light to best suit your purposes. All nine values will be needed for the two steps involved. A light, middle and dark grey will take care of the lay-in, with the full range of values added later. I prefer acrylics when working this way because a lot of overpainting is done and the fast-drying acrylics permit me to move right along without having to pause for paint to dry. If oils are used, a few drops of cobalt drier should be added to the paint, which will then dry in less than a day. Casein and gouache are also suitable, though they tend to crack if the paint is built up too thickly. The important thing is to have a dry underpainting to work over.

The underpainting effect we're going to build on is similar to that of a spotlight shining on a blank surface with the lightest tone appearing as a round light value which then dissipates into ripplelike values of middle and dark grey. Study the three paint doodles in Figure 4-15 and notice how each hints at a possible composition.

Once a particular doodle strikes your fancy, enlarge it to the size you wish to paint the finished picture. This lay-in is then overpainted with whatever realistic trappings your subject might include. I've chosen the upper right doodle of the group. In it, I can visualize some woods with perhaps a small animal or figure to give the trees a sense of scale. I now enlarge the paint sketch to picture size, casually brushing in the three values with little thought of the intended subject. See Figure 4-16.

Two options now open up to me. First, I could lay a sheet of tracing paper over the dry underpainting, and work out the drawing, composition and values in pencil before beginning to paint. The second method, Figure 4-17, is more risky, but a lot more fun. It means simply picking up loaded brushes and, with a stout heart, jumping right into the picture with little or no preliminary guide. Work proceeds something like this: The value of a rock is established here, a few darks there. Some scumbled middle values approximating bushes are stated, then I quickly move on to place a small accent of white or black to note the center of interest. If all goes well (if I trust myself it usually does) the painting starts to take on some coherency. Intuition will have guided me as to what should be emphasized and what played down. As Harvey Dunn, the noted illustrator and teacher, once wisely told a class, "Let the picture paint itself." After an hour or so of spontaneous freewheeling, I like to sit back, cool down a bit and carefully evaluate how things are progressing. Perhaps a passage of trees is too busy and needs simplifying; or some rocks are too evenly spaced and need to be rearranged. Revving up again, I complete the picture, always aware of the three-valued lay-in, with the light-valued circle of tone guiding the placement and handling of the center of interest.

I like the spotlight method because it gives me a way to kill that intimidating white canvas which can sometimes intimidate even the most experienced pro. The three casually placed preliminary tones help launch me painlessly right into the battle zone. Before I know it I'm pushing around my brush and solving whatever problems that happen to arise. Try it, you might like it.

Figure 4-15 **Preliminary paint sketches**

Figure 4-16 **The lay-in**

Figure 4-17 **The finished picture**

Subtlety of mood

There are as many different moods to be evoked in a painting as there are artists who paint. However, I find one quality which seems common to all good art. That quality is subtlety. Sledgehammer solutions like Pop Art or Op Art may attract a trendy following for a time, but in the long haul it seems that the artists who resist shouting their finds and converse in a clear, unaffected manner are the ones who remain in fashion. When an artist is moved by a subject, though the canvas may have been a regular battlefield of trials and errors, the final result seldom shows any evidence of early indecision. Images are clear without being gaudy. The painting looks complete. Not necessarily the completeness associated with meticulous rendering, but a wholeness of thought and feeling.

Occasionally such paintings achieve a timelessness, appearing fresh and alive even after generations of viewing. Edward Hopper's *Freight Cars, Gloucester,* shown on page 23, is such a painting. Hopper managed to instill into this deserted freight yard a strength and quiet dignity. The light of the afternoon sun reveals the heavy forms of the subject in stark, yet sensitive simplicity. We see not only a few shabby boxcars on the edge of a small town but the essence and spirit of similar industrial way-stops everywhere.

I'm always astonished by Hopper's deliberate, almost primitive painting style. Rather than occasionally succumbing to surface virtuosity and showing off a little with a few swaggering brushstrokes or a swipe or two with a painting knife, he's opted for a completely straightforward, almost severe technique. He literally forces us to confront the content and mood of the scene rather than be waylaid by interesting paint handling. Painting with such feeling doesn't happen overnight. Basic techniques have to be learned, then unlearned. The mind and responses need to be finely tuned. The mechanics of painting have to become second nature so when a subject strikes that special chord, the artist is ready.

Early Sunday Evening
9"x12" acrylic on Masonite.

Collection of the artist

This little unassuming acrylic is one of the few pictures I've painted that totally satisfies me. Although it was completed in less than an hour, to me it says everything I felt about what I saw. The sun is poetically embracing a few last building tops; the atmosphere, though subtle, is felt, with light, airy values enveloping the scene in quiet orchestration. We all deserve a winner every so often, and I offer this painting as one of mine.

Chapter 5

Becoming Aware of the Many Kinds of Light

Studying the various kinds of lighting possible on a subject can be a fascinating pursuit and one that has intrigued artists as far back as John Constable, who painted hundreds of studies showing the effects of light on clouds and landscapes. Claude Monet's series of the same haystacks and cathedrals painted at different times of day show how a painter can be obsessed with color changes as they occur under changing light. Sargent, too, painted "portraits" of particular times of day; and Sorolla, though he favored the warm light of late afternoon, was equally addicted to catching the fast-moving effects of the sun as it moved over the Spanish beaches and countrysides.

Probably all painters have at least a passing interest in the various effects light can produce. To begin such a study, an inventory should be made as to the different kinds of light available to the painter. Light originates from two basic sources. The first, called natural light, is the sun and moon. An overcast day, for instance, would still be considered sunlight, although the light is diffused through clouds before it reaches the earth. The second source, artificial light, includes lamplight, streetlights, firelight or any other contrived lighting effect.

Natural light has long been the artist's favorite, and for good reason. Because of the sun's and the moon's great distance from the earth, natural light can bathe a subject, be it a vast acreage of buildings or a thimble, with wonderfully bright, consistent and even coverage. Modeling tones seldom appear confusing and highlights always seem properly keyed. A study of past masters will verify this preference. Although he sometimes chose to soften the effect of sunlight shining on his models by placing a piece of cheesecloth above them, Leonardo da Vinci used the light of the sun to show the most subtle sculptural effects present in the figures and portraits he painted. Rembrandt's studio window illuminated but small passages of his subjects with a thin revealing shaft of light and often immersed most of the composition into dramatic shadow. Vermeer's pearly clear genre scenes probably were painted under a north light. James Whistler chose moonlight for illuminating some of his paintings, while the Impressionists usually favored direct sunlight.

Working indoors, artists traditionally favored natural light coming from the north, the reason being that north light remains consistent, whereas east, west and sometimes south light is affected by the movement of the sun. North light also gives the painter the ideal condition of having an identical light striking his subject, canvas and palette.

On the other hand, much can also be said for artificial light. In fact, many subjects, such as street scenes at night or windowless interiors, demand it. Contemporary painter Charles Pfahl makes effective use of artificial light, capturing dimly lit interiors with inventiveness and feeling. Another advantage of artificial light is its dependability. In the outdoors, the sun might go behind a cloud, interrupting painting until it reappears. When you work under artificial light this problem doesn't exist. It's advisable to try working under different lighting conditions. You'll soon discover the kind that best suits your needs.

Let's now move on to the particular kinds of natural and artificial light.

Collection of the artist

Nancy
14"x18" oil on canvas.

Nancy enjoyed talking while I painted and I think I captured her just as she was pondering a question I had asked. Most students tend to paint sunlight too dark and contrasty. Observe how the only real darks in the picture (and even they aren't black) are in the bandanna and door. The rest of the painting is quite high in key. Notice also the minimum amount of halftones used. Sunlight is usually very bright, and to catch this effect it's crucial to keep your lights and shadows clearly defined.

Various Kinds of Light Sources

While preparing the preliminary notes on this chapter I made a list of as many different kinds of light sources as I could imagine. The length of the list surprised me. However, in looking over it, I was reassured to see that all the sources fell into the categories of either natural or artificial light. Study my list and see if you can add to it.

sunlight	stage light
flashlight	headlight
moonlight	soft light
lamplight	hard light
firelight	candlelight
porch light	work light
night-light	strobe light
safelight	fluorescent light
daylight	neon light
starlight	streetlight
north light	bug light
	skylight

This list might give you some idea of the vast warehouse of lighting solutions available to the artist. I'm reminded of a haunting interior painted by Jamie Wyeth. The picture is entitled *The Mushroom Picker,* and shows a worker in a miner's hat gathering mushrooms in a darkened storage cellar. The only source of illumination is an eerie beam of light shining from the worker's cap. Wyeth caught the mood of the scene perfectly by his unconventional choice of lighting.

Jamie's father, Andrew, also made use of singular lighting effects. In his painting, *Night Hauling,* the artist shows us a solitary fisherman hauling a catch into his boat. The only source of light is the phosphorescent glow emanating from the fish. It's this kind of creative thinking that stamps a work with the artist's personality, giving it a uniqueness that's hard to forget.

For an artist all natural and artificial lighting effects can be categorized into nine basic conditions. They are: form light, sunlight, patchy sunlight, overcast, diffused, edge light, moonlight, backlight and front light. Once these basic nine are understood, any lighting problem can be accurately painted. In each of the nine conditions the value range should be adjusted to accommodate the particular effect. It might be helpful to think of these nine conditions as parents, each possessing many children. Edge light, for example, can be used to paint the effects of firelight, stage light, candlelight or a streetlight. Form light can be adapted to north light or lamplight, etc. By mastering these nine basic conditions, any lighting problem, be it a bug light or skylight, can be handled with confidence.

Form Light　　　Sunlight　　　Patchy Sunlight

Overcast　　　Diffused　　　Edge Light

Figure 5-1

Moonlight　　　Back Light　　　Front Light

83

Figure 5-11 — Lightest value in light; Range of values in light; Darkest value in light; Lightest value in shadow; Range of values in shadow; Darkest value in shadow

Form Light

A form-lighting arrangement is usually best controlled by indoor lighting conditions where north light, skylight or artificial illumination is used. The term is derived from the fact that the form of anything, be it a person or inanimate object, is most descriptive when the shadows cover between one third and three quarters of it. For this reason, form-lighting is popular with portrait painters, illustrators and others who wish to emphasize the structure and character of their subject. All that's needed to create the effect of form light is a standard clip-on lighting fixture, with a screw-on reflector and some sort of stand to control positioning. I use a tripod as a stand. The clip-on light, however, is flexible enough to be fastened on to any protruding surface you happen to have in your studio.

If shadow occupies more than three quarters of the subject, shadow values lighten because of the increasing amounts of reflected light, which then alters the tonal scheme to the status of edge light. If shadow covers less than one third of the subject, values are again altered and the subject begins to qualify as a front-lit condition.

The value organization in form light works like this: White, the lightest home value used, stays white in light; for shadow it drops to a half-step between middle and dark grey. Like white in shadow, black in light also occupies the middle dark grey position, while black in shadow stays black. All other variously toned home values in between are given a similarly consistent value jump, see Figure 5-11.

Notice how white in shadow is the same value as black in light. It's important to not go *above* this value in shadow or *below* it in light, as the illusion rests on maintaining a firm boundary between the two. If values are overstated, the painting takes on an inconsistency and the form-light effect becomes lost.

Study the illustration on the opposite page and observe how adherence to the predetermined value range gives the painting consistency and captures the particular effect of light.

Collection of the artist.

Hans
14"x18" oil on canvas.

I chose form light for this portrait sketch because of the attractively sculptured planes on Hans' head. Had the model possessed finer, more delicate features and a simpler hairstyle my choice may have been different. Notice how I've used the halftone planes around the nose and cheek to carve out the subtle forms falling away from the main lights. To catch Hans' ruddy yet shiny complexion, I emphasized the highlights on his nose and forehead. The painting took about 2½ hours to complete.

85

Sunlight

Of all the conditions of light, I find sunlight to be the most intriguing. The number of sparkling, high-keyed arrangements found in nature are endless and, for me, trying to capture them is great sport. Working outdoors presents a host of difficulties caused not only by a changing light source, unpredictable weather conditions, heat, cold, bugs and bothersome onlookers, but also by glare, which at times makes value and color mixing all but impossible. I usually wear a dark, neutral-colored shirt or jacket which helps alleviate part of the problem. I haven't as yet, however, been able to figure out a way of getting rid of glare completely. All things considered, though, painting sunlight on location is well worth the effort. Working indoors, from reference material, is certainly less taxing, but I find the results of working on the spot far superior to anything cooked up in the studio.

The value range used to catch sunlight contains no black. The half-step between dark grey and black is the darkest value on the scale, which is used for the home value of black in shadow. Black in light is a medium grey. White in shadow, because of the abundance of reflected light from the sky and surrounding light-struck objects, lightens to become a half-step between medium and light grey. White in light stays white. Again, all the other variously toned home values have a light and shadow range consistent with that of black and white (Figure 5-12).

Two additional factors enter into painting sunlight. The first is reflected light, which can bound around uncontrollably at times, especially on light-valued objects in shadow. Care must be taken—don't paint these values as light as they appear. Remember, the lightest value found anywhere in shadow shouldn't be lighter than the half-step middle light grey, which is the lightest shadow tone on the scale. The second consideration is halftones. Bright sunlight usually bleaches out halftones, making them appear much lighter than those found in form-light conditions.

Painting sunlight is a lot of fun and by keeping your values within the prescribed tonal range, you can create many interesting and varied sunlit effects.

Figure 5-12

Spring Foal
20"x24" oil on canvas.

I don't consider myself an animal specialist like Bob Kuhn or Stan Galli. Occasionally, however, I find it enjoyable to paint animals, especially when I catch one in its natural environment. To emphasize the bright sunlight striking the young horse, I intentionally darkened the value of the grass to heighten the effect of light on the foal's legs and body. The light dots of wild flowers were an afterthought to give the field some added interest.

Private collection

Figure 5-13

Patchy Sunlight

Patchy sunlight is a unique condition. The confetti effect of lights and shadows found sprinkling streets and gardens on clear bright days is truly a joy to behold, and if approached knowingly, a real pleasure to paint.

Though it might seem to limit this spontaneous lighting effect, a basic scheme of values is important in capturing this difficult effervescent effect.

The scale of values used in patchy sunlight is identical to that of normal sunlight. The only alteration is the addition of the patchy dots and dashes of lights and shadows. When handled with care and finesse, however, these seldom present any real problems.

I find the following procedure to work for me. First, paint the entire scene, *eliminating* any patchy effects. Next, turn away from the scene and clear your mind of any lingering images of how it looked. Now face the scene again, this time not really focusing on any one part but instead soaking up the overall view. This reconnaissance should take about ten or fifteen seconds. Now turn your back on the scene again and try to remember what impressed you most. Did the patchy quality dominate only one part of the scene or was it equally dispersed over the entire vista? Were the shapes of light and shadow contrastingly large and small or were they of about equal size? Continue questioning yourself until you've pinned down the quality that originally hooked you.

Finally, take up your brushes again and proceed to paint the patchy effect. This time, however, use the image in your mind, rather than the scene at hand, for inspiration. Use the scene, of course, for particular information (how a shadow weaves across the form of a step or hedge), but subordinate these seen facts to the image in your memory. I think you'll find the result will not only catch the patchy effect of light but present it in terms coherent to your picture's composition. The reason this coherency usually occurs is that the imagined scene fits your composition, whereas the factual cataloging of what you see may have little or no unity. Literally copying the scene could result in piling on layers of meaningless, unfelt detail.

Painting patchy sunlight requires experience and patience. But once success is met, anxieties melt away and new challenges become eagerly awaited. For an excellent example of mastering the effects of patchy sunlight, study the John Singer Sargent painting shown on page 22.

Washington Square North
16"x20" oil on canvas.

Collection of Mr. and Mrs. Ronald Pacchiana, Pound Ridge, New York

If all my paintings went as easily as this one did, I would have far fewer grey hairs. The effect of sunlight on this quiet New York street is successful because I simplified the complex and confusing patterns of shadow which practically camouflaged the whole subject. My composition is one that was often used by the Impressionists—the street converging in one-point perspective into the distance. Notice how the carefully positioned figure and cars not only provide the viewer with a center of interest but also give the scene a needed sense of scale.

Overcast Light

If asked which lighting condition offers the richest ensemble of modeling values, my first choice would be overcast light. Unlike form light or sunlight, overcast light is an even, yet firm source of illumination which reveals a subject's light, halftone and shadow planes in a clear, sculptural gradation. The outdoor genre scenes of John Singer Sargent were frequently painted under overcast light. A study of these paintings will quickly reveal a richness of modeling and variety of tonal changes which dramatically illustrate the advantages of this particular lighting condition.

The value range of overcast light gives a generous allotment of tones to shadows. White in shadow becomes a half-step between middle and light grey; white in light stays white. The home value of black in light is a dark grey, whereas black in shadow stays black. Consistent with the other lighting conditions, all home values between these two extremes should be bracketed in similar value jumps (Figure 5-14).

Because there's no harsh, direct light to raise halftone values nearly equal to light values, halftones should be painted a value about halfway between the value of light and that of shadow. A white dress, for example, would be painted white in light and middle light grey in shadow. The halftone of the dress would be painted a value slightly lighter than light grey.

Another characteristic of overcast light is a subtle softness which cloud-filtered light can bathe over an entire scene. A good example of this soft yet clear light is Vermeer's *View of Delft*. As in his indoor scenes, Vermeer has poetically captured the pearly quality of overcast light shining on a complex cityscape.

Overcast light is a quiet, sometimes somber source of illumination. Because of its subtlety, however, values are more finely graduated, forcing the artist to take greater care in mixing colors and values than with the more exaggerated tonal properties of sunlight. Beginning painters can learn a great deal painting under this condition because, unlike sunlight, overcast light usually remains consistent throughout the day, enabling painting sessions to last six hours or even longer.

The Douglas Gallery, Stamford, Connecticut

Lightest value in light

Darkest value in light

Lightest value in shadow

Darkest value in shadow

Range of values in light

Range of values in shadow

Figure 5-14

Sheridan Square
20″x30″ oil on Masonite.

 Because this subject was painted under overcast light, I was able to cluster the busy passages of buildings and people into simple patterns of easily read tones. Had I chosen sunlight to illuminate the scene, my problems would have been compounded by the added patterns of contrasting lights and shadows. Squint your eyes and study how the people seated at tables beneath the awning on the left side of the building are painted with subtle, close-valued tones, with only a sprinkle of lights and darks to give them variety. Notice also how I reserved my lightest light for the white-coated figure crossing the street, giving the composition a small, yet easily recognized center of interest.

Figure 5-15 — Lightest value in light / Darkest value in light / Lightest value in shadow / Darkest value in shadow. Range of values in light. Range of values in shadow.

Diffused Light

Diffused light is the weakest of all the conditions. Examples of diffused light include interiors, where modern, indirect light sources seem to come from all directions, canceling out any definite demarcations between light and shadow. Fog and haze also can qualify as diffused light. They can also shorten the value range of a subject turning a normally overcast condition into a diffused one.

Another hallmark of diffused light is the flatness it imparts to a subject. Painters such as Chen Chi and David Hockney frequently use diffused light in their paintings, occasionally overemphasizing the flatness to achieve certain decorative effects.

Light and shadow values in diffused light have little contrast. White in light stays white but the shadow of white is only a light grey. Black in shadow becomes a dark grey; black in light is raised to a light grey (Figure 5-15). The light and shadow tones of the subjects with home values of grey between the extremes of black and white are given a similar one-step jump between light and shadow. Halftones, though subtle, are painted about a middle value between light and shadow.

Generally, diffused light seems to lend itself best to high-key subjects containing light home-valued objects. Diffused light can be a real challenge to the artist. However, when successfully captured, the resulting painting can have the quiet beauty of subtle chamber music.

Interior
16"x16" oil on canvas.

Collection of the artist

My wife and I had just moved into our apartment when I painted this picture. The newness of the rooms and the soft, clear light from the windows gave the interior a charm I felt compelled to catch. Notice the absence of any strong light and shadow passages. Instead, forms are painted close in value, emphasizing the decorative quality typical of diffused light.

93

Range of values in main light — Lightest value in main light
Darkest value in main light
Range of values in reflected light — Lightest value in reflected light
Darkest value in reflected light
Range of values in shadow — Lightest value in shadow
Darkest value in shadow

Figure 5-16

Edge Light

Edge-lit pictures usually appear more dramatic than those painted under form light, sunlight, overcast or diffused light, and for this reason are frequently favored by illustrators. Athough sometimes seen under natural lighting conditions the effect is best controlled using artificial light. The positioning of the lights (two are needed) demands care and selectivity. The best arrangement is to position the main light in back and slightly to the left or right of the subject.

The effect we're after here is illumination of only a few telling edges of the subject. If a figure is to be painted, perhaps only the side of the head, tops of the shoulders and sides of the arms are revealed. Everything else falls into shadow. A ratio might be three quarters to seven eighths of the subject in shadow compared to one quarter to one eighth in light. The second light, called a fill light, serves the purpose of gently illuminating the shadows and sets up a light and shadow condition of its own, though much lower in values than the main light source. Because shadows can easily become overpowered by a secondary light, care must be exercised in placing it at least three times as far from the subject as the main light. If the main light, for instance, is three feet from the subject, the fill light should be about nine feet away.

The value scale used in painting edge light is broken into three parts. First, the value range in light is shortened to two values, white and light grey, with a half-step between. This means that black objects in light are painted a surprisingly high-keyed light grey. Middle grey objects in light are a half-step between light grey and white. White remains white. The reason for this short range of light values is to enable us to catch the inherent brightness and glare of the main edge light.

The second and third parts of the scale are used for shadows. Because the secondary fill light gives definition to shadow passages, it is regarded as a second light source with its own (reflected) light and shadow tones. White in reflected light is painted a light grey; shadow is dark grey. Black in reflected light becomes a dark grey, with its shadow remaining black. A middle grey home value in reflected light remains a middle grey, whereas the shadow is painted a half-step between dark grey and black. Any other home-valued greys are painted with a value jump consistent with that of white, middle grey and black.

When modeling the subtle reflected light and shadow values in edge light, be careful not to overstate accents, as too much modeling in this delicate shadow area will destroy the illusion of softness and mystery usually associated with this condition. Finally, try to use thick, crisp strokes when painting the small shapes of main light. I think you'll find they help further contrast the darker, soft-edged reflected light and shadow passages.

Eddie and Mack
14"x18"

Collection of the artist

Who can resist a boy and his dog? Not me. I used edge light in this painting to play up the clean note of white fur on the dog. Imagine the same subject with light striking from the front. I don't think the effect would have been nearly as successful. It's important to keep your modeling subtle in the shadows with this kind of lighting. Observe the boy's head, for example. Although it appears solid, the number of values I employed were extremely limited. Also notice the thick paint application in the main lights which helps clarify them as the brightest areas in the picture.

Moon, lightest value on scale

Range of values in light

Range of values in shadow

Figure 5-17

Lightest value in painting

Lightest value in light

Darkest value in light

Lightest value in shadow

Darkest value in shadow

Moonlight

Not many moonlit pictures seem to be painted these days. High-speed color photography has probably a lot to do with this, and considering the ease with which a photograph can be taken, it's certainly no wonder. Still I feel that the painter can bring a quality to a moonlit night scene that's unobtainable in a photograph. The heightened mood and dramatic effects that Pissarro, Whistler and Frederic Remington captured in their nocturnal paintings retain a remarkable freshness and originality. I'm convinced there's still a lot of unexplored territory to be discovered with this fascinating motif.

Because it's practically impossible to paint moonlight on location, the next best thing is direct observation. When the moon appears, step outdoors or turn the lights off in your room and look out a window. Let your eyes roam around noting value and color changes and try to memorize as much of the atmospheric condition as possible. Then go back to the studio and paint, draw or even write your recollections.

Ask yourself questions. Where was the lightest light? The darkest dark? What color was that distant cropping of trees? Don't forget you can always study the same scene in daylight to firm up any structural details you may have forgotten. The big thing, however, is the mood. Once that is firmly fixed in your mind the rest is mechanics.

The value scale for moonlight places emphasis on the brightness of the moon, and, like any other light source, values will be scaled down to show off its effect. White, except for the moon itself, is eliminated from the palette. The light side of white home-valued objects becomes a light grey, with the shadows dark grey. The light side of black objects in moonlight is a dark grey, while black in shadow remains black. A middle grey home value stays middle grey in light and lowers to a half-step between dark grey and black in shadow. Any other various home values follow the same bracketing of light and shadow jumps.

One characteristic unique to moonlight is the unity of shadows. Avoid painting jumpy, irregular patterns of values in your shadow passages. Instead strive for a unity by softening, where possible, brittle edges and sharp demarcations of tones.

Lastly, be sure to keep the lightest lights hovered around the area of the moon itself. It's tempting with this kind of low-keyed picture to want to sprinkle a few lights here and there just for the effect, but try to restrain yourself, using light-toned accents only when absolutely necessary.

A word about the color of moonlight. Even when the moon is full and the air clear, surprisingly little color is evident under moonlight. Whistler was known to have painted many of his nocturnal scenes using just black, white, green, blue and yellow ochre. Of course you can take artistic license as Remington did in some of his night paintings and employ many more colors to emphasize some particular mood, but keep in mind that moonlight neutralizes the color of most objects in light and practically washes out all color in shadows.

The Douglas Gallery, Stamford, Connecticut

Night Stop
14″x18″ oil on Masonite.

This was mostly a memory painting based on the recollection of a lonely moonlit Montana field I saw years ago. The image was long forgotten until I came across a small picture in a newspaper of an oil car. My past memories were stirred and I combined both images in my painting. It would have been very tempting to "pop" some near-white highlights on the railroad car and tracks but I restrained myself and worked instead for the overall mood rather than any one part.

97

Backlight

Backlight is a condition in which a light source is behind the subject, causing it to take on a near-silhouette effect. The theater and movies often employ this kind of lighting when an ominous or melodramatic mood is required. For the painter, backlight can be a useful tool, especially in handling complicated figure situations or busy still-life set-ups, where attention needs to be limited to one or two major passages.

Because no direct light is shining on a subject in this condition, our only value concerns are with the tones in shadow. A white home-valued object, for example, will drop to a light grey, with any modeling to be done confined within a half-step of that grey. Black home-valued objects are lightened slightly to a half-step between dark grey and black. All other home values are painted accordingly, between these two extremes (Figure 5-18).

Backlit subjects seldom occupy the entire composition. For this reason, limit pure black and white to only the shadows and light-struck areas of your picture. By so doing, the objects in shadow will not only retain their luminosity but keep their secondary position in relation to more important, fully lit objects.

Front Light

Front light, the reverse of backlight, contains little or no shadow. Because of its position, light covers practically the whole subject, giving it a flatness and decorative quality sometimes used by painters to accentuate subjects with interesting patterns. Matisse frequently favored this type of light, as did Norman Rockwell for some of his covers.

The value range in front light renders home values fairly accurately with white staying white. Light and middle grey also remained unchanged. Dark grey is raised about a quarter-step and black moves up to a half-step position between dark grey and black (Figure 5-19). Whenever a shadow appears, the value used to define it shouldn't go more than a half-step darker or the lighting effect will be lost. Halftones, where stated, should be kept subtle, not going any darker than a quarter-step down from the value in light.

Front light offers a lot of possibilities for clean, patterned effects. Although depth and solidity may be compromised, the richness of decorative tone and color in this condition makes up for any sacrifice in form.

Range of values in shadow

Lightest value in backlight area

Darkest value in backlight area

Figure 5-18

This painting is shown in full color on page 121

Lightest value in light

Range of values in light

Darkest value in light

Figure 5-19

This painting is shown in full color on page 121

99

Dissipating Light

One of the more subtle occurrences of light shining on an object is the gradual darkening of light passages as they grow more distant from the source of illumination. This dissipating effect of light is often overlooked by the novice because it's sometimes hardly discernible. Once understood, however, the effect becomes more obvious.

Artificial light, especially when placed close to the subject, will show the greatest effects of dissipation. Natural light, because of its extreme distance, doesn't exercise this characteristic unless intentionally overstated by the artist. There is one exception, however: When natural light shines through a small opening such as a door or a window, the dissipating-light effect can be clearly seen. The light is strongest close to the window and gradually becomes weaker, progressively dissipating its strength as it strikes objects farther and farther away from the window. Some painters like to overemphasize the effects of dissipation to give their subjects added drama and mood. In many cases the results can be striking. However, don't force the effect too much, or it will give the painting a fake, melodramatic look.

The easiest way to handle dissipating light is to first establish your subject's light and shadow range. Let's say there's a one-value jump between them, with the light being a light grey and the shadow a dark grey. Counting half-steps, we're left with three values in between. If the light is positioned above, the upper areas of the subject will be painted the brightest. To dissipate the light, all we have to do is progressively lower the values of the light as it moves down the subject, being careful not to go darker than the allotted three values. Halftones, because they belong to the light, will also dissipate. Their values, however, will be a half-step or so lower than those in the light.

All this is easier shown than explained. Study the illuminated backdrop in Figure 5-20. Notice how the area of lightest light is at the top of the object and to the right. This is because that angle most directly faces the light source. Observe the slightly darker value as the light dissipates down the surface. The opposite side of the backdrop, because it's angled away from the light more, has slightly darker dissipating values. The model, Figure 5-21, has light striking her from the same angle with a similar dissipation occurring. Figure 5-22 shows the model standing in front of the backdrop. Pay particular attention to the halftones on the figure and how they slowly darken in tandem with the lights until reaching the feet, the area most distant from the light.

Once the tonal aspects of dissipating light are mastered, we can get fancy and add color to further enhance the treatment. But let's save that for the following chapter.

Figure 5-20 *Figure 5-21*

Figure 5-22 **Dissipating light on a figure and background**

Interior Lighting

It's possible to illuminate an interior with many kinds of lights. Light from one or more windows can be effective. A table lamp is a good choice to show a pleasant intimacy. So is the light from a fireplace or candles. Fluorescent and indirect lighting can be good solutions in achieving a modern or decorative effect. Whichever source you choose it's a good idea to first visualize how a particular light affects the large forms of the room and furnishings you intend to paint.

I find it helpful to imagine an interior as an open-ended box. If window light is chosen as a light source, the play of values throughout the boxlike interior are adjusted accordingly (Figure 5-23). Whatever furnishings are added can be easily placed in the room and lit to correspond with the light source. Once a room's overall lighting condition is understood it becomes no real problem in rearranging furniture or bric-a-brac to suit a particular compositional idea.

Figure 5-24 shows the same room, this time illuminated by a table lamp. Here again, the patterns of light and shadow are positioned to coincide with the light source, in this case, with light dissipating into progressively darker values as it moves away from the lamp. Indoor paintings have a charm and intimacy uniquely their own, and if you haven't tackled an interior as yet, you have a rewarding painting experience ahead of you.

Figure 5-25

Figure 5-23
Illuminating a room with window light.

Figure 5-24
Illuminating a room with interior light.

Mary's Place
12"x16" oil on Masonite.

Collection of the artist

Interiors vary as greatly as the individuals who inhabit them and my friend Mary Boulton's New York apartment is no exception. Through the years Mary has acquired a substantial collection of antiques and bric-a-brac that makes excellent painting material. However, rather than featuring any one item, I tried to emphasize the light and mood that were the essence of this charming and personal living area. Painted on location, *Mary's Place* **took one 3-hour session.**

Figure 5-26

Winter, 59th St. and 5th Ave.
6"x8" casein on illustration board.

Collection of the artist

This painting is really a sketch for a larger picture, but it has a completeness that I find attractive. Because there were literally dozens of confusing light sources illuminating the scene, I decided to reserve pure white for only the streetlamp in the foreground. Since the horse and carriage are my center of interest, I've lightened my middle ground and background values to play up this important prop.

Combining Two or More Light Sources

Combining two or more sources of light in a picture is no more difficult than handling any of the lighting problems encountered so far. One consideration, however, must always be kept in mind. And that is to make sure just *one* of the sources predominates. Let's imagine a city street at night, with the sky above the buildings revealing a full moon. On the street a lamppost illuminates a storefront and a few houses. If I were painting such a composition, my first decision would be whether the moon or the streetlamp should provide the most powerful source of illumination. This question would be answered by further asking myself what kind of mood would best capture the essence of the scene.

If I wanted to bathe the overall composition with dancing passages of moonlight, I would underplay the harsh light pouring from the streetlamp. On the other hand, if I chose to focus attention on the lonely storefront and surrounding buildings, I would key down the spidery patterns of moonlight and emphasize the glaring light of the streetlamp, perhaps overstating the shadows cast from the forms falling away from the light. Either way, my placement of lightest lights and darkest darks would be reserved for the areas where the source of illumination is the strongest.

To me, John Pike is the master of handling two or more light sources in a picture, and a study of his treatment of light, shadow and color on buildings and landscapes can prove invaluable in learning to handle more than one light source in a painting.

Late Afternoon, South Norwalk
14"x18" oil on canvas.

Collection of the artist

This painting is a very simplified version of the scene I observed. If I had chosen to portray all the background buildings as I saw them, the resulting picture would have been entirely too busy. I think a nice counterpoint has been established through my editing. Notice, for example, how the poles of the dock and bobbing boats are easily read against the quiet foil of the brick buildings behind them. Although this painting isn't factually accurate, it does convey the mood I felt when first encountering the subject.

The Poetry of Light

At the time of this writing a large exhibit of paintings by Edouard Manet had just opened at the Metropolitan Museum of Art in New York. Seeing this gifted painter's work was not only a learning experience but a lesson in poetry as well. After rather diagramatically dissecting the various conditions of light earlier in this chapter, I feel a balance note is needed at this point, lest anyone feel it's by principle and theory alone that one paints a picture.

This poetry of light occurs in paintings of Manet and the other Impressionists but it's also present in the work of artists who preceded them—Rembrandt, Vermeer and Corot come to mind. In our century, painters like Robert Henri, Edward Hopper, Andrew Wyeth and Fairfield Porter have also imbued their work with a sense of poetry, and for this reason, their paintings have acquired a timeless life of their own.

We're all endowed with feelings, whatever our particular capabilities may be. It is to these feelings that I'd like to direct the final words of this chapter. I think every artist shares an interest in the craft of painting. By craft I mean not only proper canvas-stretching and paint-handling procedures but also theories and formulas such as those previously discussed. Although value scales approximating different light conditions, principles of dissipating light and all other important basics I've presented can get a beginning painter off the ground, they don't, unfortunately, give him the wings with which to soar. As much as any teacher may try, it's not really possible to show a student how to paint his feelings. All any teacher can do is to explain and demonstrate the basics of tangible obstacles such as value relationships, edges, and color. The rest, and really the most important part of painting a picture, is heart.

The surest way I know of caring about what you paint is to paint what you care about. What moves you? Obviously my love lies in painting light and because you're reading this book I can only assume that's your interest as well. Learn to nurture this interest by keeping your eyes and heart open to your surroundings. When something stirs you, paint it with a firm belief that you're doing something that is very important.

Use the theories and principles you've learned but more important, catch your original sensation. If it means making a shadow three or even four steps darker rather than the prescribed one step, by all means do it if it results in a more poetic statement.

By painting with conviction and a real belief in your subject, technical hurdles have a way of disappearing, and when an artist couples this with something sincere to say and accompanies it with a gut determination to say it, there's really nothing that can hold him back.

Chapter 6

Color and Light

The transition from black-and-white tonal painting to full color is frequently a difficult one. The number of juggled objects is increased and some goofs are bound to occur. After the exercises, studies and mental adjustments, tonal painting in nine values has, I hope, developed in you a sense of confidence along with some predictability of how paint behaves. When this stage is reached in my classes and I give my introductory talk on color, I find two simultaneous reactions occurring in my students. First, I hear comments like, "Gee, I can't wait," then a short pause followed by a bewildered, "But how do I do it?"

Every painter has been faced with this same challenge, and like any other area of growth, some make the transition with effortless grace while others struggle and muddle and come close to giving up the whole idea before clicking the connection. For those blessed with a natural sense of color no instruction is really necessary save for a few gentle bumps in the right direction. The majority of us do need some guidelines, however, and that's what this chapter will try to give.

There are three ways of approaching color. The first is the purest method. Here, the painter concerns himself only with effects that can be achieved with color. Purity of hue, harmony and interesting juxtapositions of intensity and neutrality all take priority over tonal considerations such as accurate value jumps, home values and the subtle modeling or dissipation of tones. Color is everything. It's used to model forms, achieve atmosphere, show depth and dictate mood, and even the thought of adulterating these pristine effects with a tonal note is usually frowned upon. A lot of contemporary painters claim to be practitioners of this school; few, however, are the purists they claim to be. The Impressionists could be considered adherents to this method, particularly Monet, Sisley and Pissarro.

The second, more classic approach is to regard color as the handmaiden to tone. In this approach it's the values that dictate the form and mood of a picture. Color is considered a superficial grace note rather than an important building block contributing its equal share to the picture's growth. Exponents of this method are usually tagged tonalists and include such painters as Camille Corot, Carolus Duran and Charles Daubigny.

The third, and most popular approach is a combination of the first two. By a sensible pooling of both color and tonal techniques, the artist can not only paint a picture that is colorfully assertive, but also richly model and pattern it with a full range of values. It's almost like having your cake and eating it too.

This method also keeps the artist from falling into a rut because it permits an open, flexible point of view. This kind of adaptability is especially important when painting diversified subjects. Because the mood I'm after varies from picture to picture, I find myself switching back and forth. The old truck, shown on page 132, for instance, would have lost a lot of its character if rendered in pure, bright, Impressionist-like colors. By the same token, a child playing on a sun-filled beach would take on an inconsistent ponderousness if painted with a dark, earthy palette.

This chapter will be discussing many different ways of thinking about color, values and light. After reading it I think you'll find that, rather than being this mysterious entity with its own rules and dictates, color is really just another tool to help you paint a better picture.

Candlewood Lake
12"x16" oil on canvas.

The Douglas Gallery, Stamford, Connecticut

Kids are a favorite theme of mine and when I saw these young children happily playing in the shallows of a nearby lake, I couldn't resist painting them. I pretoned my canvas a pale orange to complement the primarily cool colors of the trees and water. Because the subject was backlit, shadow predominated over light, enabling me to keep most of the shadow passages soft and indicative, saving my thicker, more textured strokes for the areas receiving direct light. The painting was completed in one 6-hour session.

```
                              RED
                    Cadmium  │ Cadmium
                   Red Deep  │ Red Medium
              Alizarin       │    Cadmium
              Crimson        │    Red Light
           Cobalt            │ Burnt     Cadmium
           Violet            │ Umber     Vermilion
         Ultramarine         │    Burnt
         Violet              │    Sienna     Cadmium
PURPLE                       │               Orange       ORANGE
                             │                  Cadmium
                             │                  Yellow
         Ultramarine         │                  Deep
         Blue                │                     Cadmium
                   COOL      │     WARM            Yellow
                             │                     Medium
                             │        Naples
                             │        Yellow   Cadmium
         Cobalt              │                 Yellow
  BLUE   Blue                │        Yellow   Light         YELLOW
           Thalo             │        Ochre
           Blue              │                  Cadmium
              Cerulean       │        Raw       Yellow
              Blue           │        Sienna    Pale
                  Thalo      │     Raw
                  Green      │     Umber      Lemon
                    Viridian │                Yellow
                      Chrome │     Permanent
                      Oxide  │     Green Light
                          Sap│ Permanent
                          Green│ Green Deep
                             GREEN
```

Figure 6-2 Here you can see where the tube colors fall on the wheel.

The Spectrum and the Color Wheel

Nature has given us a ready-made palette in the form of the spectrum. Hold a prism up to direct sunlight—the colors it reflects onto a nearby wall are a treat to the eye. Starting with violet, you'll see indigo blue, green, yellow, orange and red. To understand how the color wheel is constructed, imagine bending the straight line of the spectrum colors into a circle. Matching these colors with the pigment of paint colors and laying them out in a circle, we have the traditional color wheel. Another property of color is warmth and coolness. The color wheel can help us to see not only the differences between basically warm and cool colors but also the warm and cool variations found within each side of the wheel.

Putting this knowledge of the spectrum and color wheel to work requires some understanding of how the eye reacts to color. The human eye is ingeniously equipped with three sets of cones. One set is sensitive to red, a second to yellow and a third to blue. Seeing through these three primary color cones and the thousands of combinations possible within them enables us to identify the specific colors of objects and scenes around us. Theoretically, these three primaries can be intermixed to give us any color imaginable. In actual practice, however, many of these mixtures leave something to be desired. This is because paint is not nearly as pure as the colors of the spectrum, which are made up of actual rays of light. For example, the pigment cadmium red light contains a touch of orange and ultramarine blue, purple and so on. To offset this imperfection, tube colors come in a much wider variety than the seven colors found in the spectrum. Rather than attempt to mix a purple from cadmium red light and ultramarine blue, which would result in a muted plumlike hue, bright colors like purple lake and cobalt violet are available to fill the gap.

Warm and Cool Blues

In my early years at art school I once asked an instructor in a painting class which of the blues he considered warm and which cool? His answer was a firm "Ultramarine is warm because it contains a touch of purple. Cerulean blue, because it leans toward green, is cool." Sounds logical, I thought, and proceeded on with my painting. A few years later, while taking an evening class at the Art Students League of New York, I asked my instructor the same question. Feeling a little smug, because I already knew the answer, the reply I got gave me a jolt.

"Ultramarine is cool because of the purple in it, while cerulean blue is warm because it contains green."

Perplexed and confused, I asked this question of artist friends, illustrators, teachers and even photographers—anyone who I felt might be knowledgeable in such matters. The answers I received were equally confusing. I began experimenting with (it now seems like) buckets of various blues, once and for all trying to resolve this contradiction.

I'm happy to write that I now believe I have the answer. They both can be warm and they both can be cool! Here's why. Ultramarine does, indeed, contain purple, which is made up of red and blue, qualifying it as a warm blue. Likewise, cerulean blue contains some green, which is a mixture of blue and yellow, making it, too, a warm color. What really determines a warm or cool blue is the color of the light. Imagine a piece of blue drapery struck by warm, yellow sunlight. The choice of a warm blue would have to be cerulean because it leans toward yellow. The cool shadows of the drapery, by contrast, would be painted with ultramarine because of its purplish cast and opposing direction on the color wheel. If we changed the color of the light to a greyed purple, typical of some overcast days, ultramarine would become the warm, and cerulean the cool. Try some exercises on your palette, playing around with different blues under some imagined colored-light sources. You'll quickly understand how this phenomenon works. Then, if anyone ever asks you which blue you feel is warm and which cool, you'll be able to reply by wisely asking them—what color is the light?

Other blues useful on a palette are Thalo blue and cobalt blue. Thalo, like cerulean blue, is yellowish. Cobalt is a true, neutral blue because it contains neither yellow nor red.

Reds, Oranges, Yellows, Greens and Purples

Fortunately, all the other colors on the wheel have easily identified temperatures. Alizarin crimson contains blue and is cool. Both cadmium red, light medium and deep are warm because they have some orange in them. Cadmium orange can only be warm because the colors on both sides of it are warm. Cadmium yellow medium and deep are warm; cadmium yellow light contains neither orange nor green and is neutral. Cadmium yellow pale is cool because of the hint of green in it. Permanent green light is warm, containing a lot of yellow, whereas viridian and Thalo green are cool with blue predominating. Because of its reddish cast, cobalt violet is warm, while the bluer ultramarine violet is cool.

Earth Colors and Black

The earth colors have a place on the color wheel, too. Burnt umber is really a dark red, warm though greyed. Burnt sienna is a dark orange, and yellow ochre and raw sienna dark yellows. Black, because it contains little, if any, color, does not have a position on the wheel. Blacks do vary in temperature, however: Lampblack has a slight brownish black cast, ivory black is neutral. Payne's grey, a mixture of black and ultramarine, is cool.

Choosing the Right Colors for Your Palette

When I first began to paint I acquired some color charts which cheerfully displayed the complete line of colors available from several leading paint manufacturers. After carefully studying the charts, I came to the conclusion that the more colors I put onto my palette, the better my painting would be, with the ultimate picture resulting from the use of *all* the colors on the chart! While it's easy, now, to smile at my naivete, it's also understandable how any novice painter might arrive at the same conclusion. Why, then, not squeeze every one of Winsor and Newton's 117 listed oil colors onto a palette? If I suggested the best way to cook a chicken dinner was to employ every spice and condiment in your kitchen, you would laugh. The result in both cases would be a tasteless, mystery concoction void of any unique character.

I like to think of the multitude of colors available to the painter as a vast team of highly trained specialists, each possessing unique characteristics, each one ready and waiting to be called into action when needed, but seldom required in great numbers. Western painter and former illustrator Tom Lovell paints many of his pictures using only zinc yellow, vermilion, ultramarine and white. Because Lovell is intimately aware of the flexibility of each of these colors and how they interact together, his paintings appear rich and colorful. Portrait painter Clifford Jackson, on the other hand, prefers a regiment of twenty four colors, choosing to apply small, jewellike daubs of pure color to achieve an effect.

How, then, does a painter decide which colors are suitable for his particular tastes? The best way I know is to start with a red, yellow and blue. These could be neutrals like cadmium vermilion, cadmium yellow light and cobalt blue. They could also be a set of warm and cool colors, the warms being cadmium red light, cadmium yellow medium and cerulean blue, with the cools made up of alizarin crimson, cadmium yellow pale and ultramarine blue. Experiment with these three primaries and try different combinations, along with white. See if you can come up with an orange, purple and green.

Next, try to match the hues of the earth colors such as yellow ochre, burnt sienna, burnt umber and even black. If you find yourself becoming frustrated add some more colors to your palette like cadmium orange, permanent green light or viridian, a purple and perhaps a few earth colors.

With experience, color mixing will come more easily and you may even choose to eliminate a few colors. The important thing is to establish a comfortable familiarity with the colors you choose. It's also a good idea to occasionally try a new color. For example, replace viridian with Thalo green. If the results are successful, you'll have expanded your repertoire; if they aren't, you'll have learned an important what-not-to-do in future paintings. Either way, the practice will help to keep you out of a comfortable rut.

Palettes of the Old Masters

Another way of finding a suitable palette is to try experimenting with colors employed by painters of the past. I'm always fascinated by the differences and seeming contradictions of different painters' choices in this area. The following artists' palettes have been determined from either the writings of the artists themselves or museum analysis of their paintings.*

*I refer the reader to *Techniques of the Impressionists*, by Anthea Callen, published in 1982 by Chartwell Books. This scholarly work describes dozens of Impressionist paintings, intelligently analyzing them as to what colors, supports and brushes the artists employed.

Edouard Manet, 1832-1883. Although Manet, toward the end of his life, occasionally experimented with a brighter palette, his basic colors were lead white, zinc white, black, raw umber, yellow ochre, red earth or red lead, ultramarine blue, cobalt blue, viridian green and possibly cobalt green and chrome green.

Claude Monet, 1840-1926. Monet used a fairly consistent palette throughout his mature years, which included lead white, chrome yellow, lemon yellow, vermilion, cobalt violet, Prussian blue, cobalt blue, emerald green, viridian green and chrome green.

Camille Pissarro, 1830-1903. Pissarro's palette grew lighter and more colorful as he grew older. His early palette, strongly influenced by Corot's earthy sense of color, was made up of lead white, black, burnt umber, possibly sienna, yellow ochre, vermilion or red earth, Prussian blue and possibly cobalt blue, viridian green and chrome green. Pissarro's later palette included lead or zinc white, all the cadmium yellows, vermilion, red alizarin lake, cobalt violet, ultramarine, cobalt blue and most likely cerulean blue, emerald green, viridian green and chrome green.

Pierre Renoir, 1841-1919. Renoir occasionally varied his palette. The following colors are the ones he probably used most consistently: lead white, black, yellow ochre, Naples yellow, vermilion, red alizarin lake, cobalt blue, viridian green and possibly ultramarine, emerald green and chrome green.

Paul Cézanne, 1839-1906. Like Monet's, Cézanne's palette remained uniform throughout his mature years. His colors included zinc white, lead white, black, chrome yellow, yellow ochre, red earth or vermilion, cobalt blue, ultramarine blue, viridian green and emerald green. Other pigments possibly used were Naples yellow, Prussian blue and chrome green.

Prior to the 1850s, painters didn't have a wide variety of ready-made colors available. Diego Velazquez, for example, painting in the 1600s, is known to have worked with a palette comprised of only white, black, red, ultramarine and the earth colors.

Positioning Colors on the Value Palette

To help mix accurate color *values* (the lightness or darkness of your colors), you may want to lay out your paints on the graduated value palette shown on page 39 The accompanying illustration, Figure 6-3, shows the same palette with colors, rather than greys, squeezed out in their appropriate *value positions*. When mixing two or more colors it's a good idea to first make a test daub of the mixture on the desired value band to double-check the mixture's tonal accuracy. With experience, your eye will soon learn to judge a color's value; until then, an occasional test swatch on any one of the value bands can show you how light or dark the color is.

Figure 6-3 **A complete range of colors accurately placed on the value palette**

Value, Color, Intensity and Temperature

When painting a picture in full color, four basic considerations have to be made. The first deals with the value aspects of your painting. What sort of value arrangement do you plan to show? Will the painting be high, middle or low in key? Will the light source be strong or weak? What kind of abstract value pattern will be used to make the composition tonally interesting? Chapters 3, 4 and 5 discussed most of the tonal problems faced in picture making, and should have answers to any value difficulty you might encounter.

The second consideration is color. In this case, I mean the home color an object possesses before being struck by light rather than color in general. Prior to painting make sure you know the home color of the objects in your composition. Again, ask yourself some questions: Is the grass greenish blue or greenish yellow? Is the barn red or reddish brown? By knowing the home color of an object you'll find it much easier to alter its condition with whatever sort of light and atmosphere influences the subject.

The third consideration is intensity. What is the intensity of the colors in the scene at hand? Is the stretch of field in the foreground bright green or a grey green, and if greyed, how much? Intensity considerations are very important in achieving a lifelike quality in a picture. Surprisingly, nature gives us few pure-colored objects. Aside from flowers, sunsets and insects, most of the material found in landscapes is quite neutral in color. On the other hand, man-made objects such as bright-colored clothing, cars, boats and buildings can be quite intense at times.

The fourth and last consideration is temperature, which means the warmth or coolness found in the color of an object when illuminated by light. Moonlight, for example, cools the light side of objects with a greenish cast, and late afternoon sunlight warms a subjects's light passages.

Even artificial light has a color identity. Indoor lighting is usually warm, though not as warm as sunlight. Fluorescent light, on the other hand, tends to be a greyed greenish yellow in color. To emphasize a color's temperature, artists often mix some complementary color into the shadows. This not only gives a pleasing balance to the overall color scheme of the subject but heightens the intensity of the color in the light.

After painting a few pictures, consciously focusing on these four important elements, the principles will eventually become second nature and needn't be intentionally thought about again. Until then, however, paint each step thoughtfully, making sure you fully understand the purpose of each principle.

VALUE The lightness or darkness of an object.

COLOR An object's true color before being influenced by light.

INTENSITY The brightness or dullness of an object's color.

TEMPERATURE The influence of colored light on an object.

Watermelon
12"x16" oil on canvas.

 Artists often use fruit and vegetables as subjects for their paintings—probably because of their wide variety of interesting shapes, textures and colors. I emphasized tone rather than color when painting this picture, because the clear window light imparted a solidity that characterized the essence of the subject. My palette was limited to alizarin crimson, cadmium red deep, cadmium yellow pale, sap green, ultramarine and white. *Watermelon* was painted in one 3-hour session.

Collection of Tatiana Ledovsky, New York City

Complements

Matching the subtle atmospheric greys found in most subjects can be a challenge to any painter's prowess at mixing color. My solution to this ever-present challenge is to use complements rather than black to tone down a color. I find the resulting greyed mixtures not only yield cleaner, more alive-looking results but also grace the overall color scheme with a pleasing unity.

Here's my approach. Working with my usual palette which consists of warm and cool variations of red, yellow and blue plus a green, purple and orange, I quickly lay in a large mosaic of the subject's big shapes and patterns. Since most of these big shapes will be modified later I'm not overly concerned with a super-accurate rendition, but rather a more general, overall impression of the scene.

Next come the refinements. Let's say I'm painting a white building partially obscured by a large tree. My first impulse would be to set up a play of complements between the warm, orange lights and the purple blue shadows. For the shadow side of the building I'd probably use a grey mixed from white, orange, purple and perhaps a touch of blue to pick up the influence of the sky. The green in the tree's shadow will be mixed from a cool green neutralized with a touch of purple, nicely complementing the orange greens on the tree's light side. I'd also include a hint of orange on the light side of the buildings.

By using this kind of complementary color mixing your paintings will not only capture a feeling of colored light (the warm sun in this case), but the overall light and shadow patterns will smack of a rightness unobtainable any other way. Study the use of complements in the painting on the opposite page and notice that the colors, though considerably greyed, have a pleasing, luminous identity uniquely their own.

Alizarin Crimson
White
Ultramarine

Cadmium Red Light
White
Ultramarine

Permanent Green Light
White
Cadmium Red Light

Ultramarine
White
Cadmium Orange

Bond St.
15"x18" oil on canvas.

River Gallery, Westport, Connecticut

This is one of many pictures I've painted on location in New York City. Its rich diversity of people and neighborhoods has always attracted me. I spent three hours working on the spot and put in another hour in my studio simplifying a few bothersome areas. Because the light changed considerably in the three hours I spent painting, a good deal of the picture was really memory work based on my first impressions. The long cast shadow in the foreground, for example, had moved halfway up the side of the buildings by the time I was finished. Because the figures were based on quickly moving passersby, they too were painted from memory.

Color Temperature

Color temperature is the warmth or coolness of a color. Green with a little yellow mixed in becomes a warm green. The same green with a touch of blue changes to a cool green. Observing color temperature changes in your painting is important in achieving a lifelike, natural quality. Ignoring the color of light and its accompanying color changes on a subject is a big reason why many paintings lack color interest and vitality.

Figure 6-13

Study the three stacks of blocks in Figure 6-13. The first stack shows red, yellow and blue blocks. We know this because of their respective colors. The blocks appear solid because the values are correct, each shadow being two steps darker than the light. Each color was either darkened with black or lightened with white to achieve this effect. Although the blocks appear solid, they tell us nothing of the light shining on them. The effect is like an uninspired catalog illustration where the items appear solid yet lifeless.

The second stack of blocks, identical in position and values, appears different, more lifelike. This is because the color of the light, like the warmer sun in late afternoon, has been taken into consideration. The colors clearly show the change in temperature between the warm light side and the cool shadow side. Study the red block carefully and notice how the light side has an orangish cast, while the shadow leans toward purple.

By painting the subtle color temperature changes, we're able to capture the solidity of an object and give it a unique quality of existence. This is because the light striking the subject takes on an identity of its own.

Equipped with a knowledge of an object's color temperature, we are now able to paint whatever colored light we see or imagine shining on a subject. Observe the third stack of blocks. Here I've chosen a blue purple light which gives a mysterious and theatrical appearance to the blocks. Compare the red block in this stack with the one on the warm pile. This effect was accomplished by adding some purple to the light and some orange to the shadow.

Paint some simple still-life setups under different kinds of light. Start with obvious colored light sources like a warm table lamp or the cool natural light from a window. If you still have difficulty observing color temperature changes, get some colored cels or cellophane from an art store and position one of them in front of a light. The effect will be immediately obvious.

The theater and movies often use colored cels for capturing dramatic effects. Edgar Degas and Edward Hopper were frequent theatergoers for this very reason. Study as many different kinds of colored lighting conditions as you have access to and make notes on what effects were captured under what kind of lights. With experience, your eye will become sensitive to the many kinds of colored lighting, and a whole new world will open up with color changes becoming obvious in even the most subtle effects—your paintings, too, will begin to take on a new poetry.

Figure 6-14

Reflected Light

Reflected light can be thought of as a secondary light source caused by light bouncing into shadows from the sky or nearby light-struck objects. Reflected light is most easily seen when the light source is strong, and when the object reflecting the light is shiny or glossy. Glass, metal and silk will reflect a great deal of light. However, everything reflects light to some degree.

Study the illustration on this page. Notice the reflected light bouncing into the shadows of the statue. Because the white plaster is flat and absorbent, the reflected light is subtle and the value change slight. By comparison, the blue glass mug reflects a lot of light, as does the shiny paper of the book jacket. Care must be taken when painting reflected light not to overstate its value or color. If the reflected light is too light or bright, it will compete with the main light source, disturbing the illusion of solidity and causing the painting to take on a false, confusing appearance.

One general guideline is to keep even the lightest reflected light *darker* than any value in the main light areas. Remember, in paint we're limited to a dozen or so values applied to a flat canvas whereas the real subject might have a range of a hundred or more values! So interpret, don't copy.

Color changes in reflected light can be difficult and confusing. To simplify things, ask yourself what color is nearest the reflected light and how much it is influencing the color in the reflected light area. Notice in the above illustration how the orange cloth is receiving a lot of light and bouncing it into the shadows of the objects near it, whereas the green cloth beneath the objects is throwing light and color into the underside of the objects.

To capture the subtle effects of colored reflected light, mix equal amounts of the shadow color with the color reflected into it. Then lighten it slightly and soften the edges where they merge. The shadow created by the main source of light should still be the dominant touch. The ability to paint reflected light in your paintings is an important factor in creating luminosity and air.

The Influence of the Sky

A painter friend once wisely told me that it's important to think of *everything* as a reflector of light. When we apply this axiom to landscapes it is apparent that the sun and surrounding sky, indeed, give a scene many different color arrangements, not only daily but seasonally as well.

Water is the most obvious reflector of light in nature and a study of its light-reflecting qualities can prove endless. See Figure 6-15. However, other surfaces also reflect light. Study the landscape in Figure 6-16. Notice how the normally drab patches of mud, exposed at low tide, take on a shimmering character. Though these passages are not as light-reflective as the water, their moist, glossy surfaces can appear quite bright.

Less obvious, though equally important, is the treatment of the flatter matte surfaces of foliage. Observe the light side of the trees in Figure 6-17. Here I've mixed some of the warm sky color into the greens to identify the color of the sky and to give the trees a sense of belonging to the overall color arrangement. Corot once said the sky should be thought of as the dominant force when painting a landscape. When I painted both of these pictures I took Corot's advice and started by first establishing a few random notes of sky color to help me judge the other colors more truly.

Skies are fascinating subjects to paint, with subtleties of color and value that will tax every bit of ingenuity you have as a painter. Working on location is the only way I know of really learning to understand skies and their light-reflecting influences on a scene.

Even if you're a dyed-in-the-wool studio painter, spend an hour or so each week in painting outdoors. It will do wonders for your indoor compositions. Go outdoors occasionally and try your hand at painting a sky. I'm sure you'll be impressed with the wonderful reflective possibilities in the world above us.

Figure 6-16

Low Tide
12"x16" oil on Masonite.

Private collection

I couldn't resist featuring the dramatic cloud formations moving across the sky the evening I painted this picture. Because clouds change so quickly, it's impossible to do a detailed portrait of any one effect. To solve this dilemma, I usually paint, from memory, the effect that first impressed me. Notice how the color of the sky is reflected onto the wet mud and water. Although the image appears nearly mirrorlike, the values of the river are pitched slightly darker to accentuate the lightness of the sky.

Figure 6-15 **The sky's influence on the color of a landscape**

Figure 6-17

Boats on the Saugatuck
12"x16" oil on Masonite.

The River Gallery, Westport, Connecticut

After painting a so-so picture earlier in the day, I made a second trek to the nearby Saugatuck River in hopes of being more successful. The sun was fading fast, giving me about an hour and a half of painting time. After broadly laying in the important masses I quickly indicated whatever details I felt were appropriate and called it a day. I think this picture works fairly well, probably because I didn't have time to "think it out." Instead, I painted what I saw as quickly as possible.

Painting the Different Times of Day

Early Morning

Boatyard, South Norwalk
16"x20" oil on canvas.

Collection of the artist

The freshness of a new day makes it well worth the effort to rise at dawn. This picture was painted about 7:30 a.m. The sun was still low in the sky, weaving long and interesting patterns of light and shadow. Although the subject was not yet struck by the sun, the values in those areas still appeared light and high-keyed. This was due to the strong reflective light from the sky. When painting early morning, late afternoon or early evening pictures, try to maintain a predominance of either light or shadow. If they are equally distributed they tend to make the painting appear too symmetrical.

Noon

Skipper's Boatyard
16"x20" oil on canvas.

The River Gallery, Westport, Connecticut

Noon light gives little opportunity for interesting arrangements of lights and shadows. My solution to this problem is to stress the subject's color and value patterns. Notice the flatness of the boats and buildings. The harbor forms a simple silhouette against the sky. Because of the brightness of the sky, shadows at noonday tend to go lighter in value than earlier or later. Although this time of day doesn't lend itself to the rich effects of chiaroscuro, it does offer a chance to explore a flatter, more decorative approach.

Late Afternoon

Packroads
13"x16" oil on canvas.

Collection of the artist

When the sun is low in the sky and striking the subject frontally, not only are shadows minimized but the color of the light becomes warmer. To emphasize this, I usually paint my shadows cooler, mixing in small amounts of purple and blue. This also forms a pleasing complement to the oranges and yellows. Note that the sky in back of the buildings is darker than the light shining on the buildings. This is because the sun is coming from the opposite direction.

Early Evening

Dock at Peter's Bridge
20"x24" oil on canvas.

Collection of the artist

With the exception of a few slivers of sunlight catching the boats, rooftops and trees, the entire subject appears as a near silhouette against the early evening sky. The sun has almost set, giving the sky a warm, yellowish cast. Notice the edge treatment of the buildings and trees against the sky. Rather than paint this edge hard and knifelike, I intentionally softened it here and there to indicate some of the glare caused by the bright evening light.

Evelyn's Dock
11"x14" oil on Masonite.

Collection of Mrs. Jean Zallinger, North Haven, Connecticut

The last warm rays of the sun were fading fast when I painted this picture. Despite the rapid execution (the picture was completed in less than an hour), I took great care in trying to accurately record the subtle warm and cool variations of color in the scene. My palette included white, cadmium orange, cadmium yellow pale, sap green, cerulean blue, ultramarine and alizarin crimson.

Splish Splash
20"x24" oil on canvas.

This picture was painted from a photograph, and though the figure in the painting appears to be a child, my model was really a middle-aged woman. I'll often change a figure's age or appearance to suit my compositional needs. In this case I felt the warm afternoon light shining on a child conveyed the mood I was after far better than depicting a light-struck adult. Remember—your paintings are seldom judged by how accurately you copy a subject; rather, it's the qualities of light, mood and expressiveness that make a picture count.

Warm Afternoon Sunlight

Moviemakers like to call the late afternoon light "magic time." I call it the best time of the day to paint. Why? Because, to me, the light at this time of day is at its most poetic position. While tints ranging from pink to orange reveal light-struck passages, luminous purples and blues, reflected from the sky, dance in the shadows. The cinematographers are right: Even a depressing slum can take on an inviting, never-never-land quality.

Another bonus of late afternoon light is the fascinating shadow patterns caused by the low position of the sun. While interesting shadows can also occur in early morning, it's only in the late afternoon that the unbeatable combination of long, revealing shadows and warm, luminous color merge to create the most intriguing effects.

The Impressionists were probably the first artists to take advantage of this magical time of day. Spanish painter Joaquín Sorolla devoted practically his entire life to chasing after these effects.

The negative side of afternoon light is the

The Douglas Gallery, Stamford, Connecticut

speed with which it moves. One of the most frustrating things about painting this time of day is seeing the light grow ever more beautiful as the sun dips toward the horizon. Trial and error have taught me to allow no more than two hours maximum for a particular effect. If a painting is started earlier, the light is cooler and less interesting. Some artists, however, do start early and intentionally pitch their colors warmer, counting on the sun to warm up later in the day. I've always found this risky business, but if you can pull it off without losing the effect, by all means do it.

Another way around this predicament is to paint small, twenty- or thirty-minute studies only and go after the essentials. For me, catching the light at this time of day is an end in itself. You, on the other hand, may choose to do a more finished composition in your studio using small paint studies as reference. Either way, location work is indispensable.

123

Chip
14"x18" oil on canvas.

Collection of the artist

I used the direct approach in painting this picture. My son, Chip, was itchy to go out bike riding and I knew the painting session would be a short one. Because light was coming from windows on either side of Chip, I lightened up the right side of his head to give the portrait some added interest. This is essentially a cool painting in that the light from the windows was from an overcast sky. Because of this I used a cool palette which included white, alizarin crimson, cadmium yellow pale, Thalo blue, viridian, black and white.

Portraits and Figures

Painting people from life, either privately or in sketch classes, is an excellent way to improve your observation of the subtleties of color and light. All of the paintings on these two pages were done in sketch classes with no more than two hours spent on any one.

Notice the variety of colors flesh acquires under different lighting conditions. The two sketches on the bottom of this page were painted on a pretoned surface, overpainting thin washes in the shadows and complementing them with thick, impasto strokes in the lights.

The portrait sketch of my son Chip, on the opposite page, and the model wearing the oriental outfit, were painted on a white canvas. Both were built up with a mosaic of swatchlike colors placed side by side.

If you don't belong to a sketch class or have a willing model available, set up a mirror opposite your easel and practice doing self-portraits. The old masters frequently did this. The experience will not only make you a better figure artist, but surprisingly, improve your skills in landscape and still life as well.

Lorette *Collection of the artist*
14"x18" oil on Masonite.

Lorette and the other two figures shown on this page were students of mine who all posed for an informal sketch class held after school hours. The frustrating part of this painting was trying to match the brilliant Chinese red on Lorette's jacket. I ended up using pure alizarin crimson for the shadows and cadmium red vermilion for the lights.

Chuck *Collection of the artist*
16"x20" oil on canvas.

Although this picture appears to be inside a men's club, it was really an elaborate setup in a classroom. I toned my canvas a cool red to give the thinly painted shadow passages some added vitality. The rest of the picture is more or less opaque.

Nick *Collection of the artist*
12½"x17½" oil on Masonite.

Here's another classroom setup. This time a cool fill light was used to give the shadows some added interest and mood, and also to set up a pleasing complement to the orange main light. This picture falls into the edge light category, with the main light bleaching out even the darkest home values.

The Spirit Shop
10"x12" oil on Masonite.

Collection of Mrs. Donna Hair, Dallas, Texas

Although this street scene appears quiet and deserted, it was painted on a busy Saturday afternoon. Rather than disturb the lonely charm of the building, I intentionally omitted the many cars and people bustling about. A light rain had just let up, imparting to the whole scene the richness of freshly varnished wood. Notice how the few swipes of palette-knife work on the tree in front of the shop form a pleasing textural balance to the other, more broadly painted areas.

A Sense of Place

It wasn't until I happened on to a copy of Alan Gussow's evocative survey of American painting, *A Sense of Place*, that I really began to understand the special quality inherent in every landscape. Prior to this I had been painting landscapes with a certain detached generality, many times missing a subject's subtle character. While I usually caught the desired lighting effect, my paintings lacked a uniqueness of place.

I found I was painting more what I wanted to see than what was really there. Gussow's book taught me to approach a subject with more reverence, and studying the examples shown—Hopper, Charles Burchfield and Porter among others—I quickly saw the almost portraitlike sensitivity with which these artists approached their subjects. The results were not only a revealing sense of place but a successful aesthetic marriage between objective observation and personal response.

Tune yourself in to what you're painting, catch the light, but don't forget the unique character of what it's shining on.

The Bridge to Gorham Island
14"x18" oil on canvas.

The Douglas Gallery, Stamford, Connecticut

I've done many paintings of this bridge, particularly when the tide is low and the rocky edge of the shore takes on a more interesting character. While this painting is a near portrait of the bridge and its surrounding area, it's also a reasonably accurate recording of the light at the time of day I was painting. When both of these factors work together, as in this painting, a completeness occurs which, to me, is the difference between a picture's success and failure.

Saturday Morning
24"x28" oil on canvas.

Collection of the artist

 This large painting was completed in one intense three-hour session. Sunlight was shining through the window at just the right angle and I wasted no time in trying to catch its unique effect. A limited palette was used including white, alizarin crimson, burnt sienna, yellow ochre, cadmium yellow pale and ultramarine. Most of the greys were made from mixtures of burnt sienna, ultramarine and white. The floor, lamp and table were all mixed from variations of burnt sienna, alizarin crimson, ultramarine and white.

Color Expressiveness

Expressiveness is the bottom line not only in color but in all other art forms as well. Unfortunately, it's also one of the most difficult aspects of art to teach. My experience has been that no matter what kind of color sense an artist possesses, if the treatment of the subject is expressive, the painting will usually possess some degree of quality. Because no two individuals "see" color identically, it's impossible to set up any preconceived standards of taste. How, then, do you, as an artist, best impart your particular color gifts to a painting? The answer is to stress your strong points, work on your weak ones and paint with confidence.

Let's say you're essentially a value painter who takes much more delight in modeling the subtle tonal planes of an object's surface than in pursuing some innovative color effect that stresses shapes and patterns. My advice is to use a simple five- or six-color palette, even premixing the colors into different gradations of values. By so doing, you'll relieve yourself of the double responsibility of worrying about both color and value. Granted, you may not achieve the lightness and airiness of color inherent in a painting by Monet, but you will be able to fashion a perfectly adequate color arrangement which can effectively complement your preference for a sophisticated value treatment.

John Singer Sargent was not a profound colorist, but his values are so sensitively modeled that one is seldom aware of any lack in color expressiveness. If your forte is color, you may choose to underplay values in favor of striking color effects, perhaps using broken color applied in small bright daubs. Alfred Sisley is a good example of a strong colorist who stressed his assets by modeling his forms with color changes rather than value differences.

Whichever way you choose, you'll be further ahead by building a style based on your strong points, which in turn fortifies your confidence. Now the only stumbling block holding you back is the degree of expressiveness with which you apply color and paint.

At this point a delicate balance needs to be exercised, with confidence on one side and humility on the other. Too much confidence can reduce your work to a facile performance void of your true feelings about the subject. Too much humility, on the other hand, can tend to freeze your gut reactions, resulting in the subject overwhelming you to the point of reducing your picture to an impersonal statement of facts. It's up to each individual artist to find his own balance, and the best way to do that is to paint a lot of pictures.

Color expressiveness, however, shouldn't be thought of as a consistent trait. There are painting sessions when I feel I hover maddeningly close to success, then, during the last minutes of completion, the result turns sour. Other times I feel a picture building up in more or less mediocre fashion and suddenly, after putting in a few final intuitive touches, end with a real jewel. Finally, there are those dreamy days when my brush seems to have wings. From the first stroke to the last, with feeling and accuracy, I record just how I felt about the subject.

It's these days, few though they may be, that make painting worthwhile. And it's for times like these that I'd like to reassure you not to get discouraged. Paint confidently, humbly, and as expressively as you know how, and as sure as there are caps on paint tubes, you'll eventually be painting your share of winnners.

Chapter 7

Interpreting What You See

We've all taken photographs of scenic locales. The wind is blowing up whitecaps, gulls are squawking and the whole atmosphere is filled with freshness and vitality. You're glad you caught it all with your camera. Or did you? Later when viewing such pictures, how often it seems that something was missed. The dark storm clouds that at one time pushed angrily down on a small fishing village now appear tame and lifeless. The wrong buildings assume importance. The mood you felt is absent. Whose fault was it? you ask. The photographer's or the camera's? I used the wrong kind of film, you think to yourself. There's a good chance none of these factors was to blame.

The real culprit was probably in thinking the camera would interpret your feelings about the subject, and unfortunately, that's impossible. A camera only records facts, and unless you want to go through the rigorous training of becoming a professional photographer, don't expect anything more. Rather than having some friends over for a slide show of a recent trip, imagine showing some on-the-spot paint sketches of the same scene. Though the technique may not be polished and the perspective may be a little off, the enthusiasm you felt about what you saw would have a lot better chance of being communicated.

Your personal point of view is the most valuable asset you have as an artist and should be cultivated with attention and care. One problem beginning students have is the preconceived idea that if they can parrot the style of artists they admire, they, too, will be great artists. Granted, a good bit of knowledge can be gleaned from the study of other painters, but the real measure of an artistic success is how clearly an artist can express his own point of view. This takes not only nurturing but determination as well.

While visiting the small town of Truro, on Cape Cod, I was taken with a statuesque old lighthouse and decided to paint it. No sooner did work begin than an eerie sense of déjà-vu struck me. I then realized that Edward Hopper painted that very lighthouse years before. My first reaction was one of intimidation. The vivid image of Hopper's painting was hard to push from my mind. I continued working, however, trusting my senses, and soon the challenge of the subject itself again preoccupied my thoughts.

My finished painting, aside from the motif itself, had no resemblance to the Hopper painting. I depicted what I saw and felt, and though it's doubtful that my rendition will ever hang in the Metropolitan Museum alongside of Hopper's, I came away from the painting session feeling a sincere sense of satisfaction in painting a scene that moved me.

How does one go about discovering one's own point of view? The answer is by painting. The more you paint, the faster growth and maturity will develop. I spoke earlier about trusting your sensations. One way to become receptive to these sensations is by painting what interests you. Tag the qualities of life that move around you daily and ask yourself which you most enjoy. Perhaps they're hobbies, pastimes or even occupation-oriented subjects. Let's say you're a computer programmer and really enjoy the challenge of fusing together various kinds of technical data.

Pictorial ideas might be gotten from simply rummaging through junk shops collecting parts of old radios and phonographs and arranging the items into a pleasing still life. There's a chance you'll not only catch some of the nostalgia of a past technology but also feel a satisfaction in painting a subject you know and care about.

If you're the gardening type, you need go no farther than your backyard or tool shed

Jeanne
10"x12" oil on canvas.

Collection of the artist

This picture was painted using only a palette knife. I employed the flat side of the knife for broad areas such as the foliage, ground and building. The edge and tip of the knife were used for details on the figure and branches. This is a good example of what the French Impressionists called equalized surface tension, a technique in which paint is applied in similar daubs or strokes. The result is an overall feeling of unity with the total, atmospheric effect of the picture assuming importance over any one part.

for subjects to paint. The important thing is to start with subjects you care about.

Perhaps you already have a favorite place you like to paint. It could be a picturesque old alley or maybe a rocky mountain stream. The next time you go there, ask yourself just what it is you like about the place. If it's an old house, overgrown with weeds, it might be the rich array of textures that intrigues you. Or you may have walked by one day and saw a small child playing on the run-down porch, and were taken by the contrast between the small fragile child and the large, looming building.

It could be a view of the scene observed while driving by on an overcast day with the wind slapping the front door back and forth, evoking memories of Halloween or a childhood apprehension of an approaching storm. Each of these scenes might have moved something within you. To paint any one of them successfully requires your personal interpretation. It takes more than a recording of the facts to infuse your pictures with life.

131

Choosing a Point of View

Before I begin to paint, I find it a good idea to walk around my subject whenever possible, to see what view clicks intuitively with me. Many times a subject can look uninspiring when seen from one angle yet become alive and interesting when viewed from another. The sketches of the old Model T truck on these pages show the same subject viewed from several different angles. I believe the view I chose to paint shows the old truck at its noblest, a reminder of an age when man-made objects had warmth and character. I was moved by this old relic, and the view I chose best summed up my feelings. Did I choose the right view? For me, yes—for you, maybe not. These kinds of choices are what make a painting personal.

One thing I try to do when confronting a subject is to forget all the reading I've done on how a picture should be composed. Those well-meant rules can make for a regular jungle of confusing and conflicting thoughts. Rather, I try to push all preconceived thoughts from my mind and see, feel, smell, even touch and listen to the subject. By clearing my mind and seeing like a child I can begin to get to my most basic reactions.

Andrew Wyeth once said he wished he could see the world around him through the

eyes of his dog, Rattler. Wyeth was saying the same thing; your intuition is your most valuable tool, and each one of us has this gift—all we need to do is develop it.

Once a painting is started and various problems begin to arise, my inner conversation might sound something like this—"Why isn't this passage working?" Stepping back from the painting I discover why: "The shapes of the light and shadow are equal, that's why, and that's not good design. I'll emphasize the light side and make the shadow smaller and less important." Or "There's too much texture, my subject is getting lost in it. I think I'll play down the weeds to give emphasis to the rusty old metal."

You'll be happy to find that when a problem arises in a painting, you can usually solve it by this same kind of question and answer dialogue with yourself. All those rules and principles you studied aren't wasted after all. Like any tool, theories should be used when a painting isn't working, to help you find out why, rather than dictate what you paint. Filled with rules and theories, our minds can usually get us out of most any painting predicament but it's our hearts that make a painting come alive.

What You See Is What You Paint

Sound reminiscent of a camera advertisement? This catch phrase, however, also applies to the way an artist sees a subject. We all see differently at different times. Heights of stairsteps and street curbs are seen in inches and feet; an approaching friend on the street is recognized by his unique body shape, gesture and coloring. Vision can be as varied as the individual doing the looking, and this uniqueness can be one of the artist's most valuable assets.

To show how individual seeing varies, let's conjure up a make-believe art class. All the people in the class are employed in different occupations. There's a carpenter, an interior designer, a rug salesman, a young mother and a retired dancer. The class is given an assignment to paint a picture of a stairway. Size and choice of medium are up to the individuals. Though we all see a staircase as a construction of given height and width, to walk up or down, the paintings in our imaginary class might prove there's more to a staircase than meets the eye.

The carpenter will most likely see the staircase as a piece of construction. His painting will probably be solid and the perspective reasonably accurate. His color might not be exciting and his execution will probably favor precision over spontaneity.

The interior designer's painting might also have a good feeling for construction but this will probably be underplayed in favor of interesting color and value patterns, with perhaps a stylish rug added to give some flair to the composition. The handling of the medium will no doubt have a freshness, giving the subject a clean, new-looking quality.

Our friend the rug salesman might take still another point of view. Working with the soft fabric of rugs, he may well impart a sensualness to his painting. The stairway, carpeted of course, will have a carefulness about it, especially with regards to the rug, which will no doubt be a specific style and color with textures painstakingly rendered. The perspective might be inaccurate and the overall composition less than pleasing because of finicky detail.

The young mother might bring some drama to the stairway. Her association could be one of events rather than styles or materials. Her observations might focus on interesting light and shadow patterns or a less conventional point of view, simply because her experiences with a stairway are more emotional than factual. A stairway, through her eyes, might well be seen as a potential danger to her young child or a drudgery to walk up and down too many times a day. This, in turn, might give her painting a more personal quality. Although the perspective may be lopsided and the color unrealistic, our young mother's painting will probably have a great deal of life and feeling in it.

The retired dancer might also lean toward the dramatic possibilities of the stairway. Her painting could have a theatrical quality, with the stairway seen from the point of view of one who has spent time on stage—one who is less concerned with the construction of things than with their visual interest. The retired dancer's color might also have a make-believe quality, stressing mood over accuracy in her lighting and perspective.

Here are five people who probably walk up and down stairways every day, yet how interesting it is when they all paint a picture of the same subject, interpreting it through their own eyes. How do you see? Experiment in seeing everyday subjects differently, tap your experiences and feelings, and learn to see life through your own fresh vision. A whole new world of picture possibilities could become available to you. Take some time, think about what you do, your background and experiences and how *you* see stairways and landscapes, objects and people, because what you see is what you paint.

The Douglas Gallery, Stamford, Connecticut

Charles St.
20"x24" oil on canvas.

New York street scenes, be they busy intersections or quiet side streets such as the one shown here, have always fascinated me. My palette was limited in this painting and included only alizarin crimson, cadmium red deep, cadmium yellow pale, Thalo blue, ultramarine, black and white. The old stone steps and brick walls of the buildings were mixed from combinations of cadmium red deep, cadmium yellow pale, ultramarine and black. I intentionally muted these colors to catch the wonderful old patina the structures proudly displayed. While the light shining on the scene appears to be overcast—I painted the picture about 5:00 in the afternoon—the sun was actually below the background buildings, giving a pleasing touch of warmth to an otherwise cool color scheme.

Gathering Reference Material

Sometimes it's impossible to complete a painting on location. Unpredictable factors such as rain, changing lighting effects and busy, crowded streets force the artist to look for alternative ways of capturing a scene. The following methods are some of the ways painters use to get around these problems.

Reference material can take the form of pencil sketches, paint studies, photographs or even written notations describing a scene's particular color or ambience. When gathering such material, try to keep in mind your initial attraction to the scene. Perhaps it was the lazy back-and-forth nodding of an old oak tree or the poetry of a pavement reflecting some colorful storefronts.

The choice of medium is up to you. You can make charcoal sketches in the form of overall tonal impressions or linear gesture drawings with a ball-point pen. Andrew Wyeth likes to make carefully detailed pencil drawings of his subjects prior to painting them. Don't be afraid to work over these detail drawings until the information is clear enough to be easily translated back in the studio. Paint sketches can record color and fast-moving lighting effects. Avoid finicky detail when painting these sketches; instead, go for the broad areas of tone and color, exaggerating, if need be, a particular effect to help you better understand it.

Photographs can be useful in recording details, catching action and providing a factual record of the scene. Of all the reference-gathering methods, however, I find photos the most difficult to work with, and I'll have more to say about this later on. Next to your sketch, you can make written notations about the subject's texture, character or mood. Some painters actually prefer written notes over drawings or paint sketches, claiming words are a better help to trigger forgotten images.

Methods can also be combined. A painting can be started on location, worked on until the light changes or difficulties arise, then completed from memory, back in the studio. Landscape painter Paul Strisik likes to work this way. The combinations are seemingly endless. A painting can be started on location, taken back to the studio to work out difficult passages and then hauled back to the scene for a second, finishing-up session. Ray Kintsler frequently uses this approach. Or a painting can be developed in the studio from sketches and photos and finished on location. Whatever single way or combination of ways that works for you is the one to use.

I like working entirely on location and prefer finishing the painting in one sitting. The consistency and rhythm of a single performance appeals to me. I can never quite regain the same feeling about a subject when returning the following day or week. When this kind of frontal attack comes off, the painting usually sings with vitality. When it doesn't, I either scrap the painting and start a new one or return to the scene the following day, try to snare a new sensation and start fresh. When I do use reference material, I usually start and finish the painting indoors.

If your technique is careful and precise, requiring many hours to complete a picture, much of your time will probably be spent in the studio. If this happens to be the case, your preliminary, on-the-spot sketches and paint studies should be especially free and expressive. Refer to them frequently—they'll help you remember the lifelike quality of the

actual subject. At all costs avoid falling into the rut of sitting in your studio day after day, copying photographs. Keep some kind of hand-done reminders of the way the scene struck you, how you felt about it and just what sort of artistic statement you're trying to express.

Think about and evaluate the different types of reference material I've mentioned here. Even add some of your own. You might construct cardboard models, as Edward Hopper and Maxfield Parrish did, to help visualize the different patterns of light and shadow on buildings. Painting a picture is no easy matter and the artist can use all the help he can get.

Photography and the Artist

When French physicist Joseph Niepce made the first photograph in the 1820s, it's doubtful he realized the many ripples it would cause later in the art world. After his partnership with Louis Daguerre, a set designer and also a physicist, photography was off to a running start. Painters greeted this new discovery with mixed reactions. Their first responses were of amusement, dismissing the strange-looking box that produced black-and-white pictures as a passing novelty. When the novelty didn't go away, the snickers turned to threatening frowns, particularly among the strict academicians of the day, whose choice of subjects and lighting the photographers were imitating. Soon painters resigned themselves to this new phenomenon and a few of the more visionary members of the community began to see photography as a possible friend rather than foe.

Such painters as Eugène Delacroix and Edgar Degas began experimenting with photographs as possible aids in picture making. Later Edouard Vuillard, Egon Schiele and Alphonse Mucha among others began using photographs quite extensively as reference material. Even Monet was known to have toyed with photography. In America, Winslow Homer and Theodore Robinson joined the group. In Philadelphia, Thomas Eakins, inspired by the action-sequence photos of Eadweard Muybridge, experimented with similar sequences of moving figures and animals to help him visualize movement. By the early 1900s, photography had become an admittedly useful tool for the artist. Still, most painters felt a twinge of embarrassment over using photographs and usually kept their camera well closeted when not in use.

Today, this self-consciousness has greatly diminished. The second half of the twentieth century's bombardment of increasingly sophisticated technical aids has made the camera as commonplace as the automobile and television set. Cameras are easily affordable and more and more people are using them—artists included. Contemporary painters, particularly the photorealists, have not the slightest blush about working exclusively from photos.

All this technical progress has brought mixed blessings to the art world. Its advantages include the easy gathering of reference of even the most difficult subjects. With a push of the finger it's now possible to record fast-moving sporting events and animals in motion. Even underwater scenes can be photographed with relative ease.

The other side of the coin, however, is that artists seem to be forgetting about the other, more demanding types of reference gather-

ing. On-the-spot sketches and paint studies, though given lip service among artists, are becoming quaint, old practices of the past. The painter today tends to work less from impressions gleaned from direct observation and more from sharp photographic images viewed in the sheltered comfort of the studio. I'm not saying the camera should be thrown out and artists employ only methods used prior to 1850. Rather, I believe, photography should be lowered from the pedestal it now occupies, and regarded as just another tool for the artist in the gathering of material.

Let's now discuss the camera itself. If you can afford only one camera, a 35 millimeter, preferably with a built-in light meter, is, by far, your best bet. This compact little engineering masterpiece can shoot either slides or prints, color or black-and-white. A wide range of film is available in speeds as slow as ASA 64 or as fast as ASA 1000. This kind of latitude in film gives the photographer the flexibility of being able to catch virtually any lighting effect, be it a soft, candlelit interior or a crowd-filled stadium at night—and all without having to resort to a flash attachment. Because the primary aim here is to record either natural or artificial lighting, the use of the flash should be eliminated. Even if you have one, avoid using it because its glaring frontal lighting wipes away any evidence of the very effect you're trying to catch.

Painting from photographs can be a real challenge. No matter how sensitive the film, it seldom picks up the subtle tones and colors seen by the human eye. Shadows, in particular, seem to go too dark, with the color, in many cases, appearing dirty and washed out. In the lights, the reverse is true. Colors often appear too bright. Skies, for example, can take on such an intense blue that the effect is one of a brightly painted backdrop rather than a spacious atmospheric expanse. Halftones seem the most difficult to catch. It seems either the halftones merge too closely in value with the lights or they get lost in the shadow edges. An on-the-spot painting of a previously photographed subject will quickly reveal these faults.

Another problem to be faced is the distorted perspective, particularly obvious in long rows of buildings or other large receding objects, inherent in most camera lenses. Because human beings see a subject through two eyes, the objects viewed take on a three-dimensional quality. The camera, however, has only one eye, which makes it hard to figure out the depth of objects as they recede into the distance.

Knowing how to draw, and understanding the value and color limitations of paint, can go a long way in helping to overcome these difficulties, thus enabling you to *use* the photo you're working from rather than be at the mercy of the camera's inconsistencies.

All things considered, photographs can be a great help to the painter, giving him fresh points of view, access to fleeting effects and a means of documenting complicated facts that might take days of drawing to record. Learn to use your camera well, but don't underestimate the power of your sketches and paint studies, for it's only by this kind of direct eye-to-eye confrontation that a subject will yield to the artist and show its true essence and spirit.

Interpreting a Photograph

Sky darkened to give whiter, crisper appearance to the rooftops.

Contrast in chimney played down to better harmonize with middle ground values.

Cloud formation shows viewer there's space beyond the buildings.

Wall dissipates slightly to darker value to prevent viewer's eye from being led out of picture.

Dark values limited to foreground.

Figure added to give composition a center of interest, with lightest light and darkest dark saved for this area.

Light and shadow patterns simplified and cars eliminated to quiet surrounding busy areas.

139

Gorham Island
14"x16" oil on canvas.

The Portfolio, Stamford, Connecticut

 I had painted a larger picture on location earlier in the day and was all set to wash out my brushes when I noticed the beautiful effect the lower position of the sun was having on a nearby patch of landscape. My main interest in doing this painting was in capturing the subtle warm and cool greens of the trees and foliage. Surprisingly, all the greens I used were mixtures of cadmium yellow pale, cadmium yellow deep and cadmium orange with Thalo and cerulean blue. Had I chosen to use a tube green, the effect might have been brighter, but I doubt if my color scheme would have been as pleasing and harmonious.

Fact or Fancy?

Light can offer the painter countless ways of expressing a mood, and it's interesting to observe the different paths artists take in turning that fascination into an expressive, personal statement. Most artists generally fall into one of two categories: painters of fact or painters of fancy.

Vermeer, Monet and Sargent could be classified as painters of fact. These artists seldom strayed from the visual effects of the scene before them. This opinion is verified by a reply Sargent once gave to a prospective client who wanted an angel painted for an altarpiece. The artist's answer was, "How can I paint an angel if I've never seen one?" It might seem surprising that I chose to categorize Monet as a factual artist. Under the casually applied daubs of paint and effervescent color effects, however, lies an unerring eye, intent on recording the exact lighting effect that was before him. Cézanne once remarked, "Monet is only an eye, but what an eye."

To me, Degas, Vuillard, Andrew Wyeth and Fairfield Porter are good examples of painters who use light in a more fanciful way. But, you may say, why include Wyeth, who paints so realistically that his work appears almost photographic? Although the style in which Andrew Wyeth executes his finished tempera paintings is careful and precise, the artistic license he exercises in changing or emphasizing naturalistic tonal effects to suit his mood makes his work much more an imaginative statement than a factual one.

I recall reading an article on Wyeth which confirms my opinion. In the article, Wyeth talks about being intrigued with a jagged, overturned tree stump lit by sharp morning light. As the painting progressed, Wyeth said he began to feel increasingly intense about his subject. As the picture neared completion, he realized the shape and attitude of the stump reminded him of a mean, barking dog. He then recalled that when he was a boy he was chased by such a dog. Here's the case of an artist using his long-forgotten feelings to imprint his subject with a dramatic and imaginative mood.

Had the artist not sympathized with his feelings, the painting may have turned out to be just another factual recording of a harshly lit stump. By letting his imagination take a flight of fancy, the artist gives us a revealing glimpse, via the stump, into himself. We all have such remembrances. To paint them, all we need do is keep open and receptive to life around us.

How do you react to certain subjects? Is the factual recording of a scene before you motivation enough for a painting? Or do you see the naturalistic appearance of things as only the first step in developing your own imaginative variation?

Chapter 8

A Variety of Techniques

Technique means the way an artist expresses himself. It can also mean the methods and tools an artist uses while working. The painter today is fortunate in having countless tried and proven techniques and methods from the past from which to draw upon. Methods like palette-knife painting, sharp-focus realism, combinations of thick and thin paint, montage, using multiple images in mixed mediums, not to mention the myriad of effects possible with pastels, pencils and ink. Some painters even overlap mediums combining photographs with drawings or paintings. Today, literally anything goes.

While there were always exceptional people throughout the history of art who used innovative methods, generally techniques and methods went along more or less predictable patterns until the 1850s. Prior to that period, painters stayed within the confines of the procedures popular during their day. Pre-Renaissance painters, such as Giotto and Masaccio, were limited to chalk drawings, egg tempera paintings on panels and fresco. However, some early artists, such as Albrecht Dürer, found more mediums to explore. Dürer is noted for his watercolors and woodcuts as well as temperas and frescoes. Canvas did not become the common foundation for oil painting until the fifteenth century. The English portrait school and others of the 1700s painted with similarly slick brushwork on canvas. The French academy of the 1800s also favored canvas. The revolution brought about by the Impressionists also ushered in a new age of experimentation. Degas, one of the first artists to utilize unconventional techniques, devised a method of steaming his pastels to soften them, making the sticks more malleable and oillike. Later, Vuillard experimented with distemper, a technique employing aqueous paints made with a glue-size or casein binder.

Soon artists were trying to paint their pictures with everything under the sun. In the early 1900s Pablo Picasso and Georges Braque incorporated real pieces of cloth and wood into their paintings. In the 1920s some of the Dada painters like Marcel Duchamp used only actual objects for their art, and dispensed with paint and brushes entirely. The 1940s brought Jackson Pollack and the drip school. By the 1960s every conceivable method of making an artistic statement seemed to have been tried.

All this exploration can be said to be both healthy and harmful to today's artists. Healthy, because of the rich heritage of methods now available for painters to draw upon and be inspired by. Harmful, in that, like the child in the candy store, the artist is avalanched with influences, often finding them confusing his own natural form of expression.

Because this book concentrates on painting light, techniques will be limited to those compatible with that aim, with exotic methods left up to the individual. I've grouped the mediums used for various techniques into two areas: wet, which are oils, acrylics, casein, transparent watercolor, gouache and inks; dry, which include pastel, pencil and charcoal. The methods listed are meant to be a basic starter kit and can easily be elaborated upon if the technique is found appealing. It's always adventuresome trying new methods but don't feel you have to go overboard. Rather than purchase a complete set of colors, pick up a few basic colors, try them, and if they work for you, buy more.

Wet Mediums

OILS	Eight basic colors: alizarin crimson, cadmium red light, cadmium orange, cadmium yellow light, yellow ochre, permanent green light, Thalo blue, ultramarine, black and white. Turpentine or paint thinner, a medium, a palette, a painting knife, half a dozen bristle brushes of various shapes and sizes, one or two small sable brushes, cotton canvas, prepared gesso panels and rags or paper towels.
ACRYLICS	Eight basic colors (see oils), black and white, acrylic medium, a palette, half a dozen nylon brushes of various shapes and sizes, one small sable brush, cotton canvas, prepared gesso panels, illustration board and rags or paper towels.
WATERCOLOR	Eight basic colors (see oils), black and gouache white, three or four different-sized sable brushes, a sponge, a razor blade, a palette, two or three different surfaces of watercolor paper, rags or paper towels and a large water container.
CASEIN	Eight basic colors (see oils), black and white, two or three sable and two or three bristle brushes of various shapes and sizes, a palette, prepared gesso panels, illustration board, rags or paper towels and a large water container.
GOUACHE	Eight basic colors (see oils), black and white, three or four sable brushes of various sizes, a large bristle brush, a palette, rags or paper towels and a large water container.
INKS	Six basic colors: red, yellow, blue, orange, green and violet, black, gouache white, three or four sable brushes of various sizes, a pen holder, four or five different-style pen points, a palette, two surfaces of watercolor paper, bristol board, illustration board, a large water container and rags or paper towels.

Dry Mediums

PASTEL	Either a boxed set of twenty-four sticks or at least a dozen various colors, black, white and two or three greys, four or five sheets of white and tinted pastel paper, a few yards of brown wrapping paper, a kneaded eraser, a razor blade and rags or paper towels.
PENCIL	Six pencils of varying degrees of hardness and softness, a kneaded eraser, an erasing shield, two sheets of smooth and two sheets of kid-finish bristol board, a sketch pad and a tracing-paper pad.
CHARCOAL	Six sticks of charcoal of varying degrees of hardness and softness, a charcoal pencil, a black and a colored conté crayon, a few sheets of bristol board, illustration board and a newsprint pad.

Preparing Panels

While canvas is the most popular support for oil and acrylic painting, prepared panels can often provide not only a refreshing change of pace but also give the artist a chance to experiment with a less conventional surface. Some painters have mixed feelings about panels, generally agreeing on their portability and low cost, but they dislike the slippery way paint strokes tend to skid over the surface. Accustomed to the flexible give of stretched canvas, they also dislike a panel's rigidness. Most painters limit their use of panels to small paintings and studies, with 16x20 inches being about the maximum size most commonly used.

Panels can be made from either Masonite, Upsom board or plywood. Untempered Masonite, 1/8 or 1/4 inch thick, is the most popular of these surfaces because of its permanency and manageability. Plywood, though permanent, is less frequently used owing chiefly to its heavier weight. Upsom board, while perfectly suitable for sketches and studies, is impractical for permanent painting because of acid in its chemical makeup.

A panel can be prepared in two ways. The first entails covering the board with a rabbit skin glue sizing, followed by several coats of gesso made from a mixture of glue and plaster of Paris. This method is chiefly employed by traditional egg tempera painters and has been largely replaced by the quicker, less messy acrylic method. With acrylic gesso, no sizing is necessary. The artist simply covers the panel with one or two coats of gesso and the surface is dry and ready to use within a few hours. Anyone interested in more detailed information as to the specific proce-

Figure 8-1 **GESSOING A PANEL**

dures in applying glue sizing and gesso can find precise recipes and methods in Ralph Mayer's *The Artist's Handbook of Materials and Techniques* (Viking Press).

Acrylic priming requires the following materials: acrylic gesso, a three- or four-inch house painter's brush and a sheet or two of fine grade sandpaper. If a highly textured surface is desired, you'll also need a large palette or painting knife and some acrylic modeling paste.

While some painters apply as many as five or six coats of gesso to their panels, I find two coats, applied generously, to be quite satisfactory. My usual procedure is to brush on the first coat in a horizontal direction and the second coat vertically. This even crisscrossing of coats gives the surface a pleasing canvaslike texture which I find a delight to paint on (Figure 8-1).

For a smoother surface the gesso priming can be sanded after each coat to a bone-smooth finish (Figure 8-2).

A rougher, more irregular surface can be imparted to the panel by adding a moderate amount of acrylic mdeling paste to the gesso and applying the strokes in a more swirling, haphazard fashion (Figure 8-3).

If a highly textured surface is desired, increase the amount of modeling paste added to the gesso, letting the mixture dry slightly after the last coat is applied. Next, using a palette or painting knife, manipulate the stiff gesso until the now stuccolike surface assumes the irregularity of texture that's to your liking (Figure 8-4).

Figure 8-2
Smooth Finish

Figure 8-3
Rough finish

Figure 8-4
Highly textured finish

C.
Glazes used to soften hard edges and subdue unimportant detail

B.
Subject underpainted using thinly applied strokes

D.
Thick overpainting of lights to emphasize center of interest

A.
Transparent tone applied over entire surface.

Figure 8-5

Oils, Underpainting, Glazes and Overpainting

Oil painting procedures vary greatly from artist to artist. All, however, seem to fall into two categories—indirect and direct. The indirect approach, the more traditional of the two, demands more patience from the artist because of the elaborate preliminary steps involved. Indirect paintings are usually executed on a pretoned canvas or panel. Once the tone is dry, the picture is thinly underpainted by carefully blocking in the overall composition. When these passages are dry, glazes are frequently applied to soften harsh edges and tone down areas of lesser importance, with the glaze acting as a transparent veil. Next, light-struck areas are overpainted with thicker, opaque paint, forming a pleasing contrast to the more transparent handling of the shadows. Finally, the painting is fine-tuned by applying additional glazes to overly contrasting lights and shadows and firming up whatever light passages illuminate the center of interest.

For the artist possessed with a patient temperament and a need to be in control of his painting every step of the way, the indirect method is ideal. The drawback of this way of working is the tendency to overly polish a picture to the point of photographic slickness. Still, when balanced with some restraint and fortified with artistic expression, the indirect method is capable of yielding solid, eloquent results. Study the painting shown on page 67 for an acrylic version of this approach.

Oils, the Direct Approach

To me, direct painting closely resembles jazz. They're both lively, usually improvised and move along with a foot-tapping rhythm. Unlike the more carefully built-up indirect approach, a direct or alla prima painting is usually finished in one or two sittings. When successful, this shoot-from-the-hip method is capable of capturing a charm and freshness unobtainable any other way. Its drawback is its unpredictability. Unfortunately, no matter how accomplished the artist, it's all but impossible to come up with a winner each painting session. Personally, I enjoy the live150ly chanciness of direct painting. Most of the pictures in this book were done alla prima and most of the painters I admire work this way.

Study the portrait sketch below by my good friend and fellow painter Frank Ingoglia. Notice the bold, yet sensitive brushwork employed, with the entire subject reduced to a mosaic of simple, sculptural planes. This sketch took Frank about one hour to paint, yet the handwriting quality of the brushstrokes not only catches the sitter's character but reveals the artist's spirit behind the brush.

Figure 8-6
FRANK INGOGLIA
Senior Citizen
16"x20" oil on canvas.

Collection of the author

Combining Oils and Acrylics

Whenever I tell my students that I occasionally mix oils and acrylics, they usually look rather bewildered and say they didn't know the two mediums were compatible. The truth is, when mixed together on a palette, they're not. Oil paint, which contains linseed or safflower oil, resists any mixtures with water-based paint such as acrylics. When applied in separate layers, however, an acrylic underpainting, because the dried waterproof paint is practically indestructible, makes a perfectly safe permanent base on which to overpaint with oils. Because of the faster drying time of acrylics, it's important to use them as the first layer and not the reverse, as oils need up to a year or more to thoroughly dry.

The procedure works like this. First, acrylics are used to block in large areas of the composition, establishing the overall color scheme and mood of the picture (Figure 8-8). Next, oils are used to further define, model and finish up the painting (Figure 8-9). I usually tend to work more or less transparently when underpainting with acrylics, saving my thick, opaque passages for the oil overpainting. This also gives the picture a pleasing balance between thick and thin paint. Try not to go too dark in your acrylic lay-in. If you do, the oil overpainting tends to look dense and lifeless because the dark undertones prevent light from bouncing through the paint. This, in turn, prevents the colors and tones from appearing luminous.

Either gessoed Masonite or canvas is a suitable support for acrylic oil paintings. Because acrylics dry matte and oils more glossy, it's best to give the final painting a coat of acrylic picture varnish.

Every artist finds his own ways of marrying various mediums. With experience, you'll find yours. If you've never combined acrylics and oils, give it a try—you may find it's just the right procedure for your particular temperament.

Figure 8-7 **Preliminary sketch**

B.
Shadows and background massed-in

D.
Lights massed-in using thicker, more opaque paint

A.
Entire surface covered with thin tone

C.
Edges left unsoftened

Figure 8-8 **Acrylic lay-in**

E.
Shadows developed and softened

H.
Final accents and highlights are added

G.
Thick impasto strokes used to paint lights

F.
Halftones are painted in

Figure 8-9 **Oil finish**

Acrylics

Acrylics have been in popular use for more than twenty years. For many they seem to be the medium of our age. The colors are bright, and the paint, when wet, is extremely malleable, turning completely waterproof when dry. Jack Pellew, in his informative book *Acrylic Landscape Painting*, lists five possible techniques available with acrylics. These are: transparent, a combination of transparent and opaque, opaque, simulated egg tempera and combining oils with acrylics. There are probably more combinations—incorporating photos or actual objects into a painting, using acrylic medium as a sealer or glue, or even including bas-relief sculpture in a painting by building up passages with acrylic modeling paste.

Since this book is chiefly concerned with painting light, I'm going to limit the techniques discussed to those that best serve that purpose. Some watercolorists use acrylics transparently either to lay-in a painting, finishing up with traditional watercolor, or to paint the entire picture with acrylics, applying the paint transparently. The advantage of acrylics, in this case, is that the paint dries waterproof, allowing glazes and transparent overpainting to be applied without bothersome bleeding or the picking up of undercolors. Combination transparent and opaque techniques work well with acrylics. Here again, glazes and overpainting can be safely applied over even the thickest of underpainting, without worrying about disturbing the

Collection of Carmine and Caroline Santandrea, Stamford, Connecticut

Saturday Night Lookout
12"x16" acrylic on illustration board.

I happened to be strolling around downtown Bennington, Vermont, one evening after dinner and came across these three old-timers who were just itching to be painted. After taking a few photos and jotting down some pencil notations of the color and value arrangement, I went back to my studio and painted the finished piece. I think it's a good example of the kind of rich modeling to be found when painting under overcast light. The entire picture is painted in acrylics, working opaquely with a limited palette of black, Thalo green, burnt sienna, lemon yellow and white.

Pastel thickly applied to model lights and halftones

Pastel thinly smudged over underpainting

Thinly applied acrylic washes used to establish large masses of hair, shoulder and head

Pastel strokes left unsoftened to impart texture to hair

Jeanne
9"x12" acrylic and pastel on illustration board.

Collection of the artist

underlying colors or surface.

Opaque acrylic painting, my favorite approach in this medium, can effectively exploit the use of thick paint, built up in a fabriclike texture with juicy, alla prima strokes, applied with either a brush or a painting knife. This gives you the option of painting over areas again and again until the desired results are achieved. Acrylics as a substitute for egg tempera can yield excellent results. In this case the painting is usually built up with small, careful strokes, glazing and overpainting where needed until the picture is complete. Study the opaque acrylic painting shown on page 150 and notice the variety of textures and edges obtainable with this versatile painting medium.

Acrylics and Pastels

For those who like the fluidity of paint but feel lost without the firmness and control of a dry drawing medium such as pastel, you'll be happy to know you can have it both ways. While many pastelists work on specially toned and toothed papers made exclusively for that medium, still others, including myself, prefer some sort of underpainting or base on which to build up a composition. Gessoed Masonite, illustration board and even gessoed watercolor paper are the surfaces I find more suitable.

The procedure is a simple one-two. After sketching the subject with a pencil or brush, apply broad areas of acrylics either transparently or opaquely. Develop this phase as far as you feel the need to do so. I like to save my modeling and edge handling for the pastel stage and usually do no more than lay in a broad light and shadow pattern of the subject.

Next, when the acrylics are dry, start applying pastels. Using the acrylic underpainting as a guide, you may prefer to finish the picture piece by piece, or, if you're mostly impulsive by nature, you may choose to work over the entire surface, letting your intuition dictate when the picture is finished. Either way, you'll have the insurance of your acrylic underpainting to help you check out how the mood, color scheme and composition are holding up. Be sure to either frame your acrylic pastel with glass or give it a spray of fixative to prevent the fragile surface from becoming smudged.

Gouache

The word gouache comes from the French derivative of the Latin phrase "the act of fetching water." Having used gouache for a good number of years, I most heartily agree with that description. When I first took up the medium I can remember using a scratchy drybrush technique, which involved repeatedly dragging my brush over the painting surface until the picture was complete. Rather than catching the subject's character and texture, as I had hoped, my stingy use of paint and severe technique usually resulted in a scratchy, uninspired painting. One day, after completing a particularly dismal rendition of a subject, an artist friend, upon seeing my picture, suggested that I work in a wetter, juicier way. I took his advice, fetched some more water, and have had a love affair with the medium ever since.

Winsor & Newton is the largest supplier of gouache. Its line of gouache Designers Colors has been a mainstay with painters, illustrators and designers for more than half a century. I find two surfaces particularly adaptable to the medium: cold-pressed illustration board and white or tinted pastel paper. Because pastel paper is thin, I suggest you either mount the paper to a sheet of cardboard or stretch it in the usual watercolor-paper fashion to prevent wrinkling or buckling.

I find gouache especially suited to small studies and sketches. Many times I'll paint such sketches on location, seated in my car on days when rain or cold weather prevents work on larger, more elaborate compositions. Some painters prefer gouache over acrylics for a pastel underpainting. Others lay in a transparent watercolor base and refine their picture with gouache. Whichever way you choose, I think you'll be impressed with gouache's bright, snappy colors and ease of application—but don't forget to fetch plenty of water.

Under the Bridge
15"x18" gouache on toned paper.

The light grey tone of the paper proved very useful in helping me to control the values in this painting. After establishing a broad lay-in of darks, I modeled the middle tones, making sure to go no lighter than the grey tone of the paper. After developing and refining the rest of the landscape, I completed the picture by painting my lightest lights in and around the figures splashing in the water.

View of St. Andrews
12"x16" watercolor on cold-pressed paper.

This was an "after-dinner picture." I paint many such pictures during the summer when the light lasts well into the evening. There are two light sources in this painting: the first, and strongest, coming directly from the sun and striking the left side of the building; the second, and less obvious source, is from the sky, which considerably lightens many of the shadow values. This effect is most evident on the top planes of the stone handrailing leading up to the church. If you count the subtle reflected light bouncing up under the stone archway above the doors, there are really three light sources. Because I've simplified the main lights and massed all the shadow values into two or three basic tones, the juggling of the three different light sources presented no real problem.

Watercolor

My editor tells me that books on watercolor are by far the most popular how-to art books sold. It isn't hard to figure out why. Not only is watercolor the easiest medium with which to apply paint to a surface, but it also lends itself to a variety of techniques enabling the artist to finish a painting in a comparatively short time. Another attraction is the singular charm with which paint strokes, be they flat washes, drybrush or wet-in-wet, sparkle and dance around the pristine white paper highlights. Add to this the relatively low cost of a basic watercolor kit and it becomes plain to see the reason for watercolor's wide following.

While I totally agree with all of the above, I must add that watercolor is also one of the most demanding of the painting mediums. With oils, overpainting and scraping out mistakes are a normal part of a day's work. So, too, with acrylics, gouache and even pastel. Watercolor, however, can be a strict taskmaster, permitting little margin for error, forcing the artist to either succeed or fail. I feel this riskiness is healthy, however, because it keeps the senses sharp and the painter on his toes.

I've found the following tips useful in getting the most out of the medium. With practice, you'll find your own ways; until then, these suggestions may help get you started. First, keep your preliminary drawing limited to a few simple guidelines, drawing as you paint rather than "number painting" on top of a complex maze of carefully drawn details. Second, work as quickly as you're able without getting haphazard. Third, let the medium direct your course of action. If, for example, an accidental blending of color suggests a distant clump of trees, by all means incorporate it into your painting instead of feeling obligated to strictly adhere to a predetermined compositional idea. Lastly, don't feel guilty about popping in a correction or two with opaque color. Sargent did, and so did Winslow Homer and John Pike, and these men are among the best watercolorists this country has ever produced.

When watercolor is approached with a spirit of adventure and flexibility, a charm can be imparted to the picture unobtainable with any other painting medium. So what are you waiting for? Pick up your brushes, relax and enjoy it.

Pencil Charcoal Pen and Brush

Pencil, Charcoal and Pen

A quick sketch of a fast-changing lighting effect can be an effective alternative when paints or a camera are unavailable. Most every artist has his pet drawing mediums. Mine are pencil, charcoal and pen. All three are portable, inexpensive and, along with a small drawing pad, provide a compact sketching kit. Soft pencils, such as 4Bs and 6Bs, are the most practical. Use the sharp tip of the pencil for details and the broad side of the lead for tones.

Charcoal, which comes in either sticks or pencils, can be used the same way. Charcoal also has the advantage of being easy to soften, enabling the artist to lay in a bold preliminary drawing and, with either the thumb or a soft rag, wipe the tones around until a pleasing pattern is achieved. Important passages can be refined with sharper lines while highlights are easily picked out with a kneaded eraser.

Many artists prefer the eloquent line of the pen for recording their sketches, working either in pure line or in conjunction with a hatching technique which creates tone. A few swipes of black applied with a brush can also add a pleasing tonal contrast to the drawing. Art supply catalogs list numerous pen points and holders available from different suppliers. I've always liked the flexibility of a crow-quill pen point, which can render either a fine hairline or, when more pressure is placed on the pen, a progressively thicker line.

Waterproof India ink is the most suitable for pen drawing because it allows washes to be placed on top of the lines without disturbing the underdrawing. Mixing drawing mediums is another popular technique, combining, for example, a pen line with pencil or charcoal tones. By developing a comfortable sketching technique you'll not only acquire a useful way of recording a fast-moving effect, but share in the pleasure these three drawing mediums have to offer.

Drybrush

My first exposure to drybrush was as an illustrator for *Field & Stream* magazine. I was to do illustrations to be printed in black-and-white, and Herman Kessler, the art director at the time, was looking for a style that would capture the ruggedness of the magazine's outdoor theme. He suggested drybrush. I gave an agreeable nod and headed back to my studio. Little did Kessler know that I had never done a drybrush drawing. I did some homework and found the old "pulp" adventure magazines of the 1930s full of excellent examples. When I delivered my drawings later that week, not only was the

art director pleased but I felt good about learning a new skill.

Drybrush is simple to do and only a few drawing materials are needed, which qualifies it as a good medium to use when doing quick, on-the-spot sketches. All you need are two or three old watercolor brushes of various sizes, some black India ink or designers gouache and a couple of sheets of two-ply bristol board.

To begin a drybrush drawing, dip your brush into either the ink or the paint, making sure most of the liquid has been removed beforehand. Using the same kind of arm movement and stroking as when you're painting, lay in a few basic areas of the composition. Don't worry too much about values at this point; rather, try to get a feel for the bulk of the picture. You may want to change brushes for different-sized areas or, as in the example shown below, execute the entire sketch with one medium-sized brush.

Make sure you keep a light touch when applying the paint or your sketch will tend to appear dense and heavy. Let the white of the paper act as the light-struck side of objects, leaving the halftones and shadows to suggest the form. Drybrush drawings seem to look best when drawn in smaller-sized formats, such as 11x14 or 12x16 inches. Anything much larger requires more subtle blending of edges and takes a lot of the fun out of the medium.

Study the illustration below and notice the many kinds of textures and edges obtainable with drybrush. The sketch was done on location and took less than an hour to complete.

Backlot Near Brewster
12" x 16" drybrush on illustration board.

Collection of the artist

Mixing Mediums

I usually limit my mediums to one; occasionally, however, when I'm unsure of exactly how I want to tackle a painting, I'll incorporate whatever mediums best help solve the problem. The accompanying painting presented such difficulties. Although I was fairly certain how I wanted to compose the picture, I was less certain how I would paint it.

My first step was a confident one, boldly establishing the composition with a brush and waterproof ink. Being less sure of how to approach the massing stage, I switched to gouache and thinly stated a general shadow pattern. So far, so good. Had I not been satisfied with the results, however, it would have been a simple matter to wash off the water-soluble gouache and start again, without disturbing the underlaying waterproof ink drawing.

Acrylics were chosen for the next phase. The choice was dictated by the paint's fast drying quality and the waterproof and turpentine-resistant base it would provide in case the final layer of oil paint was unsuccessful and had to be washed off. Finally, the painting was refined and completed with thick, juicy oil paint applied with both brush and palette knife.

Although I prefer the purity of one medium, it's nice to know that when an unusual problem arises, there's always the option to use whatever mixed mediums are available to help solve it. Some painters use mixed mediums all the time, letting an ink line or acrylic passage show through the oil overpainting here and there. Whatever methods you choose, keep mixed mediums in mind as either an alternative solution or a finished technique in itself.

STEP 1
Ink drawing

STEP 2
Gouache lay-in

STEP 3
Acrylic buildup

STEP 4
Oil refinement

The Net Mender
24"x30" oil on canvas.

Collection of Mr. and Mrs. A. Weitzer, Stamford, Connecticut

People at work have always intrigued me, particularly craftsmen and other artists. One problem that confronted me in this painting was how to underplay the dock and background paraphernalia enough to set off the figure without subduing it to the point where it became unrecognizable. The most difficult part of this picture, however, was the net. I had to repaint it five times before it harmonized with the rest of the picture. I used a lot of palette-knife work in this painting, which helped give character to the weather-beaten look of the figure and objects.

Chapter **9**

Picture Making

Equipped with a working knowledge of values, color and technical skills, as well as an understanding of various lighting conditions and their peculiarities, it's now time to blend them into a unified working procedure and tackle picture making. But you may ask, haven't we been making pictures all along? The answer is yes and no. Yes, in that some of the value studies and paint sketches done in working out previous problems may have captured a freshness of application or a pleasing arrangement of color and values, which could qualify as a satisfactory finished statement. No, because more than likely, most of the work done up to this point was directed to solving isolated problems rather than attempting complete compositions.

What, then, makes a finished picture? To me, the answer is unity. Whether it be unity of color, tone, pattern, texture gesture or even paint application, unity is what gives a painting its personality. Remember, there is no such thing as a perfect picture. An artist can only paint what moves him, emphasizing those qualities of color or tone or texture which he feels are most important.

A good example of unity is the Jan Vermeer painting shown on page 17. Observe the satisfying completeness of this quiet, yet powerful composition. Notice how the areas of strongest value contrast hover around the figure, hand and scale, directing our eye to look there first. Study the simplicity with which Vermeer indicated the cloth resting on the table in the lower left-hand corner and how the skirt is underplayed. The simple treatment of the painting hanging behind the figure at first seems nearly photographic, yet upon closer inspection is simply done.

The organization of shapes in this painting serves more than a decorative function. Notice how the dark shape of the large background painting effectively leads the viewer's eye, like an arrow, to the hand holding the scale. The dark opened box on the table likewise points to the center of interest. Obviously stirred by his subject, one wonders if Vermeer consciously thought of these devices while painting. I somehow doubt it. This superb masterpiece was probably done in a workmanlike manner, with Vermeer's intuition deciding what would go where, rather than consciously planning these effects.

By contrast, turn to the Alfred Sisley painting on page 19. Here we have a busy river scene, probably painted on location, yet endowed with the same pictorial unity as the Vermeer. It's interesting to note how Sisley's picture breaks one of the cardinal rules of landscape composition, and that is, of never placing an important element across the center of the picture. Yet Sisley has broken this rule. Notice how the bridge in the foreground, riverbank and houses have been positioned in the middle of the composition. If I were to describe such a composition to a fellow artist, he might say these elements should be either raised or lowered, to form a more interesting breakup of shapes. Why, then, is Sisley's painting effective? The answer is found in the handling of color.

Like the other Impressionists, Sisley was trying to capture the effects of light. In studying his composition more carefully, we see that the entire painting is unified by the

Soho Flower Market
18"x24" oil on canvas.

Private collection

Early morning, like late afternoon, offers the painter numerous options in composing interesting shadow patterns. When I painted this New York flower market, the sun was just starting to edge its way up into the sky—shadow dominated the scene. Fortunately, because the effect lasted only an hour or so, I was able to catch the poetic quality of the subject by taking some reference photos and making some fast pencil notations, painting the finished picture in my studio.

warm light of the sun. Rather than emphasizing any one part of his composition with stronger value contrasts, Sisley has chosen to sprinkle his entire composition with various-shaped light, medium and dark values, no doubt arranging them in much the same way as he observed them. This kind of candid composition is similar to the snapshots we take today of scenic locations, where the overall view takes precedence over any one part. Where Vermeer focused on the figure and a few objects, Sisley avoided concentrating on any one aspect. Instead, he showed off the light and color playing over the entire scene.

Here we have two artists with entirely different points of view, yet much alike in painting what stirred them. Each probably chose the most direct way of expressing his feelings about what he saw.

This is what picture making is all about. Finding what stirs you and expressing it simply and honestly. A study of all the great paintings of the past and present reveals

these same qualities. Although values, color schemes, choice of subject matter and paint handling vary greatly from artist to artist, the underlying thing they all have is the unity of a sensation seen, felt and recorded.

There are as many different ways to approach picture making as there are artists who paint. The following demonstrations will show you some of my ways. Keep in mind, however, that your ways may vary from mine. The best way to find your personal approach to picture making is to explore many different procedures. Your nature and personal makeup might give you a clue as to how to start. If, for example, you're a careful, methodical person, you might begin a picture with careful studies from different points of view. These could be followed by pencil renderings to familiarize yourself with the subject, then perhaps a color sketch and finally on to the finished painting.

A more spontaneous temperament might get impatient with an excess of preliminary work and choose to jump right into the finished painting with only the simplest drawing as a guide—solving color and value problems as they arise, directly on the finished canvas. Whatever your temperament, work *with* it, instead of against it. Trust yourself and the knowledge you've acquired—with experience your own smooth procedure will evolve. Then, when you come across a subject that stirs you, you'll be able to disregard what's unimportant and paint a picture that shows how you felt about your subject.

Learning From Other Artists

Whenever I find myself getting stale and starting to repeat pet color schemes and compositions, I know it's time to reshuffle my point of view. One remedy I've found useful is to do some small, free interpretations of paintings by artists I admire, working from either book reproductions or prints. If you don't own any good material, there are many fine art books available at your bookstore or public library on past and present artists and schools of painting. Still better, take your paint box to the nearest museum and paint a sketch from the original. This requires getting permission, but most museums are cooperative in this respect—some even have easels available for you.

I find it comfortable working the same size as the reproduction I'm copying. It simplifies scaling problems and also helps prevent me from getting too enamored with details. I usually spend an hour or so on my sketches, striving for a simple, free interpretation rather than a stroke-for-stroke duplication. It always surprises me, after finishing a copy, how much more penetratingly I see the original painting—probably because I'm forced to really scrutinize the picture rather than just look at it. It's also a good idea to concentrate on the particular aspect of painting that the artist was using to communicate his idea. Because Sorolla and Potthast were both primarily interested in color and light, my copies concentrate on those aspects of their pictures (Figures 9-2 and 9-3). John Pike, by contrast, was essentially a tonal painter and my copy of his painting emphasizes tone over color (Figure 9-4).

Make your copies in whatever medium you feel most comfortable rather than sticking to the one the artist used. The John Pike study, for example, was done in oils, while Pike painted the original in watercolor. The important thing is to try to put yourself in the shoes of the artist, and become aware of the color, value and compositional problems he faced and what devices were used to overcome them.

Figure 9-2

AFTER JOAQUÍN SOROLLA
I learned a lot painting this sketch after the Spanish impressionist Sorolla—particularly about painting white objects. For example, notice the dresses on the two women in the right foreground. While intense sunlight bleaches out most of the color in the light, the shadows are loaded with subtle reflected color and light from the sky, sand, water and other nearby light-struck objects. It still amazes me how high on the value scale Sorolla painted the shadows of white objects, seldom using more than a one-value jump to show the difference.

Figure 9-3

AFTER EDWARD POTTHAST
Edward Potthast's beach scenes, strongly influenced by Sorolla, also catch the brisk air and bright sunlight of the seaside. However, painting this copy showed me that Potthast was still his own person. Notice the carefully designed pattern the figures and waves weave against the darker blue greys of the distant water and sky. Aside from the dark hair and bathing trunks of the two foreground figures and a few middle ground accents here and there, the painting remains light and high-keyed.

Figure 9-4

AFTER JOHN PIKE
It's interesting to compare this copy of a John Pike to the other two sketches. While Pike is obviously more of a tonalist, his painting still conveys a credible feeling of bright sunlight. Study the shadows of the background buildings. Notice that, although they are painted with darker values than either Sorolla or Potthast would have used, they nevertheless appear fresh and white. This is because the dark mass of tree foliage, knowingly placed above the buildings, causes the building's shadows to appear much lighter than they actually are. Hold your hand over the tree branch and you'll see what I mean.

Preliminary Paint Sketches

Although I'm a staunch believer in alla prima painting, I occasionally feel the need to do a preliminary paint sketch or two prior to tackling my finished canvas. The sketches shown on this page, executed in various mediums, were all done for a series of paintings depicting scenes of New York.

I usually keep these sketches small—the ones reproduced here are only slightly larger in their original size. Most of the finished pictures in this series were painted in my studio rather than on location. I did these sketches to help freshen up my recall of the city's bustling life and interesting local color. I've intentionally minimized detail and stressed only masses of color and value.

Squint your eyes and notice the effect of the carefully considered warm and cool colors as they imply sunlight without actually defining objects. I try to avoid carrying these sketches too far because they can easily sap the spontaneity I like to save for my finished picture and I end up trying to duplicate the charm of my sketch rather than creatively improvising on the finished canvas.

Acrylic on Board

Oil on Masonite

Watercolor on Paper

Oil on Masonite

42nd St. at 7th Ave.
24"x28" oil on canvas.

Here's the finished painting. My procedure was simple and straightforward, first laying in the large masses with thin washes of color, refining piece by piece, yet keeping an eye out to make sure the overall composition stayed unified. After the lay-in I put away my color rough and charcoal sketch and improvised as I went along, assured that my preliminary work would intuitively come out as the picture was being painted. It did—although occasionally it doesn't. *42nd St. at 7th Ave.* took three 4-hour sessions to complete.

162

From Color Rough to Finished Painting

After completing a satisfactory color rough I usually scale it up slightly and redraw the scene's large shapes onto a piece of paper to further explore the subject's compositional potential.

Although I've elaborated on my color rough, my approach is still quite simple. The tree in the middle ground, for example, is one big value with just a few squiggles used to show its trunk and branches. The figures are made up of a few simplified forms with the stress on gesture. This is a telling stage. If the sketch looks good, I redraw it onto my finished canvas. The sketch provides a helpful clue as to just how big or small I should work. If the sketch doesn't come off, I toss it away and start from scratch.

Collection of Mr. and Mrs. A. Weitzer, Stamford, Connecticut

Demonstration: Flower Child

Heather, the model for this painting, is now a mature high school student. When I painted this picture, however, she was only nine and summed up that sense of wonder all kids that age seem to have.

I decided to base my color scheme on variations of green, using a complementary red to accent Heather's hat. After choosing a fine-grain linen canvas, which I felt appropriate for the subject, I toned the surface with a yellow green oil wash. This enabled me to thinly paint in most of my dark and middle tones without any bothersome patches of white canvas showing through. I reserved my lightest accents—the light side of the figure and flower—for last, and applied them with thick, impasto paint. I tried to keep all my strokes fresh and vital to enhance the mood of the picture.

STEP 2
Using the position of the sun as my guide and working with a medium-sized filbert bristle brush I massed-in a general shadow pattern using cerulean blue. Next, shadow passages were thinly painted in cool, blue green colors. Even the flesh has a generous amount of blue mixed into it. Up to now my palette has been limited to white, burnt sienna, cadmium yellow pale and cerulean blue.

STEP 1
After toning my canvas with a thin wash of green mixed from cadmium yellow medium and cerulean blue, I drew in the basic gesture of the figure plus a few lines to suggest the background. No attempt was made to go beyond a basic drawing. As with most of my other paintings, I prefer to refine the drawing as I develop the painting.

STEP 3
After adding alizarin crimson, cadmium orange and sap green to my palette, I start to mass-in my lights, reserving pure white for only the light side of the hat. Once my lights and shadows were massed-in, I switched to smaller filbert bristles and worked at random, moving all around the painting, putting in a note here and an accent there, until the composition felt complete.

Flower Child
12"x16" oil on canvas.

Private collection

After a careful evaluation of what I'd done so far, I began to refine the figure. Notice how the light, halftone and shadow of the legs have been softened to round the form. The shirt and shorts, though treated more loosely, are also soft and fabriclike. Finally, using a small flat sable, I painted the warm reflected light into the shadowed face and modeled the hands, hat and flower Heather is holding. I finished the painting by indicating a few wisps of flowers in the middle ground. *Flower Child* took two 3-hour sessions to complete.

Demonstration: A Breezy Day on the Saugatuck

I painted this picture entirely on location working ankle-deep in mud with a bright yellow umbrella attached to my easel shielding my canvas from the sun. (No wonder when people sometimes see artists at work, they think they're a little strange!)

Because the dramatic cloud-strewn sky impressed me most about the subject, I decided to make it dominate the composition. Starting with acrylics, I sketched in a few basic guidelines and quickly covered them with large washes, refining my drawing as I went along. Next, I switched to oils and developed the picture until the overall effect felt right. Final refinements included the small buildings, boats and pier—then the painting was finished.

STEP 1
Working with bristle filberts of various sizes and an acrylic palette consisting of white, alizarin crimson, yellow ochre, cadmium yellow pale, cerulean blue and ultramarine, I layed in the whole picture. I tried for a simplified version of how the finished painting would look. Notice the broad treatment and lack of detail. Because I'll be overpainting with oils, the paint is kept thin and textureless.

STEP 2
Using the same colors as in Step 1, I began my oil overpainting. Notice the thick, juicy treatment of the sky with emphasis on the movement of the clouds rather than on any detailed characteristics. To play up the whiteness of the small building and boats, I was careful to keep the values of the trees and foliage lower in key. Rather than using a tube green for the foliage, I chose to use mixtures of cadmium yellow pale, yellow ochre, cerulean blue and ultramarine, which harmonize better with the sky.

A Breezy Day on the Saugatuck
20″x24″ oil on canvas.

Collection of Mr. and Mrs. Robert Oldford, Stamford, Connecticut

After refining the sky and indicating some texture on the trees, I added some final accents to the building, boats and pier. Some sea gulls were put in as an afterthought, then wiped out because they appeared trite. By resisting the temptation to tighten up the painting, I think I've retained some of the freshness that impressed me so much when I first confronted the scene. The painting took two and a half hours to complete.

The Doors
18"x24" oil on canvas.

Collection of the artist

 I submitted this painting to two different art shows. The picture was rejected at the first and received first prize in the second. The lesson is—don't feel rejected if your painting isn't accepted and don't feel you're a superstar if it is. I walked through these doors thousands of times before seeing them as pictorial material. Since this painting, however, I've probably done six or seven variations. To me, what makes this painting successful is the play of warm and cool greys alternating down the doors, walls and ceiling of the short hallway. The colors used to mix these greys were ultramarine, cadmium orange and white. The other colors included on my palette were alizarin crimson, cadmium red deep, cadmium yellow pale and cerulean blue.

Be a Maverick

Painters are deluged these days with books on "how to paint—whatever." One book will state *never* to work on a white canvas without first applying some sort of tone. Another preaches the virtues of *only* painting on a white surface, implying that a tone is taboo. Art instruction books seem to be riddled with such contradictions, which, though certainly unintentional, leave many potentially good painters scratching their heads rather than painting.

My experience has been that just about any painter of note has something to offer—the trick is to separate what's useful to your particular needs and what's not. This is easier said than done. It's embarrassing to remember the number of times that I've been enamored with a certain artist's procedure—frequently to the point of actually employing an identical working method, naively thinking my results would be equally successful. What did result was a second-rate, uninspired picture. This led me not only to be more selective when studying other artists' habits but to resist the inclination to be associated with any *one* school of painting. This mavericklike attitude proved right for me and was an important step in my maturing as an artist.

While I've had the best intentions, in these last few pages, in showing you my methods, in no way do I expect you to strictly adhere to them. For me they work; for you they may not. If you really want to find your own natural working method, learn to quickly discard what doesn't feel right.

For example, I'm usually itchy to get to the actual painting as soon as possible, and like to start a picture by sketching in only the bare bones of the subject, altering and refining as I paint along. You, on the other hand, may feel more comfortable by carefully drawing each element with accuracy and precision before picking up a brush. Both ways are right; it all depends on who's doing the painting.

Finding yourself takes a lot of trial and error, false starts and downright disasters. By sticking with it, however, your natural way of working will begin to surface. This, in turn, will not only give you a better batting average but stamp your paintings with a genuineness uniquely your own. To me, one of the saddest things that can befall any artist is when he loses his own intuitive feelings and limps along solely on the methods of others.

It takes feistiness to paint a picture, as well as stubbornness and daring. Mix these with just the right amount of humility, and an interesting personal statement is bound to result. The big thing is not to get discouraged in the process. Paint boldly or carefully, but be a maverick and do it your own way!

Some Final Thoughts

Earlier this year my wife and I went to see a large exhibit of the paintings of Edouard Manet. On the way to the show we found ourselves discussing the pros and cons of the seeming overabundance of precise, photographic approaches to picture making that appear to be showing up more and more in galleries and exhibits. Where, I remember asking, if this trend continues, will people be able to go to see and learn about other alternatives of painting? What's to become of the artists who are more interested in exploring color and light than in documenting more or less predictable subject matter? I suppose the glossy, plastic world we're surrounded by contributes no small part to this sad imbalance.

As we turned a corner and came into view of the museum, I found myself totally unprepared for the sight that greeted me. Not hundreds, but perhaps thousands of people, many holding umbrellas against the strong wind and swipes of flurried snow, were waiting, ten and twelve deep, in a long, S-shaped line.

The sight itself could have been something out of an Impressionist painting with the crowd appearing as sporadic dots of color flickering in toylike movements against the massive stone backdrop of the museum. Standing, ill dressed, for three hours in that first slushy snow of the year, alongside thousands of others, swiftly dissipated my earlier pessimism of the imbalance in today's painting. While the show itself was most rewarding, my best feeling came from seeing all those expectant faces, from all walks of life, patiently waiting in line to see the work of a man who was booed, jeered and dismissed as a fake when he first exhibited. How pleased Manet would have been to see all those people waiting respectfully to acknowledge his fresh vision of the world.

Despite the somberness of our times, I believe we're fortunate, as artists, not only to have a rich heritage of enlightenment enabling us to appreciate and understand the work of a maverick like Manet, but also to have the freedom to express ourselves in any way we wish.

Thinking about those throngs who would flock to a museum on a cold winter afternoon reminds me of Robert Henri's sensitive observation on the great brotherhood of people bound together by art. "Through art mysterious bonds of understanding and of knowledge are established among men. They are the bonds of a great Brotherhood. Those who are of the Brotherhood know each other, and time and space cannot separate them."

Winter, Riverside Avenue
6"x8" oil on Masonite.

Collection of the artist

This was the first of four small pictures I painted in my car one snowy November afternoon. It's also the only one of the four that was successful. Painting is a lot like fishing in this respect, because the following day I remember getting lucky and painting three consecutive winners. To me, painting small pictures on location is the very core of learning to paint anything well. With repeated practice your hand and eye coordination grow more sensitive. More important, your ability to express yourself about what you see becomes heightened—and isn't that what painting is all about?

Autumn, Skipper's Boatyard
12"x16" oil on canvas.

The Douglas Gallery, Stamford, Connecticut

Debbie Reading
10"'x12" oil on illustration board

Collection of the artist

Suggested Reading

There are seemingly acres of art books on the market these days. Some are how-tos, others bios of past and contemporary painters. Such publishers as Skira-Rizzoli and Abrams have excellent large-format monographs on many of the old masters. Some publishers print lower-priced paperback editions of their popular hardcovers. By shopping selectively and keeping an eye out for sales, a surprisingly adequate art library can be built up for a reasonable sum. I started collecting books in art school and my library has grown steadily ever since. The knowledge and inspiration I've received in reading about different artists and studying their working methods has paid for the price of my books many times over. The following are some of my favorites.

Drawing

Edwards, Betty. *Drawing on the Right Side of the Brain*. Los Angeles: J. P. Tarcher, 1979.

Nicolaides, Kimon. *The Natural Way to Draw* Boston: Houghton Mifflin, 1979.

Values, Color And Technique

Gruppe, Emile. *Gruppe on Color*. New York: Watson-Guptill, 1979

Callen, Anthea. *Techniques of the Impressionists*. Secaucus, N.J.: Chartwell Books, 1982.

Reid, Charles. *Painting What You Want to See*. New York: Watson-Guptill, 1983.

Past Masters of Painting Light

Gerts, William H. *American Impressionism*. Seattle: The Henry Art Gallery and the University of Washington, 1979.

Gorden, Robert and Forge, Andrew. *Monet*. New York: Harry N. Abrams, 1983.

Levin, Gail. *Edward Hopper: The Art and the Artist*. New York: Norton, 1980.

Leymarie, Jean. *Corot*. New York: Skira-Rizzoli, 1981.

Rewald, John. *The History of Impressionism*. New York: Museum of Modern Art and the New York Graphic Society, 1960.

Simo, Trinidad. *J. Sorolla*. Valencia, Spain: Vicente García Editores, S.A., 1980. (Text in Spanish)

General Thoughts on Painting

Hawthorne, Charles. *Hawthorne on Painting*. New York: Dover Books, 1960.

Henri, Robert. *The Art Spirit*. Philadelphia: Lippincott, 1960.

Index

A
Aerial perspective, 60
American Impressionists, 12
Ashcan School, 12
Atmosphere, 66

B
Bama, James, 46
Bellows, George, 12
Benson, Frank W., 12
Botticelli, Sandro, 10
Braque, Georges, 142
Bridgman, George, 30
Burchfield, Charles, 126

C
Caravaggio, Michelangelo da, 12
Cassatt, Mary, 12
Cezanne, Paul, 12, 111, 141
Chardin, Jean-Baptiste-Siméon, 41, 43
Chen Chi, 92
Chinese art, 10
Clark, Kenneth, 65
Color, 106
 and light, 106
 at different times of day, 120
 black, 109
 blues, 109
 color wheel, 108
 complements, 114
 earth colors, 109
 expressiveness, 129
 intensity, 112
 mixing, 110
 neutralizing, 114
 of skies, 118
 positioning on value palette, 111
 prism, 108
 reds, oranges, yellows, greens, purples, 109
 reflected, 117
 relation to values, 112
 "seeing" personally, 129, 130, 134
 spectrum, 108
 temperature, 108-109, 112, 116
 transition from tone, 106
Constable, John, 12, 16, 43, 80
Corot, Camille, 105, 106, 118

D
Dada painting, 142
Dash, Richard, 25
Daubigny, Charles, 15
Davies, Ken, 46
Degas, Edgar, 116, 137, 141, 142
Delacroix, Eugéne, 137
Duchamp, Marcel, 142

Dunn, Harvey, 76
Duran, Carolus, 106
Dürer, Albrecht, 142

E
Eakins, Thomas, 137
Edges, 66
 awareness of, 68
 how to soften, 71
 kinds of, 70
Egyptian art, 10
El Greco, 12
English Academy, 56
English portraiture, 142

F
Filmmakers of the 1920s, 12
Francesca, Piero della, 10
Freilicher, Jane, 25
French Academy, 56

G
Gallagher, Christy, 25
Giotto, 10, 142
Greek art, 10
Gussow, Alan, 126

H
Halftones, 40
Hals, Frans, 13, 15
Hassam, Childe, 12
Henri, Robert, 12, 15, 25, 105, 170
Hockney, David, 92
Homer, Winslow, 16, 30, 137
Hoowij, Jan, 15
Hopper, Edward, 13, 15, 23, 74, 78, 105, 116, 126, 130, 137

I
Impressionism, 12, 14, 54, 106, 122, 142, 158
Ingoglia, Frank, 147
Interpreting what you see, 130

J
Jackson, Clifford, 110

K
Keying a picture, 72
Kinstler, Everett Raymond, 24, 25, 136
Koerner, W. H. D., 20

L
Lawson, Edward, 12
Leader, B. W., 65
Learning from other artists, 160
Leonardo da Vinci, 12, 80

Linear painting, 36
Lovell, Tom, 110

M
Mancini, Antonio, 12
Manet, Edouard, 105, 110, 170
Masaccio, 142
Massing lights and shadows, 46
Materials, 143
Matisse, Henri, 36, 98
Mayer, Ralph, 145
Melone, Janis, 36
Michelangelo, 12
Monet, Claude, 12, 15, 16, 65, 80, 106, 111, 137, 141
Mood, 66, 78
Morisot, Berthe, 12
Mucha, Alphonse, 137

N
Nicholidies, Kimon, 48

P
Painting light, 25, 96
 and color, 106, 108, 117
 a sense of place, 126
 at different times of day, 120-121
 changing direction on the head, 50-51
 colored, 116
 combining two or more sources, 103
 coming from the sky, 118
 dissipating, 100
 history of, 10
 important movements in, 14
 kinds of,
 back light, 80, 82
 edge light, 94
 diffused light, 92
 form light, 84
 moonlight, 96
 overcast light, 90
 patchy sunlight, 88
 sunlight, 86
 on the head, 50
 past masters of, 10
 poetry of, 105
 reflected, 117
 relation to color, 106
 today, 25
 warm afternoon, 122
Painting on location, 136
Palette, 110
 choosing colors for, 110
 of past masters, 110
 setting up, 111
Parrish, Maxfield, 137
Pellew, Jack, 150

174

Pfahl, Charles, **25, 80**
Photography, **130, 136, 137, 138**
 Daguerre, Louis, **137**
 history of, **137**
 Muybridge, Eadweard, **137**
 Niepce, Joseph, **137**
 photo realism, **137**
 painting from, **32, 58, 138-139**
 35 millimeter camera, **138**
Photo Realism, **137**
Picasso, Pablo, **142**
Picture making, **158**
 choosing a point of view, **132**
 preliminary paint sketches, **162**
Pike, John, **103, 160, 161**
Pissarro, Camille, **12, 18, 56, 65, 74, 96, 106, 111**
Planes, **50**
Pollack, Jackson, **142**
Porter, Fairfield, **25, 105, 126, 141**
Portraits, **125**
Potthast, Edward, **12, 21, 54, 160, 161**
Prehistoric art, **10**
Prendergast, Maurice, **12**
Preparing panels, **144**
Pre-Renaissance painting, **142**

R
Raphael, **12**
Realism, **14**
Reference material, **136**
Reflective surfaces, indoors, **52**
 outdoors, **54**
Reid, Charles, **25**
Rembrandt van Rijn, **12, 27, 80, 105**
Remington, Frederic, **96**
Renaissance, **10**
Renoir, Pierre, **12, 111**
Robinson, Theodore, **12, 137**
Rockwell, Norman, **50, 98**
Roman art, **10**

S
Sargent, John Singer, **22, 25, 41, 54, 80, 90, 129, 141**
Schiele, Egon, **137**
Schmid, Richard, **25**
Serov, Valentin, **12**
Seurat, Georges, **56**
Shadow, **26**
 changing direction of, **30**
 complex subjects, **32**
 designing, **29**
 less obvious effects, **34**
 massing, **27**
 on simple forms, **28**
 power of suggestion, **27**

"quick glance" method of seeing, **27**
Sisley, Alfred, **12, 19, 65, 106, 158**
Sloan, John, **12**
Sorolla, Joaquín, **11, 12, 54, 80, 122, 160, 161**
Sovek, Charles, paintings by
 Autumn, Skipper's Boatyard, **172**
 Bananas, **64**
 Boats on the Saugatuck, **119**
 Boatyard, South Norwalk, **120**
 Bond St., **115**
 A Breezy Day on the Saugatuck (demonstration), **167**
 The Bridge to Gorham Island, **127**
 Candlewood Lake, **107**
 Charles St., **135**
 Chip, **124**
 Chuck, **125**
 The Clam Digger, **67**
 Debbie Reading, **173**
 The Dock at Peter's Bridge, **121**
 The Doors, **168**
 Early Sunday Evening, **79**
 Eddie and Mack, **95**
 Evelyn's Dock, **122**
 Flower Child (demonstration), **165**
 42nd St. at 7th Ave., **163**
 Gorham Island, **140**
 Hans, **85**
 Hot Dog Man, **33**
 Interior, **93**
 Jeanne, **131**
 Jeanne #2, **151**
 Late Afternoon, South Norwalk, **104**
 Lorette, **125**
 Low Tide, **118**
 Mary's Place, **102**
 Nancy, **81**
 The Net Mender, **157**
 Nick, **125**
 Night Stop, **97**
 Packroads, **121**
 Saturday Morning, **128**
 Saturday Night Lookout, **150**
 The Scavenger, **37**
 Sheridan Square, **91**
 Skipper's Boatyard, **120**
 Soho Flower Market, **159**
 The Spirit Show, **126**
 Splish Splash, **123**
 Spring Foal, **87**
 Washington Square North, **89**
 Watermelon, **113**
 Winter, 59th St. and 5th Ave., **103**
 Winter, Riverside Ave., **171**
 Under the Bridge, **152**
 View of St. Andrews, **153**
Strisik, Paul, **136**
Symbols in painting, **10**

T
Tarbell, Edward, **12**
Techniques, **142**
 acrylics, **151**
 charcoal, **154**
 combining acrylics and pastel, **151**
 combining oils and acrylics, **148**
 drybrush, **154**
 dry mediums, **143**
 gouache, **152**
 historical development of, **142**
 mixing mediums, **156**
 oils, the direct method, **147**
 oils, the indirect method, **146**
 pen, **154**
 pencil, **154**
 preparing panels, **144**
 watercolor, **153**
 wet mediums, **143**
Texture, **62**
Tonalism, **14**
Toulouse-Lautrec, Henri de, **36**
Turner, J. M. W., **12**
Twachtman, John, **12**

V
Values, **36**
 as opposed to linear painting, **36**
 basic value scale, **38**
 bracketing values, **42, 48**
 changing light and mood outdoors, **56**
 enlarging basic value scale, **44**
 foreground, middle ground, background, **58**
 home values, **39**
 making a value palette, **38**
 massing lights and shadows, **46**
 procedure in painting, **42**
 simplifying, **45**
 spotlight effect, **76**
 transition to color, **106**
 truth of tone,
 understanding, **65**
 using the value palette, **38**
Velaizquez, Diego de, **111**
Vermeer, Jan, **12, 17, 41, 80, 90, 105, 141, 158**
Vuillard, Edouard, **25, 137, 141, 142**

W
Whistler, James McNeill, **96**
Wilson, Jane, **25**
Wyeth, Andrew, **27, 82, 105, 132, 136, 141**
Wyeth, Jamie, **82**

Z
Zorn, Anders, **12**

Acknowledgments

This book would have been impossible to write without the help and support of a lot of people. Besides my old friends coming through, as usual, with a helping hand when needed, some new friends were made along the way, happily adding to my already interesting task some final garnishes of well wishes that made the whole project a totally satisfying experience.

With one very big bow I'd like to give the following thanks. To Deborah Dutko-Sovek, who has always believed in me. To my great kids, Chip and Jeanne, for their patient posing and inspiring selves. To my editor, Fritz Henning, who gave me the freedom to put this book together exactly the way I saw fit. To Alex Domonkos, whose fresh eye helped me immeasurably. To my typist, Martha Runner, whose nimble fingers and flawless spelling never faltered. To Zoltan Henczel, whose helpful hints and professional eye behind the camera were indispensable. To Bill Noyes, for his lively photo portrait. To Doug Jayne, at the Douglas Gallery in Stamford, Connecticut, for his caring assistance in rounding up my paintings; Cele Scher, at the River Gallery in Westport, Connecticut, for her interest and support; and Sally Moss, at the Portfolio in Stamford—all their encouragement and belief in me as an artist help keep my brushes moving forward. To Ray Kinstler, painter par excellence, for his loan of a painting. To Mrs. Ruth Koerner Oliver, for her permission to reproduce the fine painting by her father, W. H. D. Koerner. To Merrill J. Gross, who took the trouble to make available his superb Potthast painting. To Christy Gallagher, friend and artist, for the use of her painting. To Janis Melone, for the use of her sensitive illustration, and to my old friend Frank Ingoglia, for the use of his lively portrait sketch.

Special thanks to Debbie Everett, at the Hispanic Society of America; Glenda Galt, at the Brooklyn Museum; Linda Lawson, at the Metropolitan Museum of Art; Ira Bartfield, at the National Gallery of Art; Laveta Emory, at the Freer Gallery of Art; and Nicki Thiras, at the Addison Gallery of Art.

To Frank Vincent Dumond and Frank J. Reilly, whose clear thinking and teaching proved most inspirational.

I'd also like to thank my mother, Mrs. Estelle Webster, and my sisters, Mrs. Charlene Ikonomou and Mrs. Estelle Long, for their caring interest and support.

Finally, I'd like to thank the sun above for being so inspiring—without it this book would never have been written.